Art-Based Research

Art-Based Research

Shaun McNiff

Jessica Kingsley Publishers
London and Philadelphia

First published in the United Kingdom in 1998 by
Jessica Kingsley Publishers
116 Pentonville Road
London N1 9JB, UK
and
400 Market Street, Suite 400
Philadelphia, PA 19106, USA

www.jkp.com

Copyright © Shaun McNiff 1998
Printed digitally since 2009

Library of Congress Cataloging in Publication Data
A CIP catalogue record for this book is available from the Library of Congress

British Library Cataloguing in Publication Data

McNiff, Shaun
Art-based research
1. Arts - Therapeutic use - Research
I. Title
615.8'5156'072

ISBN 978 1 85302 621 8 (paperpback)
ISBN 978 1 85302 620 1 (hardback)

There are more things in heaven and earth, Horatio,
Than are dreamt of in our philosophy.

Hamlet, Act I, Scene v

Contents

Acknowledgements 10

Preface 11

I. Theoretical Foundations

The Emergence of a New Vision of Research 21

From Justification to Creative Inquiry 31

Connections to Imaginative Science 39

Art's Integration of Empirical and Introspective 49
Inquiries

Practitioner Research 63

II. Review of Art Therapy Research

Breadth of Inquiry 85

A Showing of Imagery and Experiences 91

Research as a Focus in Art Therapy 111

Artistic Knowing in Art Therapy Literature 121

An Overview of Research in an Art Therapy 135
Graduate Program

III. Research Ideas

The Method of Discovery 145

Practice of Research 151

Structure 155

Artistic Amplification of Case Studies 159

Ideas 169

 The effects of aesthetic quality 171

 Method studies 178

 Histories 198

 Outcome assessments 201

Postscript *207*

References *209*

Index *219*

Acknowledgments

Art-Based Research has been shaped together with many colleagues and graduate students. Former masters and doctoral students, too numerous to name, have been my principle collaborators. I will name some who represent what others have also achieved – Janice Shapiro, Kit Jenkins, and Jo Rice, the first wave of art-based researchers; Stephen Hardy who taught me how to release the voice; Stephanie Grenadier who affirmed my faith in the intelligence of the total process of creative inquiry; the masters thesis groups who carried the work deeper than I could imagine and especially the 1994–1995 group that enabled me to leave Lesley College inspired by their creations; and finally, the students who became my thesis faculty team.

Special thanks to Sr. Kathleen Burke of Ursuline College for providing access to her art therapy graduate program thesis materials and then helping with the process of interpretation; and to Katherine Jackson of Ursuline who discussed the thesis materials with me. I am especially grateful to the following colleagues who reviewed the manuscript: Pat Allen of The Open Studio Project in Chicago; Holly Fenn-Calligan of Wayne State University; Linda Klein, at Endicott College; Debra Linesch of Loyola Marymount University; Cathy Malchiodi, Editor of *Art Therapy*; Paulo Knill of the European Graduate School; and Bruce Moon of Marywood College. Thanks to Peter Hart for his consultation; to the Endicott College librarians – Tom Cesarz, Betty Roland, and Karen Atkinson – for aiding me with their research skills; to Ruth Henderson, a PhD candidate at the Union Institute who gave the manuscript a 'test drive' as she began to plan her research; to Kendra Crossen for her many lessons on writing books; and to Jessica Kingsley for her support of this project and her belief in the future of art-based research.

This book is dedicated to Rudolf Arnheim, who has pioneered the integration of thought and image in research.

Preface

As the process of research draws increasing attention within the creative arts therapy profession, it is time to ask whether or not we are ready to use our unique methods of artistic inquiry to shape a new vision of research. Research is a process committed to the creation of new knowledge, but yet we have been reluctant to expand the methods of inquiry needed to enlarge our intellectual and therapeutic assumptions.

Art therapy and all of the other creative arts therapies have promoted themselves as ways of expressing what cannot be conveyed in conventional language. Why is it that we fail to apply this line of thinking to research?

Graduate training programs are increasingly being required to deal with issues of research and practitioners are in need of support offered by useful research findings. This book strives to illustrate how practitioner-researchers can become involved in art-based inquiries during their educational studies and throughout their careers. A primary goal of this volume will be the demonstration of how we can create new types of research which resonate with the artistic process. Rather than going outside our discipline to discover how to do research, we can take another look at what we do and identify models for research in the existing practices and writings of creative arts therapists. I hope to show how research has been inseparable from the practice and writings of the founders of our profession.

Research can be integrated with practice at every level in order to promote knowledge, enrichment and creative renewal. The wealth of experience generated by the practice of creative arts therapy offers significant opportunities for eliminating the chasms that typically separate research and practice within our discipline. I also believe that creative arts therapy can make unique contributions to the larger context of human understanding as researchers in other disciplines begin to explore ways of expanding their investigations through the arts.

Imagine a time in the future when creative arts therapists, accustomed to defending their aesthetic work within the framework of positive science, begin to act as resources and guides to researchers in psychology and education who want to investigate phenomena with creative methods capable of under-standing the objects of inquiry and their expressions.

I welcome the initiation of empirical research projects which will measure outcomes that the general creative arts therapy community views as essential to practice. I have a keen interest in numerical data when they help to illuminate the issues that we face within our profession, and in later sections of this book questions and problems are identified which can be studied through statistical inquiries. Creatively designed experiments can contribute immensely to our understanding of the essential processes of creative arts therapy. However, there are many other ways to approaching research outside the sphere of counting and measuring procedures which can impose a methodological fundamentalism onto the process of inquiry. Many of the important issues of creative arts therapy practice require modes of inquiry which are based on principles of artistic knowing.

The first step in building a research culture within the creative arts therapy community is the recognition that there are manifold issues and problems to be studied and that they will require equally diverse methods of investigation. We must get beyond the attempt to impose a single type of research onto every life situation. This book addresses the lack of attention being given within the creative arts therapy community to research methodologies based in the process of artistic inquiry. I realize that because I emphasize the need for art-based research, some might think that I am questioning the value of more conventional behavioral science methods. This is not my intention. My goal is to establish a respected place for art-based research within the total context of research. Artistic inquiry must be given its place at the table.

Methods of behavioral science research are useful to creative arts therapy and they are important sources of guidance and inspiration; but they do not define the universe of research methods that can be used to further our understanding of our new discipline. They are concepts from a 'related' culture and academic tradition which do not emerge from the unique qualities of what we do in creative arts therapy. In all of the published creative arts therapy writings about research, there is a laudable embrace of varied approaches to investigation and a desire to create designs for inquiry which fit the problems being investigated. What is missing in this new body of literature is an examination of how the essential processes of creative arts therapy can be applied to research.

Whenever I review writings and research projects dealing with the creative arts therapy experience, I instinctively apply an innate personal test of truthfulness to determine whether or not the study corresponds to my sense of practice. Does the study appear real? Does it touch and illuminate qualities that I experience in creative arts therapy? The quantitative–qualitative framework for viewing research has little connection to the realities that I encounter in the

creative arts therapy relationship because there is no place for artistic inquiry within the duality. Art is by no means purely 'qualitative' because it is a thoroughly empirical activity.

I define art-based research as a method of inquiry which uses the elements of the creative arts therapy experience, including the making of art by the researcher, as ways of understanding the significance of what we do within our practice. If we look carefully at what is already published in our literature; at what people are doing today in creative arts therapy; and, most important, at the experimental activities of creative arts therapy graduate students; we will discover that art-based research is widely practised but never declared when the creative arts therapy profession formally reflects on the nature of research activity.

My objective in this book is an expansion of assumptions about what research can be. I give many ideas for research projects and examples of art-based research drawn from my experience and the work of others, with the goal of stimulating the imagination and the experimentation of the reader, but my primary objective is the immersion of my profession in the serious epistemological discussions that must always accompany research. As one of my graduate students said to me, 'It's all about how you frame it. We are either served or held captive by the structures we use.'

C. G. Jung similarly described how 'it all depends upon how we look at things' (1997, p.91). As we look in new ways, I trust that we will create new knowledge. Jung felt that the 'voyage of discovery' involves an immersion in the creative imagination and its 'uncertain path' (Ibid., pp.33–34). He describes how sustained personal 'confrontation with the unconscious' led to the creation of his psychotherapeutic methods and psychological theories: 'This idea – that I was committing myself to a dangerous enterprise not for myself alone, but also for the sake of my patients – helped me over several critical phases' (Ibid., p.27).

Why is it that artistic knowing and creative experimentation have been given so little attention in our discussions about research? I believe that much of this problem can be attributed to the adoption of supposedly scientific modes of research because the creative arts therapies lack confidence in their innate ways of discovery. The roots of this condition are complex and they perhaps emerge from the marginal self-image that art therapy sometimes has when it comes to the practice of psychotherapy (Allen, 1992) and research (Linesch, 1995). This problem is so pervasive that many people whom I perceive as research innovators, do not see themselves conducting research.

I do not in any way oppose science. I am suggesting a partnership, in which we identify areas of common concern with established scientific research,

while clearly distinguishing those creative objects and processes that require new ways of understanding.

I have conducted various forms of creative arts therapy research and I have supervised many hundreds of graduate students in their masters and doctoral level investigations of the creative arts therapy process. My goal as a supervisor has been to help graduate students to investigate their creative arts therapy experience with as much freedom as possible. There is less concern with making sure the study fits standard definitions of research and more involvement with determining whether or not the plan for inquiry passes the researcher's personal test of truthfulness: will the study be of use to others and to ourselves? Will the process of inquiry help people in any way? And, most important, does the study resonate with the researcher's experience of creative arts therapy?

In keeping with the example of science, I have never set out to teach research methods as a subject unto itself. My teaching laboratory is pervaded by principles and values which have drawn people to conduct research in this particular type of setting. As I work together with students in an environment characterised by a commitment to artistic expression, a tradition of inquiry has emerged and I do not feel that what we do fits completely into any of the existing typologies of research that exist today. Other disciplines such as education and women's studies have experienced the same need to create new ways of conceptualizing research, and discussions about methodology are a primary focal point in doctoral programs in sociology, psychology, and counseling.

I feel that attempts to further variety through the creation of new typologies of 'qualitative' research contribute to the increasing emphasis being placed on teaching stock research methods. Establishing lists of types creates the impression that the categories are all-inclusive. When 'phenomenological', 'heuristic', and 'hermeneutic' methods are designated as 'qualitative' research methodologies, they are presented as aspects of behavioral science. These procedures are larger in scope. The effort to include them into an expanded scientific paradigm is a reflection of scientism which assumes that science is the only tool for understanding human experience.

The philosopher Hans-Georg Gadamer suggests that all attempts at experiential knowing are aesthetically oriented: 'Aesthetic experience is not just one kind of experience among others, but represents the essence of experience *per se*' (1994, p.70). Gadamer believes that since an 'experience', defined as an intentional act of consciousness by Edmund Husserl, can never be fully explained in any attempt to attribute meaning, we discover experiential truth by contemplating a phenomenon 'solely by itself in its aesthetic being'.

Gadamer emphasizes the primary place of artistic knowing in the history of human understanding and he describes how we are now experiencing a 'phenomenological return to aesthetic experience'. The increased interest in aesthetic modes of learning within psychology, in the guise of 'qualitative research', suggests that psychology is both a scientific and an aesthetic discipline and the rise of the creative arts therapy profession is an expression of the latter.

Although I admire Gadamer, I do not see myself as a 'hermeneutic' researcher. Similarly, I am in sympathy with the values of phenomenological and heuristic inquiries but I do not attach these labels to my way of viewing research. Art-based research is simply defined by its use of the arts as objects of inquiry as well as modes of investigation. I research the therapeutic qualities of the arts and the subject matter of my investigations will always determine how I proceed.

The discipline of aesthetics is often simplistically associated with subjectivity and inconsistency, and this notion is paired with the assumption that there is an objective and constant reality at the core of experience. If there is a constant reality which underlies all experience, science has shown that we cannot know it. The shortcomings of attempts to wrap all knowledge into the scientific method are no reason to initiate an equally one-sided rejection of science. We need both scientific and aesthetic knowledge, and the two have always complemented one another through human history as they continue to explore the unknown. It is time, however, to acknowledge that human experience cannot be completely understood through the scientific method and to apply the discipline, rigor and intelligence, that we commonly associate with science, to the process of aesthetic inquiry. We must also realize that creative arts therapy, which is an outgrowth of psychology's aesthetic aspect, needs to encourage research from this perspective. But under no circumstances do I want to contribute to the creation of yet another dichotomy within creative arts therapy research. Aesthetically-oriented research may suit some projects and not others.

The greatest challenge presented by art-based research is the boundless possibilities. It is much easier to approach the design of a research project through a sequence of standard steps. In keeping with the nature of creative experience, art-based research may sometimes encourage immersion in the uncertainties of experience, 'finding' a personally fulfilling path of inquiry, and the emergence of understanding through an often unpredictable process of exploration. These values are quite different from the teaching of research through the planned implementation of a set of principles established in advance. Art-based inquiry, like art itself, may often include carefully

calculated studies but the truly distinguishing feature of creative discovery is the embrace of the unknown. This way of research is clearly self-selecting and not for everyone. However, it must be made available for those artists who desire to use their skills and unique sensitivities to research their experience.

I will not be presenting a step-by-step guide on how to do art-based research, even though a manual of this kind could enjoy considerable popularity because so many people want to be told exactly what to do. This human tendency largely accounts for the standardization of research methods that we see today in behavioral science. If I present one way as the definitive method of inquiry, I will be omitting the endless possibilities that may emerge from future experimentation. The greatest difficulty we confront in striving to be more innovative within contemporary psychology is that the discipline and the society have been indoctrinated into relatively narrow ways of viewing research. I will suggest methods and issues that will, I hope, spark interest in readers. While giving demonstrations of different ways of conducting research, I will show directions and discuss ideas, trusting that individual researchers will perfect the details of their methods through the experimental process.

While I am ultimately interested in all of the creative arts therapies and the way in which the different modes of expression interact with one another throughout the creative experience (McNiff, 1981, 1987a), I will focus primarily on a review of 'art therapy' research in this book. By concentrating on art therapy I hope to show how the practice of research has emerged within a particular area of study. This approach to scholarship is in keeping with my personal practice of multidisciplinary creative arts therapy in which the visual arts have always been a 'trunk' with roots and branches into other expressive modalities. I admit personal affection for the art therapy community which has been engendered by three decades of involvement. Yet, individual sentiments aside, the power of creative expression in therapy will not be fully realized until researchers begin to acknowledge and investigate the profound kinship amongst all of the imagination's faculties and the way in which they augment and support one another.

I will draw on research conducted in the other creative arts therapy disciplines and from the interdisciplinary practice of expressive arts therapy whenever they enhance and deepen understanding of forces and phenomena that need not be restricted to a singular track of investigation.

In the first part of the book I address principles that apply to all of the creative arts therapies. In the next two parts art therapy becomes the object of my research. The literature and history of art therapy offer extensive data and my focus on this discipline can be likened to the parameters that researchers define to create a matrix for an object of inquiry. Research in one area does, one

hopes, illuminate others. My intention is that this analysis of the art therapy discipline will be applicable to dance and movement therapy, drama therapy, psychodrama, music therapy, poetry therapy, and multidisciplinary creative arts therapy.

As in the practice of creative arts therapy, different sensory expressions will inevitably pass through any conceptual enclosure that I establish. Ideas and creative acts can never be strictly circumscribed. An Irish farmer in Connemara once said to me, 'You can't fence anything with wings' and in my experience artistic expressions are more prone to flight than to earthbound solidity. Nevertheless, for the purpose of this particular review of research I will attempt to stay concentrated on a single discipline, realizing that there will be an ongoing encounter with natural movements across conceptual boundaries. The focus on art therapy in Part II of this book can be likened to a case study in which I will research this discipline with the hope that connections will be suggested to what exists 'outside' the sphere of visual art therapy.

When I draw on research in other areas of creative arts therapy, I trust that this will illustrate how vital these related disciplines are to one another. My presentation of possible research activities in the Part III will suggest many projects which integrate different art modalities. This concentration on total expression in research will some day contribute to the release of the forces that move through a comprehensive and circulatory system of creative expression that cannot be fenced by specializations. All of the arts participate in the intelligence of the creative imagination which is a vast frontier for discovery. Carl Jung explored the ability of the imagination to comprehend and transform difficult life situations in ways that were more effective than the reasoning mind, but his pioneering efforts did not significantly alter psychotherapy's exclusive alliance with reason and its epistemology. Creative arts therapy research has continued in the tradition of psychology while the creative imagination, the essential ingredient of our therapeutic practice, is at best an object of inquiry, and rarely the instrument of investigation.

In writing this book I have identified three themes which are essential to initiating a rigorous and creative tradition of research within the creative arts therapies. The first and major objective for art therapy and all of the other creative arts therapies is epistemological. We must come to a better understanding of how artistic knowing is different from scientific under-standing. Second, there is a need for research methods and questions which arise from the unique character of the art experience and its application to therapy. And finally, the achievement of these two goals will help us to determine where and how conventional behavioral science research methods

can be selectively used to further understanding of creative experience in therapy.

While encouraging cooperation with the larger community of scholars researching the human condition, we creative arts therapists need to spend more time amongst ourselves examining what it is that we bring to the interplay with research colleagues. What are the goals and outcomes that we all see as valid? How do we describe these to one another? What varied methods do we use to achieve them? How do we convince ourselves, our clients, and our colleagues of their effectiveness?

This book is directed toward my colleagues in all of the creative arts therapies and the students we strive to educate. In order for research activities and innovations to be perceived as valid, we must have some degree of general agreement as to parameters, goals, methods, and assessments of value. For too long we have looked for direction outside our discipline and this has created considerable confusion and has resulted in lost opportunities to apply the passion and imagination of our clinical work to the pursuit of research. It is not healthy for a profession to look continuously for guidance outside itself. The creative arts therapies have earnestly sought external verification of their self-worth, becoming somewhat codependent on the good and bad habits of behavioral science. We have consistently defined ourselves through the perceptions of the more dominant partners in the mental health field. It is time to individuate our profession while keeping connections open to others.

If we can believe in what we do, in our unique artistic epistemology and practice, and if we can create rigorous standards for art-based research, then our profession will become an important contributor to the research community. But first we must convince ourselves that we have a special intelligence and value. As we become more secure and confident in our practice and research, we will in time influence those outside our discipline. I feel that creative arts therapy is currently operating within a paradox. It is only a matter of time before the profession inverts its dependence on others and finds its unique place within the collective effort to advance human understanding.

I

Theoretical Foundations

§

The Emergence of a New Vision
of Research

As the new creative arts therapy profession began to focus on the need for research two or three decades ago, there was a universal assumption that behavioral science research methods, both quantitative and qualitative, were the exclusive tools of inquiry. Creative arts therapy perceived itself as an extension of psychiatry and wanted to advance its image by demonstrating efficacy according to 'acceptable' research standards.

The word 'research' means to study thoroughly. To 're-search' is to 'search again' through a process of disciplined inquiry. However, in creative arts therapy we have generally accepted the idea that research and scientific investigation are synonymous. By identifying the word research with only one of its aspects we are limiting possibilities for advancement through new and imaginative inquiries. Creative arts therapy is by definition a new integration of previously separate disciplines, yet we have been remiss in giving serious attention to the research traditions of 'all' the disciplines which constitute the new entity. By calling for a more comprehensive vision of research I do not want to negate the value of scientific methods. I actually believe that scientifically-oriented inquiries will be revitalized if we can create a more diverse research environment.

Over the course of my career I have progressively come to the realization that it is the arts, the primary contributors to the emergence of creative arts therapy, which have been most conspicuously absent from the profession's discourse about research. When I did my doctoral research during the mid-1970s I focused on the psychology of art and interviewed artists and children about their motives for creation. The artistic process was examined through the behavioral science research method of the interview. I won an

award for my art motivation research and published the findings in different fora, but I cannot say the study has had a lasting impact on me or anyone else.

In my work supervising masters thesis students, and an occasional doctoral student intent on creative work, a new direction began to emerge in the early 1980s. My graduate students were not interested in conducting the kind of psychological research that I did when I reviewed the literature of the psychology of motivation and then presented interview data and my conclusions in a conventional written format. At first I thought that maybe the students were lacking intellectual curiosity. They wanted to focus more attention on the process of making art and their relationships with their creations. When given the freedom to follow their interests, my students chose to focus on how they could integrate their personal creative expression with the production of a masters thesis or doctoral dissertation. I felt that if I insisted on regular research methods, I would be making them conform to standards that were removed from the essential practice of creative arts therapy.

As I relaxed my control over the process of inquiry, my students began to research their personal creative expressions in ways that I had not experienced myself. My scholarship up until that point had been largely focused on the usual process of writing about my observations of other people's work and recording what they said about their expressions in interviews. What I was doing felt second-hand and more distant from the creative process than the studies initiated by my students. These studies were consistent with what I was teaching them within our training studios where the students were constantly involved in making art and responding to it in imaginative ways. Time has shown me that these students were committed to the full realization of their visions about the healing powers of the arts. They saw no reason to make the dichotomy between practice and research that I had accepted. They were committed to the practice of the work in the most complete way possible, whereas I was constantly shifting my perspective from the studio to psychologically-oriented journals.

This 'split' identity between practice and research is still common within the creative arts therapies. Practitioners feel that what they are doing every day is separate from 'research' which is associated with projects conducted by 'full-time' professional researchers. Graduate students have been my teachers in demonstrating how research and practice are inseparable and mutually dependent. The separation of research from practice can be attributed to the tradition of scientific objectivity which assumes that a participant in a process cannot truly see what is occurring. There are many aspects of life that call for observations made by outside observers within controlled conditions, but the

practice of art and therapy and the combination of the two into creative arts therapy demand new ways of approaching research.

One of the first art-based masters thesis projects that I supervised involved a woman who did a series of paintings of female bodies. Rather than write about what women told her about their body images or what she saw in their drawings and paintings, my student chose to spend the school year investigating the female body through paintings of large human figures. The finished work included the presentation of the paintings in the thesis, an exhibition of the works, and a written text reflecting on the process of making the series of paintings and its effects upon the artist (Jenkins, 1988).

I was intrigued by what my student had done, but at the time I was still encouraging thesis writers to follow research procedures that corresponded to my own experiences in conducting interviews, making observations, writing case studies, designing questionnaires, sorting and counting data, recording patterns and trends, and suggesting future outcomes. As a painter, something in me was activated by this student's art-based inquiry, but I did not yet understand that her pioneering thesis project had broad implications for creative arts therapy research. I enjoyed working with her on the project and I noticed how passionately committed she was to the work through every phase of the thesis experience. As other students spoke of their frustrations in getting started with their thesis work, she would emerge from hours in the studio covered with paint. I began to think about how what I did in my art studio was isolated from my psychological research about the artistic process. I didn't realize how my slight discomfort with the early forms of art-based research was an expression of the separation between my artistic and psychological identities.

I asked myself whether personal artistic inquiries were self-indulgent or narcissistic. Where was the service to others and to the profession, and where were the connections to psychology? I was working with words to produce scholarly publications that I hoped would advance the field of creative arts therapy, and my thesis student was in the studio making paintings and engaging images with words, body movement, vocal improvisations, drums, and performance art. She was much closer to the phenomena of creation with her methods. I noticed how the most talented and committed students in the graduate program began to work together with her in the studio. She influenced and inspired their thesis projects, and I began to question the way I approached research in creative arts therapy.

As I continued to ponder the work my thesis student was doing, I realized that it was her involvement in my art therapy studios that influenced and actually taught her how to work in this way. I was her teacher and a primary

influence, but she made completely new applications of what I taught her. At that point I had not considered that making art and personal reflections on your own creations could be a basis of research. The conventional psychological thesis method required reflection on what other people did with artistic media. The process of writing a thesis or dissertation was supposed to be a deductive academic exercise, outlined in advance, and designed to meet the prevailing standards of psychological research as reflected by professional journals. And within the creative arts therapies there were no institutional incentives to discover new methods of investigation. Artistic inquiry as a basis for research involved a complete paradigm reversal, since art was considered to be raw material for psychological research methods which analyzed the process and objects of creation.

The thesis focused on paintings of the female body. It had a major impact on me and the college community in no small part because the pictures were so big and bold and were exhibited prominently as part of the thesis process. The images were unforgettable, and their expressive power made a significant contribution to my paradigm shift concerning the purpose and methods of research. The graduate student described her research methodology as 'empirical' in that there was a direct involvement between the maker of the art and the paintings produced. The goals of the thesis included a deeper understanding of the relationship 'between artist and art; between artist and space; between images and space; between artists; between images; and between art and artist-therapist' (Ibid., p.2). The thesis cited Paracelsus who in 1526 declared that the purpose of research is 'the deepest knowledge of things themselves'. By declaring the art studio to be a research laboratory dealing with empirical things, this study was a key turning point in my approach to the process of investigation. I was delighted that my students were taking something that I gave to them and returning it to me in a more advanced form.

The methodological foundations for art-based research had been suggested to me a year earlier when another graduate student presented the thesis idea of making one large painting over the course of a year which would focus on her relationship with her mother. I was intrigued and felt that the process of making the painting would guarantee that the thesis research would be more than a self-immersed journal about the mother–daughter relationship. My experience with thesis students made me wary of self-reflective studies which tended to be little more than personal musings. I do not wish to suggest that introspective research is always self-indulgent. Many of the greatest insights into the psychotherapeutic experience and the creative process emerge from self-analysis. There is however a tendency within this type of inquiry to lose

contact with the over-riding objective of searching the self in order to help others and to advance the work of creative arts therapy in some way.

The very personal nature of the proposal evoked potential challenges to the goals of the thesis program which focused on service to the profession and personal mastery of the practice of creative arts therapy. As I worked with the student, I kept asking myself: 'How can this study be useful and helpful to others, and to the student herself?'

The thesis plan was simple and straightforward. Over the course of two semesters the student would work on a single oil painting of her mother which would go through a process of continuous transformation. The stages of the painting would be photographed, and this would provide a record of the different phases that would be painted over with subsequent interpretations of the same subject matter. The painting would be perceived as an ongoing process in which the covered and lost phases were as important as the final form of the painting (Rice, 1987). One of the most intriguing issues raised by the thesis method was the determination as to when the painting would be completed. The painting could be viewed as unending and lifelong with the finishing point being the date for the completion of the thesis, or that particular painting could be viewed as embodying a phase of the artist's lifelong relationship to her mother. In addition to the time-frame of the thesis project, there might also be aesthetic considerations, such as when the painting called for completion within the context of its structure and composition.

From a therapeutic vantage point, this project affirmed the value of C.G. Jung's method of holding fast to the image. Rather than jumping about from one exercise to another, there was a sustained meditation on a complex theme and the way it was played out within the medium of a painting. The artist-researcher's relationship with her mother was enacted within the material process of making a painting. Feelings and memories inspired expressions in paint, and the process of shaping the image in turn changed the nature of the artist's attachment to her mother. There was an ongoing correspondence and mutual influence between what happened with paint and the artist's inner relationship to one of the most significant figures in her life. As the picture unfolded there were many 'finished' compositions which were covered over by yet another painting. These completed pictures were likened to episodes that come and go over the course of a long relationship. They were covered over but still present 'underneath' the later forms of the painting. The painting became a physical embodiment of the phases we experience in our lives.

What has impressed me most about this thesis is the way the inquiry was totally based in the material process of making art. It demonstrated how the

research of an artist in the studio can be likened to what a chemist does in a lab. The key to keeping the arts as primary modes of psychological inquiry lies in making sure that the research is focused on experiments with media just as the chemist works with physical substances. I keep returning to this project as a model of art-based research. The painting was a palpable focal point bridging artistic expression and psychological contemplation. A sense of experimental data was conveyed by the photographs which served a vital role in the overall design of the project, since the outcomes had as much to do with the visual evidence as the verbal deliberations. The artistic process offered a clear structure and a reliable method. The researcher documented the way in which the thesis helped her personally and it was immensely beneficial to me and a new generation of creative arts therapy researchers in our graduate program.

This thesis was not simply a personal reflection on the mother–daughter relationship. The key finding was the way the changing phenomena of the painting and its ongoing process of production served as an abiding psychological focal point. As the researcher held fast to the process of making the picture and contemplating its expression, she sustained her reflection on the depths of her relationship to her mother. From my perspective, the primary contribution of the thesis was methodological. The task of making the artwork becomes the structure for a sustained therapeutic experience.

A third experience with a student's thesis project further challenged my thinking about what research in creative arts therapy can be. When I began my work with this student, I had become more aware of the importance of personal and first-hand artistic inquiry as a way of doing research in the creative art therapies. The thesis project was pursued as a pictorial account of a young girl's mythological journey through the vicissitudes of everyday life and realms of imagination. The drawings were beautifully rendered, and the picture book spoke for itself without words. We approached it as an archetypal story book. Since the project was to be presented as fulfilling the requirements of a masters degree, I insisted that the student write a section reflecting upon the process of making the visual thesis.

My rationale went something like this: 'You need to offer psychological reflections in order to distinguish the thesis from something you would present for a masters degree in fine arts. Since you are a candidate for a degree in creative arts therapy, you must show mastery in that discipline.'

I was willing to see artistic inquiry as the major element of the thesis, but there had to be a psychological deliberation. The student had worked very closely with me, and we had great respect for one another. She politely listened to me but showed little enthusiasm for my recommendations. I sensed that she felt that a psychologically descriptive account would be an imposition that did

not resonate with the gist of the study. She had committed a period of her life to this research and was not about to compromise its integrity and essential message. Yet I had to uphold the standards of the thesis program. I was keenly sympathetic to her position and ultimately felt that I would leave it to her to find a solution that would fulfill the two demands.

She was engaged with aspects of the creative process that I had not yet encountered in my personal experimentation. I was her teacher and the keeper of the learning environment, but she clearly penetrated to a depth of involvement with the creative arts therapy process that was new to me.

The student came back to me a week later describing how she couldn't 'explain' the story or reflect upon it in a traditional psychological genre. She felt that an external voice commenting on the work would not get close enough to what was happening within the thesis research. I had no answer and suggested that she spend some time sitting with the problem and that a resolution would ultimately emerge.

In our next meeting it occurred to the student that she could give a voice to the young girl who was the protagonist in her story. The girl would describe, 'from her point of view', what the thesis was all about. The first person voice allowed the thesis student to reflect upon the experience in a more intimate and imaginative way that was consistent with the emotional expression of the drawings. Speaking as the young girl enabled the thesis writer literally to 'get inside' the thesis process and access insights that would not have resulted from an external analysis. She responded to the visual artwork with another artistic statement through the creative use of language. Art was used to interpret art. As the reader of the thesis, I observed how this way of speaking about the story gave a more engaging and readable account of the project outcomes. The student invented a new way of integrating artistic expression and psychological reflection within the context of a research project. Throughout every phase of the project she functioned as an artist researching psychological aspects of experience (Shapiro, 1989).

From this thesis project I learned that the images and processes of artistic creation are always at least one step ahead of the reflecting mind. If we continue to follow the standard behavioral science methods of establishing what we plan to do before we do it, we undermine the power of our discipline to offer something distinctly new and useful to research. My student's creative experimentation was farther along than my ideas about creative arts therapy research, and the artistic process was operating beyond both of our conceptual frameworks.

As I worked with my thesis student, I was focused on the integrity of her research and how we could devise methods that would fully realize the

potential of the project. After the thesis was completed, I began to see how her work was pointing to new ways of practising creative arts therapy. The thesis project confirmed how we have responded to expressions of the creative imagination with analytic and explanatory reflections that do not continue or advance the expressive qualities presented by the works being contemplated.

I began to reconsider how I react to artworks in my therapeutic practice. Could I find more imaginative, artistic, and intimate ways of engaging the images I produced? If I respond more imaginatively and poetically to my paintings, will I access qualities within them that were inaccessible to the explaining mind? I recalled C. G. Jung describing how the bird flies away when we explain an image. The generative powers of a creative expression need to be fed with a corresponding consciousness which appreciates and keeps their mysteries.

In my efforts to encourage innovation in creative arts therapy research, I have found the greatest obstacle to be stock definitions of 'research'. In *Depth Psychology of Art* (1989) and *Art as Medicine* (1992), I work with my own artistic expressions as a means of understanding therapeutic and artistic processes. When I published those books, largely inspired by the works of my graduate students, I feared ridicule from the profession which had previously displayed distinctly conservative attitudes toward research. Until that time everything about creative arts therapy had been focused on researchers analyzing the works of others. Therapeutic 'distance' and 'impersonal evaluation' were among the most basic doctrines of the research code.

To my surprise, there has yet to be any published criticism of artist-researchers studying their personal expression. To the contrary, others are using the method and taking it further. The publication of Rosalie Politsky's paper, 'Penetrating our personal symbols: Discovering our guiding myths' (1995a), marked the arrival of personal artistic inquiry in creative arts therapy's international journal. Pat Allen's *Art Is a Way of Knowing* (1995a) has taken artistic self-inquiry to a new level of depth. The enthusiastic response to Allen's book illustrates the hunger within the creative arts therapy profession for this type of inquiry. Bruce Moon has emerged as one of the strongest and most persuasive voices calling for art-based research, training and practice in creative arts therapy. He includes personal artistic expressions in his books as a way of describing: how work with patients influences him; how he personally practises the principles he advocates; and how everyone involved in the discipline of creative arts therapy might consider asking, 'Why do I make art?' (Moon, 1994).

An indication of the validity of creative arts therapy is the extent to which we use these modalities to treat ourselves as well as our clients. In the early years

of creative arts therapy practice, it seemed that most practitioners sought out personal therapy with verbal therapists. There is a dramatic change in this pattern today as creative arts therapy is increasingly perceived as a primary rather than as an adjunctive therapy. A future quantitative research project might explore what kind of therapies art therapists chose for themselves.

Robert Landy's concept of the 'double life' combines personal growth with the theory and practice of creative arts therapy (Landy, 1996). The experienced creative arts therapy educator realizes how the most important outcome of a graduate education is the integration of these three factors. In my experience, the personal character of the therapist and the ability to examine one's own experience together with that of the patient are primary indicators for future success. Therefore, it follows that there are many advantages to art-based research within a graduate training program. In addition to offering a first-hand understanding of the healing properties of the creative experience, art-based research makes the future therapist familiar with the blocks, struggles and pains that often accompany artistic expression. The graduate student also establishes a basis for lifelong personal experimentation with the creative process.

Art-based research does not stop with graduate education. I see its greatest potential being realized as a way of deepening and renewing practice throughout a person's career. Research, personal artistic expression, and the practice of therapy can be joined through the exploration of new approaches to research which support the wide spectrum of needs being manifested within the creative arts therapy field.

Creative arts therapy can promote more useful and innovative research through a rigorous critique of the prevailing doctrines of research governing the mental health field. We seem to have missed the intellectual expansions offered by the postmodern era and its deconstruction of orthodoxy. Our discipline continues to support not only the most conservative tenets of research, but also the use of methods that do not use the arts as primary modes of inquiry. The reliance on behavioral science research methods continues the adjunctive mentality that has permeated creative arts therapy from its inception. As we begin to envision ourselves as the practitioners of a primary therapy, we may become more open to the use of the arts as primary modes of inquiry in research projects.

I know that many therapists and graduate students want to involve themselves in art-based research. People entering the profession choose this way of working with people because of their personal experiences with the process. Two graduate students from New Mexico recently interviewed me for an art therapy project; I asked them why they are involved in art therapy. They

said, 'We come from that place where art has healed our lives and we know it can do it for others'. One of the women went on to say, 'I know that art has saved my life. There is no question for me.'

There is no doubt that we could all benefit from a scientific study verifying whether or not most graduate students select the creative arts therapy field because of personal experiences they have had in their lives with the arts. It would be an interesting research project, and I might even do it myself one day. But as I talked to these graduate students, they affirmed impressions that I have had over the past three decades in the field. They want to become more involved in using their experience with the creative process as a way of understanding and researching creative arts therapy. They are committed to learning the methods and subtleties of practice. Why not simply let them choose from amongst different ways of conducting research? Right now most graduate programs require behavioral science projects and dismiss art-based inquiry as outside the scope of valid research.

If graduate programs let students freely choose research methods and goals, a research project might be conducted to document and interpret the outcomes. Since everything we do is a potentially rich source of data for research of some kind, we should consider including our experience with art, which is certainly a primary element of our profession.

§

From Justification to Creative Inquiry

In creative arts therapy we have not begun to ask ourselves critically why we do research. The conventional approach has been fueled by the assertions that we have to use 'accepted' measures to prove our efficacy and that our training programs must guarantee literacy in these methods. The latter assertion has been particularly frustrating to me throughout my career as an educator because it is difficult to dispute what has been the dominant paradigm of our profession.

I have continuously maintained that we do not have to legitimize ourselves according to another group's values and criteria. The need to use these external measures actually reveals a lack of confidence in artistic inquiry as well as an acceptance of a secondary or adjunctive role within the research community which reinforces a comparable position within the mental health field. If we are to further practice and the imagination of the profession, we must begin to use the languages, the ways of thinking, and the modes of creative transformation that constitute our collective being.

One of the most enduring themes in science and philosophy is the tension between what can and cannot be known and expressed. I believe that this gap is the most basic energy of the creative spirit, and I see no reason to resolve or bring closure to the tension. Creative arts therapy is engaged with both aspects of experience, and this clearly distinguishes our practice from disciplines which base themselves on totally predictable outcomes. As an art therapist I recognize the value of science and its research methods; but they can never encapsulate the totality of what I do. Many aspects of existence can be unraveled by science, whereas others stubbornly resist definition. The tendency to identify research exclusively with science has created a limiting imbalance. The application of one-sided scientism to the creative process is an attempt to fly with only one wing and the same applies to a disregard for scientific understanding.

Justification is an essential element to research activities which strive to introduce change and a new way of doing things. This approach to research will always frame the experimental activity or the gathering of evidence with the goal of influencing a particular mind-set which has the power or the ability to accept a new or changed way of doing things. Examples include the use of a new drug versus existing remedies or the making of a construction material in a new way because research indicates that the product will be stronger and longer lasting than what is currently being used.

The value of justification research was recently made apparent to me during a conservation committee hearing in the city where I live. A group of neighbors attended a meeting in City Hall to oppose a proposal to build a house in a wetland area in our village, one of the first settlements in colonial New England. The neighbors argued from the perspectives of history, aesthetics, and the ecological importance of protecting an area that naturally filters water run-off before it passes to a cove nearby. Historical photographs were submitted to document how over the course of the past two hundred years houses were not constructed in the area in question, even though the village was densely settled. Neighbors implored the conservation committee to consider the fate of the creatures and plants living in the wetland and the shell fish in the cove that could be harmed by the increased run-off of unfiltered water. They described how the developer was trying to profit from increased property values. The committee had previously made a site visit, and it was apparent that the area in question was the wettest place in the village. The developer of the site was represented by an engineer who produced plans and scientific data.

As the session progressed, and after observing previous hearings before us on the docket, it became clear that the committee activity was conducted exclusively within the context of scientific and engineering data. A friend sitting behind me, waiting for his turn before the conservation committee on another matter, leaned forward and said to me: 'You've got to get a professional engineer's study and lab tests of water samples in order to influence those guys. They're all engineers.'

It was conclusive that if our group was going to persuade this particular committee of engineers, we had to research the issue and justify our position on the basis of information and data which fit into their way of viewing the problem. If we wanted to prevail, we had to learn to play on a different playing field.

I believe that almost all of the thinking about research within the creative arts therapies to this date has been oriented toward justification. As with the example I have just given, creative arts therapists have accepted the fact that in

order to advance the profession and influence public attitudes, they must justify the work to 'external' decision-makers who view reality exclusively according to the outcomes of scientific evidence. There are many other goals for research which I will describe at a later point. If creative arts therapy research is conducted exclusively with the objective of influencing people outside the profession, something important will be lost. We must also rigorously explore the essential qualities of the work within a context which understands and enhances its unique properties. We must hold fast to the images and processes of creative expression and trust that a heightened appreciation and understanding of the phenomena being studied will carry the profession to a more advanced and respected status in the world.

As we move away from justification as an exclusive motive for research, we will find that scientific methods of inquiry will emerge naturally as preferred ways of gaining a deeper understanding of certain phenomena and problems. Without the pressure resulting from the imposition of one way of looking at the world onto every research opportunity, science and art will be free to interact naturally and collaboratively as they have done throughout history.

Pat Allen has correctly assessed how the creative arts therapy field manifests a 'clinification syndrome' which she attributes to a sense of inferiority in relation to the more institutionally dominant scientific mental health professions (1992). This prevailing need to justify oneself according to the standards of something external to one's being results in the closeting of the essential artistic nature of the discipline. Allen suggests that the field might consider the artist-in-residence model for creative arts therapy practice as an alternative to the scientific-clinician archetype. The artist-in-residence is not necessarily someone who comes and goes for brief visits, as we experience in schools and colleges. The therapeutic artist-in-residence is someone who stays and creates a reliable and constant artistic environment which acts upon people with its unique medicines and spirits. Allen questions the psychotherapeutic and clinical model as a way of approaching art's timeless healing properties. If we shift our attention away from the clinical model to the studio approach to artistic medicine, we have a completely different world of research assumptions and practices.

Paolo Knill (with Helen Barba and Margot Fuchs, 1995) reminds us that every research activity will always be conducted according to a particular image of reality. Do we research our work within an artistic vision of the world or do we continue to see ourselves according to an external vision? Do we shape reality through our own artistic questioning of nature and our beliefs or do we investigate our work through someone else's questions, doubts and needs for proof?

I just read an article which criticized the studio-oriented approach to healing through the arts because these methods were not backed-up by 'research'. In essence the author of the paper was saying that something occurring outside the paradigm within which she worked and viewed reality could only be justified according to that paradigm and its standards of research. This is an old rhetorical trick through which you demand that the perspective of the adversary be proven within the framework of reality that you construct and which denies the essential premises of the other's point of view. If the 'outsider' complains that this imposition of an external measure of reality distorts the position being presented, the weight of the contemporary bias toward scientific truth is then used in yet another rhetorical move, *reductio ad absurdum*, which likens the complaint to a condition of absurdity, because who after all can question the absolute veracity of 'scientific evidence'?

I read with interest how recent scientific studies suggest that early exposure to music education can augment a child's mental capacity. The public response to this study illustrates how our civilization, like my local conservation committee, views truth almost exclusively through a scientific lens. We quietly sat by as public schools across the country dropped the arts from the curriculum in favor of other subjects considered more essential. It is wonderful that scientific studies come along and prove the obvious. The reliance on the supposedly objective measure of science reflects a deeper malaise and an inability to take positions on what we innately know about the value of human experience. Those who demand scientific evidence typically display an absence of deeply felt convictions about what individual people and civilizations need. Reliance on scientific proof for social and educational policy will produce the most conservative and risk-free modes of education and therapy. German Baroque music and the traditions of African percussion were conceived according to deeply ingrained creative instincts that not only furthered the intelligence of the individual musicians who made the music but also their respective regional civilizations and then ultimately the world's musical intelligence. Do we need a scientific study to verify these conclusions?

Imagine if the twentieth century pioneers of creative arts therapy felt that they could only proceed on the basis of existing scientific validation for what they sensed the world needed. I remember the constant question that I was asked when starting a creative arts therapy graduate program in the early 1970s. 'How can you train people,' I was asked, 'if there are no jobs?' I was frustrated by this limiting question which tried to make sure everything we did in the present was framed by what already existed. 'The graduates will go out and create jobs,' I said. At this point, nearly a quarter of a century later, many

thousands have done as I envisioned, and hundreds more continue to do so every year.

Research in the area of human experience has become a mode of social justification and control. What we do or do not do collectively must be 'backed up' by research data. Although this conservative and careful approach to social and professional policy has its merits, especially in terms of responsibility to subjects and the management of scarce resources, the one-sided preference for these methods undermines and represses creative experimentation and discovery.

If we are able to expand our vision of research beyond the scope of justification according to scientific standards, what goals might this enlarged realm espouse? There is an assumption that research is always directed toward some form of knowing and explaining. My experience in creative arts therapy suggests that research can be concerned with other complementary objectives such as the need to experience, to inspire, and to collectively build a profession. In *Tending the Fire*, Ellen Levine offers a poetic basis for research activity. She describes how she hopes that her personal artistic inquiry 'stimulates' others to create. As a researcher, Ellen Levine's goal is to make her voice 'one flame that joins with others in our field to keep the fire alive' (1995, p.15).

Levine also gives an idea from the Jewish tradition, *tikkun ha'olam* (the repair of the world), as an underlying purpose of her work. She practises creative arts therapy and researches its purpose with an over-riding spiritual goal of repairing personal and global environments that have been damaged by pain and misfortune. The repair is achieved through the poetic fires of creative transformation. These alchemies are forever characterized by uncertainty and a faith that the process of creation will carry us through difficult situations.

Ellen Levine's work suggests that research activity can be pursued in order to inspire and stimulate others to perform with increased conviction and creativity. She illustrates her personal process of creative expression with the goal of inciting her readers to do the same for themselves and then to make this experience available to other people. This objective resonates closely with my experience of the creative process. My personal creativity and my commitment to the artistic process are fueled by the expressions of others. I am challenged by artistic images and the creative journeys of other people. Levine's goal of 'repair of the world' also stimulates my spiritual sensibility; it arouses my compassion for others and my commitment to the transformation of suffering. I know from my experience and history that art contributes to these spiritual goals. Do these positions require scientific proof? Or is it better to approach research as documentation of their effects in the present and as a way of tracing

the constancy of these themes throughout history and the different cultures of the world?

The examples of art-based research that I have given from my work with graduate students illustrate how the process of inquiry can further the effectiveness of professional practice. In my personal experience I have always approached research as a way of experimenting with therapeutic methods and materials. I try out new ways of doing things, explore connections among media, and use my personal experience in the studio or my practice with others as an ongoing process of research. There are no divisions between research and practice. I am always striving to learn more about what I am doing, to discover more creative and fulfilling ways of approaching the making of art, and to link what I do with the thematic continuities of history. My respect for abiding themes requires research that integrates the library and the studio, history as well as immediate practice. This commitment to the broader scope of ideas and practices has always made it necessary for me to oppose an exclusive adoption of behavioral science research methods by the creative arts therapy profession. The phenomena which I study cannot be boxed within controlled experiments which restrict creative and critical thinking.

The desire 'to know' will always be a driving force in any research tradition, including one which utilizes the arts as principal modes of inquiry. Pat Allen's *Art Is a Way of Knowing*, enlarges the epistemological discourse to include distinctly artistic ways of understanding. Artistic knowing is different than intellectual knowing; this distinction is the basis of its creative value, therapeutic power and future significance for research. In a foreword to Allen's book, M. C. Richards describes artistic knowing as intuitive, mysterious, and renewable, as 'an underground river that gives us life and mobility' (1995, p.vii). Allen's presentation of personal experience is in keeping with the traditions of artistic expression and inquiry. She offers her expression as testimony of how knowledge is gained through the process of sustained artistic inquiry. As Allen records her personal experience, she simultaneously identifies universal themes and principles manifested through her experience. The personal is used as an opening to the experiences of all people, and the guiding tenet of artistic knowing is a faith that the process will carry us to deeper levels of insight and knowledge.

In the creative arts therapies, we all want 'to know' how the process of creation affects us. We need a deeper knowledge of what works in different therapeutic situations. I have recently been reading a doctoral dissertation which utilizes art-based inquiry guided by the belief that the phenomena must be allowed to speak for themselves. The dissertation was focused on the use of mask rituals in expressive arts therapy. The researcher presented a simple and

direct goal as the basis of her inquiry, 'determining how the mask ritual works', rather than measuring its efficacy (Paquet, 1997, p.132). The doctoral student used her experience with masks and an experimental group as the basis for comparison with psychological and anthropological literature on the ritual use of masks. I realized in reading this dissertation how research and training are inseparable. Both are concerned with establishing personal familiarity with the intricacies of practice.

Even at the most advanced levels of practice we are constantly educating ourselves through our practitioner-research. Stephen Levine suggests that the creative arts therapy experience involves the disintegration of old patterns in order to make way for new creations. He states that, 'It is the therapists' own fear of breaking down that prevents them from letting clients go through the experience of disintegration' (1997, p.22). Based on this observation, we might focus creative arts therapy research on making therapists personally familiar with the transformative effects of disintegration in order to let patients go through their personal encounters with the creative process without unnecessary intervention. We constantly undergo personal experience with the creative process in order to know its properties and to be ready and open to help others.

Art-based research grows from a trust in the intelligence of the creative process and a desire for relationships with the images that emerge from it. These two focal points are the basis for a new tradition of inquiry.

As the field of creative arts therapy expands and matures, we will involve ourselves in deeper and more open-ended studies into how the process 'works'. Liberated from having constantly to justify our practice to others and to ourselves, we will be able to understand it more intimately and thoroughly. I urge the creative arts therapy profession to return to the studio, realizing that it is the natural place for artistic inquiry and expansion. All my research and experimentation with the creative arts therapy experience affirms that we must be able to 'trust the process' and allow it to do its work of transformation. The more we know, the more we will trust and open ourselves to the medicines of creative expression.

A more established and secure profession will also be able to focus more completely on the images and expressions it generates. In keeping with the practice of creative arts therapy, the image we research will hold all of the ways we approach it. The abiding presence of the image sets the parameters of research rather than a particular discipline's rules of engagement.

Experience in supervising student research has shown me how the use of established approaches to inquiry, such as traditional behavioral science methodologies, does help to generate a more consistent and concrete end

product, a less uncertain research experience for the student and supervisor, and a relatively consistent standard for the evaluation of quality. The methodology is laid out in advance, with the major area of choice being the selection of the problem to be investigated. These research activities often appear more concerned with teaching a particular scientific method than with the creation of new knowledge. The less imaginative researcher can produce an acceptable project by following procedures that do not demand a depth of creative resources. As a teacher and supervisor of research, I am well aware of the benefits of approaching the process of inquiry in this standardized manner. But when I read the completed studies, they tend to look the same and they bear little resemblance to the experience being investigated.

Art-based research generally does involve more ambiguity, risk and uneven results in terms of the end product. But the outcomes tend to be more creative, less mediocre, and more conducive to advancing the sophistication of practice. The final studies are distinctly individuated expressions, more likely to be different from one another than similar. Most important, art-based research corresponds completely to the benefits and difficulties of the process being studied; for this reason it must be given more attention within the creative arts therapy profession.

§

Connections to Imaginative Science

As creative arts therapy becomes increasingly involved in research activities, it is appropriate to ask, 'What are the goals of inquiry?'

Is the purpose of research to justify creative arts therapy according to the standards of medicine and behavioral science? Or do we strive to advance practice through creative experimentation? It is not necessary to create a dichotomy between these two goals which may ultimately serve one another. Art-based research is essential to advancing the sophistication of practice.

Research on all possible fronts will ultimately serve the best interests of the discipline and the different research communities need to communicate continuously with one another in order to create new synergies.

The cautions that I and others have with regard to creating impressions of self-indulgence when researching personal expressions strike at the heart of the paradigm shift suggested by art-based research. The traditions of behavioral science stress objectivity, which may be an illusory goal in reference to any research associated with the personal psyche and the creative process. What are the implications of research in a discipline where everything is interactive and where nothing can be studied as an entity unto itself? Do we begin with a pragmatic openness to whatever helps to further our goals or do we establish an allegiance to a particular set of rules about research?

When I began to focus my work with graduate students on art-based research, critics dismissed what we were doing by saying, 'That's not research.'

It is easy to negate a new form of inquiry by judging it according to standards of the existing paradigm which operates according to different purposes and methods. What is true and valuable from one perspective may not be respected by another. Every frame of reference carries its standards of truth. Within classical scientific disciplines there has always been a partnership with the philosophy of science which rigorously questions the relevance of research methods. But within creative arts therapy we have not adequately asked the

most fundamental epistemological questions which include: Does the language of inquiry correspond to the expression of the phenomena being studied? If the object of research is art, do we then conduct inquiries within the languages of the arts? Can I study an artistic object or the processes of creation through languages and conceptual frameworks that do not resonate with their beings?

Those who insist on scientific standards for research in creative arts therapy do not necessarily acknowledge that even natural science determines validity completely within the perspective of the discipline conducting the study. Rudolf Carnap, a principle figure in the twentieth century philosophy of science wrote: 'If someone wishes to speak in his language about new kinds of entities, he has to introduce a system of new ways of speaking, subject to new rules; we call this procedure the construction of a *framework* for the new entities in question' (1950, p.21).

When we require the use of behavioral science methods in creative arts therapy research, we are in effect declaring that new ways of acting are to be studied according to old ways of viewing experience. Our conceptual frameworks have not adjusted to what we are doing. The French philosopher Jacques Derrida, known for his deconstruction of ruling doctrines says: 'When you discover a new object, an object which up to now hasn't been identified as such or has no legitimacy in terms of any academic media or academic field you have to invent a new type of research' (1994, p.3). Creative arts therapy is a new phenomena which dramatically illustrates Derrida's call for new ways of conducting research which will advance our understanding of the discipline.

Critical analysis of the prevailing standards of research is an integral part of designing methods that help us understand new phenomena. However, creative arts therapy professional associations and licensing bodies tend to assume that research curricula within graduate programs will only include behavioral science models. This one-sidedness limits innovative research which is always based on acting in uncharacteristic ways. There is also considerable ambiguity as to the ultimate purpose of research within graduate training programs.

The undeclared purpose of current approaches to research in the education of creative arts therapists is to assure that every graduate has an understanding of behavioral science research methods. The standard rationale for this requirement is that the professional therapist must be able to read and apply research results to practice. Because these research methods are so ingrained within psychology and its related disciplines, they are generally followed without a critical analysis of their ultimate value.

As a researcher I strive to communicate the results of my work in a way that avoids technicalities and jargon that may limit readership. I might conduct research that requires specialized and advanced skills but I strive to convey outcomes and descriptions of the inquiry in a text that the general reader can understand. Rather than placing the responsibility for communication exclusively on the reader, it seems more reasonable to question the 'readability' of research reports. Therefore, it appears that it is a false assumption to require training in highly technical research jargon and methods in order to assure that every professional can read and apply studies conducted by others.

The prevailing attitudes toward research within the creative arts therapies no doubt compensate for the fact that our ways of communicating and practising therapy express a significant departure from what used to be the norm in the mental health field. In the early stages of professional growth, connections had to be made to the standard paradigms of psychology and mental health. In the formative phases of creative arts therapy a commitment to partnership was expressed by adopting the more influential colleagues' measures of efficacy. Within the mental health community the creative arts therapies have become less adjunctive in recent years and this realignment creates a need to review the purpose of research. I do not wish to eliminate productive links to other mental health disciplines. Rather I believe that a more innovative and art-based approach to research within the creative arts therapies will advance our value and credibility within the larger research community.

The best way of determining the purpose of creative arts therapy research will always be standards of usefulness. Citing historical precedents Carnap said, 'Let us grant to those who work in any special field of investigation the freedom to use any form of expression which seems useful to them; the work in the field will sooner or later lead to the elimination of those forms which have no useful function' (Ibid., p.4). When we shift our emphasis to usefulness, there will be considerably more freedom and openness in the practice of research.

The limited vision of research that currently exists is largely due to the fact that professional and academic communities have experienced an unparalleled inflation of research activities and courses without a corresponding assessment of usefulness. Research instruction tends to follow relatively fixed procedural rules of indoctrination; a practice which contradicts the creative purpose of the enterprise. The unstated goal is the acquisition of approved methods of inquiry which are reinforced by educational and licensing policy makers who are under no obligation to produce innovative research results. The system continues to feed almost exclusively on itself because it is not required to assess usefulness according to impartial standards.

The history of science reveals a very different approach to research instruction. Advanced science has always placed more emphasis on discovery and innovation than on standardized instruction in a particular set of methods. In *The Art of Scientific Investigation* W. I. B. Beveridge describes how 'Research is one of those highly complex and subtle activities that usually remain quite unformulated in the minds of those who practice them. This is probably why most scientists think that it is not possible to give any formal instruction in how to do research' (1950, p.x). The successful scientist is an open person with imaginative and broad interests, who is capable of making new creative connections between ideas and practices that challenge contemporary doctrines. Whereas according to Beveridge, 'constant study of a narrow field predisposes to dullness' (Ibid., p.7).

If creative arts therapy is to realize its potential to change the practice of therapy and research as well, it must have the confidence that its unique modes of inquiry have the ability to make important contributions to human understanding. The field needs to think about itself as a primary mode of investigation and not as a source of data for conventional psychological analysis.

Inventing new types of research in creative arts therapy will further the effectiveness of practice. Through experimental activities with arts media we learn more about how they can be used in therapy. We constantly experiment with different ways of making art in order to deepen our understanding of the creative process and we examine varied ways of relating to our expressions in order to further our appreciation of how they affect us. Our primary concern is the continuous exploration of how creative activity influences people. We work directly with the materials of expression in order to study their effects on us and we simultaneously advance our skills as practitioners. As participants in the process of research, our reactions, impressions, and judgments are essential ingredients.

The participation of the artist-researcher in the experimental activity distinguishes art-based research from the controlled laboratory experiments of physical science. Personal involvement in the experiment is a direct extension of the practice of creative arts therapy. Chemistry and other physical sciences do not involve interpersonal transferences, counter-transferences and other subtle and ever-changing nuances emanating from the process of the experiment. However, advanced science does recognize the impact observers have on experiments. It can be argued that personal participation in creative arts therapy research is necessary because it is consistent with the conditions of practice. Experimental designs striving to eliminate personal factors and uncertainties, contradict the conditions of therapeutic and creative practice.

Therefore, the disparaging comments about art-based research being 'personal' actually articulate a necessary condition which is missing within conventional behavioral science studies of therapeutic relationships. If the purpose of research conducted by future therapists is improved practice, then it follows that the context of research activities should approximate the conditions of practice.

Through experimentation I try different ways of responding to the images that I make in order to understand their expressive properties. I experiment with my personal reactions to materials and processes so that I may become more confident and knowledgeable in using them with others. I test what works and what does not work for me.

No matter how systematic my inquiries may be, art-based research will always produce results that simply 'happen' as a result of the unique conditions of the particular process of investigation. The various elements of the experiment and the overall effort of the researcher are essential factors which ultimately shape the outcome, but the total process is a 'complex' which can rarely be reduced to a linear sequence of steps. As the educational researcher Karen Gallas says when describing how she and her colleagues respond to the moment when a individual child learns how to read: 'We know in our hearts that the event of reading is magical...we are awestruck – not knowing absolutely that any one thing we did so systematically caused that outcome' (1994, p.3).

There is an inherent magic or enchantment that is basic to creative arts therapy practice which has yet to make its way into our research tradition. 'Magic' is an alchemical transformation which is the basis of the creative process. Although we might practice our work systematically and diligently, the unexpected and unpredictable moments of magic are fundamental qualities of the enterprise. These chance happenings can be likened to the way accidental events interrupt the laws of the physical world and introduce changes in organisms. Artists similarly break the established patterns of expression in order to make new culture.

Uncertainty and mystery rather than reliability and predictability are the driving forces of artistic transformation. But yet the scientism that has pervaded the mental health establishment, as well as public attitudes toward therapy, has made the word 'magic' the ultimate taboo within creative arts therapy.

A fundamental goal of creative arts therapy research might be a restoration of the place of creative enchantment within our lives. Our research activities can document the non-linear and precarious ways of creative transformation. There are ways of investigating the 'magic' of creation within the scholarly

tradition of aesthetics which speaks of a process of being 'seized' by a sublime experience, an insight, or a turning point in expression. Art-based research offers us the chance to work with all of our expressive and cognitive faculties.

Since magical events also take place within the scientific laboratory, this principle alone is not sufficient reason to insist upon an expanded approach to research within the creative arts therapies. The most fundamental rationale can be based on the fact that understanding the therapeutic value of painting or rhythmic expression can only occur by investigating these phenomena within the framework of their particular expressive qualities.

Howard Gardner has combined his knowledge of the arts, cognitive psychology, and neuropsychology, to refute the limited notions of intelligence that still permeate our educational institutions. Linear logic and verbal information systems 'all fail to come to grips with the higher levels of creativity' (Gardner, 1983, p.24). Gardner has given considerable credibility to the idea of multiple intelligences. He asks whether the 'operation of one symbol system such as language involves the same abilities and processes as such cognate systems as music, gesture, mathematics, or pictures' and whether information gained from one medium can be transferred to another (Ibid., p.25).

Many questions for creative arts therapy research are raised by Gardner's theory. Although it may not be possible to transfer what we experience and know within the framework of painting to a verbal or spoken text, conventional attitudes toward creative arts therapy research are based on this operation. Future research projects might focus on those qualities of creative arts therapy experience which can and cannot be translated into verbal language.

When using verbal language to describe and validate what occurs within the realm of what Gardner describes as another 'symbol system', we are translating from a primary to a secondary medium of experience. I am not against these translations which are currently necessary in professional communication. My objections are focused on the assumption that we must use secondary symbol systems in order to 'know' what occurs within the art experience. And I do not wish to denigrate language which is itself a primary medium of artistic expression. I am referring to the assumption that visual, kinetic, or auditory communications must always be translated into verbal language in order to be understood. This situation can be likened to the belief that the meaning of a verbal or poetic expression can be grasped only if it is translated into pictures, movements, or sounds.

Although the most important insights about the therapeutic qualities of a particular artistic medium or process occur through primary experiences with

them, I do not wish to encourage thinking about art exclusively within the framework of artmaking. Language, analytic thinking, and the scientific method all bring special resources which contribute to the process of inquiry. The creation of new knowledge emerges from an interplay of contributors. However, I believe that we can alter and expand our current notions of creative arts therapy research to include the primary process of artistic activity.

If the arts are the vehicles of understanding which give a purpose to our professional existence, then it seems logical to augment our knowledge of their resources through direct, as well as indirect, exploration. With all due respect for encouraging varied perspectives on a particular phenomenon, it is time for creative arts therapy research to stop defining and justifying itself through the eyes and values of external authorities. As we begin to know our discipline in a more immediate and comprehensive way, we will display a new confidence and wisdom that will affect others. I see the primary purpose of research in creative arts therapy as the realization of a more complete understanding of past practices and current activities with the goal of enlarging practice and stimulating innovation.

In encouraging creative arts therapy to examine itself through its unique ways of experiencing life, I do not wish to encourage isolation from other disciplines of inquiry. The way in which creative arts therapy has established itself through partnerships with other professions is a special feature of our history (McNiff, 1997).

As we deepen our comprehension of the complexities of creative arts therapy practice, I trust that our research tradition will build closer ties to imaginative and advanced science. For example, since our profession is thoroughly involved with matter, energy, kinematics, optics, and other phenomena studied by physics, we might consider exploring connections to this discipline which may be a more appropriate partner than the reductionistic labeling theory that has been widely associated with art therapy.

There are many creative arts therapists who avidly associate their work with science. I am not as interested in making creative arts therapy into a science, as I am in establishing creative connections with science. Our work corresponds to the principles of science but our discipline is essentially an art. Art and science are complementary partners, but one cannot be reduced to the other and this is at the root of the current confusion that permeates contemporary creative arts therapy research.

As we continuously explore connections to science, creative arts therapy will, one hopes, become more attuned to advances in scientific thought. We learn from quantum physics that any element introduced to a situation for the purpose of observation will alter the phenomena being observed. Therefore, it

may behoove us to explore ways of creatively engaging this effect in art-based research when we reflect upon our own experiences with artistic processes and materials. How does artistic interpretation alter the phenomena being observed? Is it scientifically possible to posit constant and lasting interpretations of any artistic expression? What is the goal of the process of interpretation when we approach a clinical situation through a state of mind guided by the principles of quantum physics? Compare this mode of interpretation to reductionistic practices that box and label experiences according to outdated psychological theories.

The physicists are telling us that we create reality through our interactions with the world. This idea has great significance for creative arts therapy. If we create and recreate our worlds, then it follows that a therapy based on the practical application of this theory will have major scientific as well as artistic relevance.

Carl Jung's belief in the purposeful process of human experience establishes close links between psychology and the theoretical advances of physics. Where Freud's psychology is based upon the mechanistic cause and effect relationships that characterized nineteenth-century science, Jung suggests that the psyche is a complex and self-regulating system in which different aspects of experience complement one another. This conception of the inner life of a person is close to Niels Bohr's theory of complementarism which views antithetical points of view as necessary contributors to a larger whole. Dualities are accepted without feeling the need to reduce them to something else. They become partners in the creative act. Imagine the many ways in which Bohr's theory of complementarity can be researched within different artistic media and therapeutic experiences. Once we accept how contradictory experiences have a necessary function within our creative and psychic lives, we have established an entirely new arena for psychological inquiry. Advanced physics offers yet another rationale for expanding the spectrum of research methods to include artistic inquiry.

If the intricate mathematical methods of laboratory physics are inaccessible to many of us, the theory of advanced physics is surprisingly close to what we experience in creative arts therapy practice. The dynamics of the creative process, as I have experienced them, are closely related to a fundamental tenet of quantum physics which emphasizes a mechanics of discontinuity as contrasted to the old mechanics of continuity. In his essay 'Quantum Physics and Philosophy' Niels Bohr affirms how varied fields of knowledge confront the same situations engaged by quantum physics. He writes, 'We are not dealing with more or less vague analogies, but with clear examples of logical relations which, in different contexts, are met with in wider fields' (1963, p.7).

Advanced scientists such as Bohr, as contrasted to the practitioners of scientism, are careful to separate fields of inquiry from one another and to respect the unique methods of inquiry used by each discipline. We make 'parallels' between the discoveries of physics and what we experience in creative arts therapy. Disciplines influence and assist one another with ideas and themes that apply to the broader context of life.

Art-based research and advanced scientific thinking share a fundamental commitment to allowing the phenomena being studied to speak for themselves. If we stay closely attuned to the images and processes of creative expression, they will suggest new frontiers of understanding.

Art-based research requires this open-ended interplay amongst different areas of knowledge with the researcher returning again and again to the images and the process of expression as the foundations of inquiry. The creative researcher avoids stock theories and rigid methods of inquiry and prefers insights emerging from sustained reflections on phenomena. This approach to research corresponds to Werner Heisenberg's idea that the world is a complex of many different kinds of connections, all of which interact with one another to create what we envision as the whole (1958). There is no single and authoritative way to relate to a work of art or to the intricacies of artmaking which are even more elusive. I see art-based research as fostering many different and unusual ways of relating to the practice of creative arts therapy trusting that our collective efforts will advance understanding.

I urge creative arts therapy to assure that its conception of research is in synchrony with the transformative nature of the creative process. It is time for research that embraces discovery, experimentation, and bold ventures into unexplored areas.

§

Art's Integration of Empirical and Introspective Inquiries

Art-based research typically involves an integration of different methods of inquiry. The 'textbook' approach to teaching and practising research labels particular methods and places them into compartments, often defining approaches in opposition to others – art versus science, qualitative versus quantitative, subjective versus objective, heuristic versus phenomenological, and so forth. In this chapter I will strive to present an integrative model which corresponds to art's inherent use of varied and sometimes contradictory materials and ideas. I realize that different 'kinds' of research have to be distinguished from one another and I am not proposing an undifferentiated amalgamation of methods. The delineation of the different aspects of a situation is fundamental to critical analysis as well as integrative thinking. The problem lies in assuming that these multiple factors exist in complete isolation from one another, an attitude which arrests their potential to create together.

Comprehensive study of varied types of research will enhance the natural emergence of an integrative vision. The positive response to the efforts of Debra Linesch and Maxine Junge to support varied paradigms for research within art therapy (Linesch, 1992; Junge and Linesch 1993) suggests that a pluralistic approach to research corresponds to the diversity that exists within the profession. As the merits of different types are understood by researchers, new integrations amongst them are inevitable.

Creative discovery is based upon putting previously separated entities into new relationships with one another. One of the most elemental of conceptual dichotomies involves the split between art and science.

Art-based research and scientific inquiry may have more in common than many realize. Science and art have always been closely allied and they share a common commitment to innovation and the creative imagination. Creative

scientists are more likely to view themselves as artists than as technicians following prescribed procedures. It is scientism which has distanced itself from artistic inquiry through efforts to extend control over research and professional practice. Scientism holds that methods of investigation used in the natural sciences should be applied to every intellectual inquiry. This way of approaching research ironically attributes to science a narrowness and rigidity of procedure which does not characterize the methods of truly innovative scientists (Beveridge, 1950). Scientism is an institutional perspective which has retarded creative genius from making new connections amongst previously separate entities.

As a result of the attitudes engendered by scientism there has been an increased polarization between empirical and introspective approaches to research. The word empirical, connoting sensory knowledge, direct observation, and pragmatic procedure has become exclusively identified with science whereas art is stereotypically identified with introspection and subjectivity. When we refer to empirical experimentation, it is generally assumed that we are talking about something quite distinct from art. Art-based research requires that we revisit the split between empirical and introspective inquiries, a separation which makes little sense when studying the artistic process and its outcomes.

My experience with art is thoroughly empirical as well as introspective and scientific researchers say the same about experimental and creative activities within their discipline. Art-based research is grounded upon a comprehensive and systematic integration of empirical and introspective methods, and I believe that this mixing of previously separate elements is a significant innovation. How can we avoid using the senses and conducting physical experiments when researching the nature of the art experience? Isn't the very purpose of creative arts therapy an empirical immersion in the immediacies of life? Within our discipline empirical research activity expands beyond the experimental laboratories of scientists. Self-inquiry is just as important to art-based research as empirical experimentation and in this chapter I will try to offer suggestions as to how we can begin to integrate these two aspects of research theoretically and practically.

Science can be defined as a mode of disciplined inquiry which strives to further understanding of the world. It includes 'any' methodological and thorough study of phenomena which generates knowledge through experience. To me science has always been an expansive activity which involves rigorous observation, classification, examination, experimentation and theoretical elaboration. There are many features of the natural world which can be studied according to strict standards of positive measurement and

prediction. But there are also many natural and experiential phenomena that are not subject to exact quantification. They include human relationships, motivations, interpretations, reflections on experience, personal expressions, and the dynamics of the creative process. As scientific inquiry expands to study these phenomena, it must devise methods of investigation, description, and theoretical explanation which are capable of accurately articulating the processes being examined.

The most important contribution of creative arts therapy to the larger research community may emerge from demonstrations of how science and art can work together within the process of disciplined inquiry. The objects of research generated by creative arts therapy demand this integration.

Today we are generating extensive data throughout the world which suggest that artistic expression is a vitally important way of acquiring and communicating information about human experience. Artistic ways of knowing are needed to 'read' and study these data. The scientific aspect of this integrated inquiry involves thorough and systematic study while the artistic component offers ways of communicating information and methods of investigation. It is possible for art-based research to combine science and art in every phase of its operations.

In the popular mind art has been perceived almost exclusively as a way of expressing emotion, as entertainment, and now as healing. It has not been appreciated as a way of knowing and systematically studying human experience and other natural phenomena. There are exceptional cases such as John Audubon's drawings of birds and animals, Leonardo's anatomical and mechanical studies, and the illustrations of naturalists, which have made direct contributions to scientific understanding. These modes of artistic represent-ation fulfill the most rigorous standards of empirical scientific observation. More recently, photography has become closely allied with scientific investigations.

I believe that much of the contemporary confusion about research involves the polarization between supposedly scientific and non-scientific methods of inquiry. Because new disciplines like the creative arts therapies do not encourage critical studies of the history and philosophy of science, we easily become ensnared within contemporary doctrines of research even though they may not suit our needs.

Psychological research is still tied to positivist tenets advanced by John Watson in the early twentieth century. Striving to become a branch of the more prestigious natural sciences, psychology declared that it was exclusively concerned with the study of objective behaviors which can be predicted and controlled. Psychoanalysis and other psychotherapeutic psychologies were

distinguished from 'legitimate' scientific methods because they relied on introspective data that could only be observed by the persons experiencing them. This is the basis of the split between psychoanalysis and twentieth century academic psychology. Creative arts therapists, beholden to the contributions of Freud, Jung, and other analytic psychologists, find themselves operating within academic institutions and professions that encourage research values which reject the basis of the enterprise. No wonder there is terrible confusion about the nature of research in creative arts therapy. We are caught up in the qualitative–quantitative dichotomy of behavioral science and we tend to accept it as encompassing the universe of research possibilities offered by our discipline. The roots of the conflict go much deeper.

Psychology became heavily involved in psychometric testing because this particular activity produced data that were capable of being reviewed objectively by others. Drawings and other human expressions were similarly treated as research data and in this way creative arts therapy established a foothold within academic psychology. But interestingly enough, these images were often analyzed according to the same psychoanalytic theories that were rejected by psychological positivism. The research methods of positive science were used to attempt measurements of introspective and highly subjective data. My criticism of this type of research should not be confused with valid and reliable uses of empirical–quantitative research.

Modern science has philosophically defined itself in opposition to classical ways of knowing based on introspective musing validated by systematic reasoning. In the seventeenth century the new empirical standards of science emerged from the belief that only the observation of natural phenomena can produce valid knowledge. Emmanuel Kant, who strived to integrate the two traditions, reminded philosophy that it is impossible to observe the world independent of *a priori* judgments, which we describe today as paradigms, frameworks, and constructs. Every point of view has an inherent perspective or bias. Advanced science and post-modern philosophy have today realized that there is no absolute criterion for evaluating experience but these values have not yet dissolved the unnecessary split between 'quantitative and qualitative' modes of research in behavioral science.

Within the psychological research community, introspection is spontaneously re-emerging as a respected mode of inquiry and I attribute this to its archetypal place in human understanding. This revival of pre-behavioral methods of inquiry is being initiated by heuristic research which shares many concerns with art-based inquiry.

The Greek word 'heuriskein' means to discover and find. Today heurism connotes a method of learning through which knowledge is discovered through an inquiry based upon the examination of personal experience.

'In heuristics,' according to Clark Moustakas, 'an unshakable connection exists between what is out there, in its appearance and reality, and what is within me in reflective thought, feeling, and awareness' (1990, p.12). Moustakas emphasizes 'sustained immersion' in the issue being researched and 'direct, personal encounter' with the objects of our research.

The subjective perspective, once considered inimical to research, becomes a primary feature of heuristic inquiry which encourages the telling of personal stories. Moustakas describes how this approach to investigation actually requires 'autobiographical connections' through which 'the heuristic researcher has undergone the experience in a vital, intense, and full way' (Ibid., p.14). The affirmation of the personal perspective has been welcomed by many people within the psychological community.

Heuristic research is principally focused on the examination of the self and this accounts for its many contributions to psychological inquiry where there has been a tendency to make the research process as impersonal as possible. Conventional behavioral science assumes that research must be rigorously objective but there has not been enough critical attention given to the place of bias in all interpretations of the world. As Hans-George Gadamer suggests in *Philosophical Hermeneutics* (1977), bias is a person's opening to the world. Every interpretation is based on the perspective of the interpreter and in the case of behavioral science, from the perspective (or bias) of the theory of research.

Hermeneutics can be defined as the art of interpretation, a discipline which depends upon the personal perspective of the interpreter. The 'textbook' approach to teaching research encourages students to separate heuristic and hermeneutic investigations without examining how they support one another. The principles of phenomenology are similarly presented as a separate entity rather than showing how they can help heuristic and hermeneutic researchers stay in contact with the objective expressions of things.

Research in the area of human relations is inevitably characterized by personal, cultural, and theoretical pre-dispositions. The best way to arrive at relatively unbiased outcomes is to acknowledge and define the personal bias of the researcher as a feature of the study. In human relations, objectivity is a quality which emerges from a discourse where personal bias is revealed as a condition of the dialogue. Another purpose of heuristic inquiry can be a more comprehensive understanding of how the personal bias of the researcher affects practice.

As Jacques Barzun and Henry Graff state in their classic study of the process of research, 'An objective judgment is one made by testing in all ways possible one's subjective impressions, so as to arrive at a knowledge of objects' (1957, p.146). In a research project our subjective perspectives work together with many other points of view and techniques which expose the objects of inquiry to precise examinations that do not take place in our everyday interactions with them.

Art-based research expands heuristic research by introducing the materials of creative expression to the experimental process. When we study the therapeutic effects of the arts, we are keenly interested in what the different media of expression do. We examine how 'they' affect us. Heuristic research studies have a tendency to appear more 'self-involved' than art-based research where the emphasis is on a partnership between the materials of expression and the researcher. In art, the self is a major participant but there is always the goal of making expressions that are able to speak for themselves. There is also a research tradition within the arts which carefully investigates objects and materials as independent entities.

An understanding of inner-directed heuristic research is essential to art-based research where there is a comparable emphasis on direct and personal participation. For example, if I had applied heuristic methods in the doctoral studies of art motivation that I previously described, I would have given considerable attention to my personal motivations for making art, my reasons for selecting this particular theme, and my history with the subject, all of which would have provided important insights into the point of view operating behind the research activities. My art motivation study was focused on what other people said during interviews (McNiff, 1977). If encouraged to look at the subject in a more heuristic fashion, I would have interrogated myself about my desires for creative expression in the present and the past. This dialogue with myself would have expanded my study to include a much more explicit statement describing my personal perspective and my inevitable biases toward the subject matter. My experience could then be compared to what I learned from other artists in my interviews. The final results would have been presented more as an interplay of perspectives as contrasted to my attempt to discover essential elements or universal laws of art motivation.

I also realize that my art motivation study involved very little direct encounter with art objects or live experiment with the creative process. If I had given the objects more attention during the study, it is possible that they might tell stories about how and why they came into existence. These accounts might have varied considerably from what their maker described. Even if the art objects do not contradict the statements of artists, they will always expand the

discourse about origins and perhaps we would discover how at various phases of emergence they might have influenced and motivated the person making them. If I had practiced art-based research in my doctoral dissertation I would have asked: 'What does the art object or expression say about itself?' This type of examination amplifies both traditional interviewing and heuristic analysis.

When we involve objects of expression as co-participants and partners in the process of inquiry, these materials elicit the new responses from the researcher suggested by Derrida. While art-based research makes good use of heuristic 'self-dialogue', it also includes the study of external phenomena and dialogue with the object.

Heuristics alone may not be well suited to creative arts therapy research. In supervising heuristically oriented doctoral dissertations and masters theses in creative arts therapy, I have observed how these projects lean toward one-sided presentations of the emotions and concerns of the artist. There can be a lack of creative tension between the researcher and the objects of expression. When the process of research recognizes objects as full participants, there is a decided shift away from one-sided autobiography and toward the examination of an interplay. As an 'aspect' of art-based research, heuristic inquiry cooperates with empirical ways of knowing the artistic process.

My commitment to an integrative method of art-based research has been shaped by my experience in observing graduate students pursue research projects where the only voice in the study was that of the first person. The objects of expression and the process of creation were obscured as the self-examination of the researcher took precedence over other aspects which contributed to the experience. The studies tended to spiral into labyrinths of personal feelings and fragments of thought. In criticizing this type of inquiry I realized that the heuristic dimension would be furthered if there was more interplay or dialogue between the self and external things. I was also concerned that these criticisms of self-immersed and one-sided studies could threaten the more general use of self-inquiry as a way of understanding phenomena.

The most important frontier for art-based research is the empirical study of the process of artmaking. Once we realize that live experimentation is as appropriate to art as it is to science, the possibilities for future research will be enhanced in major ways. In the case of my doctoral studies of art motivation, an empirical approach to research might have involved experiments during which I could have reflected upon motivations for expression during an actual session of artmaking. I sense that this approach to inquiry will take on a completely different character than research focused exclusively on verbal reflections with other people well after the completion of an artwork. I realize that my original art motivation research was a highly abstract study which largely began and

ended with ideas living within the realm of the psychology of motivation which I applied to art.

In an art-based study of art motivation I might examine my personal art motives as I make a painting, describing my initial feelings and inclinations as I stand before the canvas. I might identify familiar and recurring motives as well as new sensations, all the while linking these with aspects of the immediate experience in a particular environment. As I work on the painting, I can identify how these initial feelings are sustained; the ways in which they change; and how I respond to particular things that emerge through the process of painting. In an experiment of this kind I anticipate being influenced by the emergence of thoughts as I work. The concrete qualities of the painting, compositional problems, and accidental occurrences will probably have a large influence on what I do. I predict that motivations will emerge through the physical process of painting and that since my style of painting is highly improvisational, these unexpected arrivals will strongly impact the final outcome.

I might reflect upon when to stop the painting and how I am motivated to make this decision, or whether the painting itself decides when it is finished, and in essence supplies the motivation for its own completion.

I anticipate that the physical aspects of the painting process will have more of an effect on the eventual outcome than the inclinations I had at the beginning of the process. This type of inquiry will necessitate an art-based language since I will be involved with empirical observation and description, whereas my original art motivation study tended to use abstract, psychological language. In this regard, art-based research may begin a new tradition of inquiry with its own empirical and conceptual terminology. However, I do not want to initiate yet another form of professional jargon and narrow specialization. We must find a way to expand research opportunities while placing equal emphasis on establishing a language which is shared with colleagues from other disciplines.

As I research the act of painting, I will no doubt realize that personal ideas, memories, themes, and inner-images will contribute to what emerges on the canvas. Art-based research involves reflection on the interplay between these mental motivations and the physical ones that appear through contact with the medium.

While experimenting with my personal artistic expression in this way, I can also expand the process of inquiry into the studios of other artists. In addition to interviewing painters as they work, I might videotape and photograph interactions with the canvas. The written text, the documentary imagery, and the paintings themselves provide extensive empirical data for analysis. I trust

that as we accumulate data, they will begin to motivate and direct the process of research in ways that I cannot foresee at this time. The experimental experience will shape the future of art-based research.

What is most intriguing about creative arts therapy research is that it requires the integration of the two elements that have been polarized through the past four centuries of debate over what constitutes appropriate scientific methodology. Art-based research comprises both introspective and empirical inquiry. Art is by definition a combination of the two. The artist-researcher initiates a series of artistic expressions as a means of personal introspection and the process of inquiry generates empirical data which are systematically reviewed.

At this point in the history of research, science has reached almost complete acceptance as the only true vehicle for understanding human behavior. Serious philosophical inquiry has not been viewed as an essential aspect of behavioral science research and consequently, there is little critical analysis of prevailing standards of truth. This dominance and one-sidedness is not good for science which thrives on new synergies and fresh perspectives on the world. An integration of scientific and artistic methods may be as good for science as it is for art.

I welcome art-based research which revives aesthetic criteria for the assessment of reliability and validity.

I can imagine studies which revive the long-standing philosophical discourse on beauty. Is the experience of beauty largely subjective or are there objective standards of aesthetic quality as posited by classical Greek philosophy? This discourse will add a new dimension to the heated debate about process and product within creative arts therapy. Is it necessary always to pit one position against the other? Can the perception and creation of beauty bring healing qualities? Do I have to make turbulent and gut-wrenching images in order to feel that I am truly expressing myself in a therapeutic context? Do whimsical and pleasant pictures always express a defence against true feelings? Is the experience of beauty the basis of art's healing power?

I caution against the pitfalls of oppositional and divisive thinking which automatically says that because I encourage the contemplation of beauty, I overlook the place of ugly, grotesque, and bizarre expressions. I have little interest in a saccharine approach to aesthetic values. It is not difficult to imagine a discourse on beauty which embraces both subjective assessments of quality and a more objective examination of expressive features.

In *The Sense of Beauty* first published in 1896, George Santayana presents the subjective and emotional argument for aesthetic experience: 'To feel beauty is a better thing than to understand how we come to feel it... If we appealed more

often to actual feeling, our judgments would be more diverse, but they would be more legitimate and instructive' (1955, pp.11 and 19).

Without denying the primacy of feeling in creative imagination we can recognize that there are certain physical characteristics which are likely to generate a relatively predictable aesthetic response. Because this interplay between subjective and objective elements takes place all of the time within the creative process, it is foolish and limiting to set them up as antagonists. The introspective feeling of beauty does not have to be separated from the empirical conditions being experienced. As creative arts therapists we must embrace both the significance of felt experience and tacit knowing while understanding that certain objective conditions are likely to generate a particular kind of response. Art and science are integrated into every aspect of our discipline.

Classical standards of objective beauty such as harmony, symmetry, and order, narrowed the spectrum of aesthetic values to a set of political and social ideals which are today perceived as limiting. Rather than simply dismissing the attempt to articulate objective experiences of beauty, Rudolf Arnheim presents a new standard which is 'that property of form that makes expression pure and strong' (1972, p.197). This definition resonates with the values of authentic expression within contemporary creative arts therapy practice.

Many different kinds of studies can be undertaken to explore how aesthetic reactions to expressions made within art therapy may determine the quality of the therapeutic experience. Is the therapeutic power of an expression determined by the degree to which it invites empathy? A sense of emotional presence? The activation of emotion?

Do artistic expressions stimulate reactions that correspond to their physical qualities? Will the aesthetic quality of the artistic expression determine its therapeutic effect? How does the sensibility of the perceiver, both therapist and client, affect the quality of the aesthetic response? What can be done to further empathy and receptivity to the different aesthetic qualities of expressions? To what extent will a given type of expression evoke relatively universal and/or individual responses? Even if artistic objects will sometimes elicit universal reactions, do we ever want to reproduce the outcomes of creative arts therapy practice? Does creative arts therapy strive for the infinite variation of art, the predictability of science, or a combination of the two depending on the needs of the situation?

What expressive qualities summon universal reactions and what kinds of expressions are more likely to generate diverse responses? Should aesthetic empathy – the ability to feel what images, people, and situations, are expressing – be taught in graduate programs? How does the widespread emphasis on the

psychological analysis and explanation of imagery in art therapy, influence empathy?

The assessment of beauty depends upon the emotional sensibilities extolled by Santayana. However, we can have idiosyncratic preferences and diverse tastes while recognizing that there will be more universal responses to certain phenomena. Thomas Aquinas described the experience of beauty as arresting motion which can be likened to what we would today describe as a gasp of appreciation, a striking perception, or an experience which seizes attention and 'stops us in our tracks.'

I tend to stop working on a painting when there is a sense that any additional movement will hurt the image. When the picture feels 'just right', I stop. There is a sense of completion and satisfaction that I perceive within the image and correspondingly feel within myself. These aesthetic judgments involve a constant interplay between the objective qualities of the image and the sensibility of the artist. Within an artwork I experience beauty as a sense of completion, satisfaction, expressive vitality, uniqueness, and delight. The image stimulates me, holds my attention, and I want to return to it again and again just for the sake of looking and appreciating its qualities.

When I review my experiences in creative arts therapy I realize that a sense of beauty is aroused in me when people sincerely strive to express themselves, an effort which evokes an aura of sacredness and authentic presence within the therapeutic space.

The appreciation of beauty might be frightening or unsettling as well as pleasing. The aesthetic phenomena may be a 'terrible beauty,' an over-whelming force or life-threatening storm which makes the human presence feel small and insignificant. Beauty is not always nice. Theodor Lipps saw beauty in objects and experiences which reverberated with vitality.

We resist using the experience of beauty as a criterion for measuring validity because aesthetic judgments continue to be perceived as purely subjective and personal. Pat Allen described to me how people who read her book *Art Is a Way of Knowing* write to express how her personal accounts of the significance of artmaking validated their experiences. The effectiveness of the author's communication is measured by the extent to which it connects to the experience of readers who are so 'moved' that they complete the cycle of communication by corresponding with the originator. The work can be assessed through empirical reactions which can be counted.

The psychiatrist Harry Stack Sullivan described this feedback process as 'consensual validation'. I witness it again and again in my practice of creative arts therapy. The quality of the expression is evaluated according to aesthetic dynamics – the clarity and directness of the text, its persuasiveness and

authenticity, its vitality and ability to generate feelings of empathy in the perceiver, and so forth. In my experience there tends to be far more consistency among people making these aesthetic assessments under the same conditions than inconsistency.

The beauty of a person's expression evokes an aesthetic reaction in the witness whose communication back to the artist validates the significance of what has been conveyed. This interaction of both introspective and empirical expressions is the basis of the creative arts therapy experience which requires the ability to be 'moved' and 'touched' by the beauty of creative expression. Beauty and aesthetic infusions are the medicines of art.

The greatest obstacle to using the aesthetic experience of beauty as a way of determining validity in the creative arts therapy experience is the lack of openness that many within the profession have toward expressive phenomena. We are so restricted by our particular theoretical values and the presumed need to offer clinical explanations, that we are not universally capable of the Thomistic response of arrested motion before the image. Is this reaction caused by the ambivalence that many creative arts therapists feel about their identities as artists? Do creative art therapists and the more general behavioral science community suffer from aesthetic phobia?

Pat Allen described to me how the great shadow aspect of art therapy involves the therapist's sense of 'unworthiness as an artist'. What can be done to remedy this situation? More artistic training and reinforcement in graduate school and throughout a person's career? Most of us are drawn to therapeutic work because we are fascinated with psychopathology in ourselves and others. Can we see beauty, defined as an image brimming with vitality, in this fascination? Can creative arts therapists shape an unique aesthetic perception from their practice and interests?

The most ingrained impediment to aesthetic determinations of validity is the distrust of personal reactions. We continue to separate the subjective and objective elements of experience, the introspective and empirical, in ways that simply do not correspond to the conditions of life.

Yet I will be the first to acknowledge legitimate cautions about the dangers of one-sided subjectivity and introspection. The most difficult challenge for art-based research is the avoidance of the quagmires of personal experience. Introspection must find ways to work collaboratively with empirical data and make useful connections to things beyond itself. In my experience it has been the objective presence of the art object and the physical process of artmaking, together with an over-riding commitment to inquiries which are useful to others, which have helped to check excessive self-immersion.

Rudolf Arnheim's writings on the psychology of art demonstrate how a researcher interacts with objects and environments in a process which seeks to understand their expressive qualities (1954, 1972, 1986, 1992). Since Arnheim does not write about the therapeutic process, his research initiatives can be expanded by creative arts therapy to contain the heuristic element that is essential to the therapeutic relationship. When we combine Arnheim's attentiveness to objects with Moustakas's in-depth self-examination, we have the necessary ingredients of art-based therapeutic research which have not been included in previous psychological methods.

Future research might consider focusing more on what happens during the process of making a particular artwork. In creative arts therapy research we can document the ways in which people make paintings. Our subjects can include patients, artists, and ourselves.

When we examine a painting that we make ourselves, we have access to a more direct encounter with inner motivations and creative forces. The heuristic dimension to this type of research increases the validity of what we say about the process of making the painting because the researcher has directly experienced the process being investigated. This type of inquiry by artist-researchers will offer accounts of the inner and transformative forces which are the basis of the creative arts therapy discipline.

Rudolf Arnheim's research in the psychology of art illustrates how to blend the visual skills of the artist with psychological inquiry. Most of the other twentieth-century studies in the psychology of art analyze art objects and artistic motivations from the vantage point of a particular psychological theory and there is virtually no interplay between scientific and artistic inquiry. The great popularity and influence of Arnheim's scholarship results from his attentiveness to the physical qualities of the objects being examined. There is always a sense that Arnheim is working together with the artist who made the object in an effort to help us see and understand things in a more comprehensive way.

The key to following Arnheim is not a strict adherence to his particular method of scholarly inquiry. I suggest emulating his way of placing previously separate disciplines in new relationships to one another. Arnheim teaches us how to use many tools to study phenomena. His primary discipline was perceptual psychology which he integrates with art history, aesthetics, physics, biology, architecture, film, photography, painting, drawing and poetry. There is a tremendous sense of unity in Arnheim's scholarship, achieved by returning again and again to the particular object of investigation. It is the physical thing being researched which sharpens the scholar's focus, rather than the academic discipline or theory within which the investigator operates.

Creative arts therapy can build upon the foundations of Rudolf Arnheim's research in the psychology of art by letting objects of inquiry elicit ways of responding to them. If the phenomenon being studied by a creative arts therapist is an artwork, then it follows that art history, aesthetics, perceptual psychology and other disciplines have resources that will be useful to the researcher. Arnheim demonstrates how staying focused on the qualities of phenomena can give the researcher the freedom to include different intellectual disciplines as vehicles of understanding. Art-based research needs to explore the many benefits to be realized through a combination of Arnheim's focus on the empirical object and Moustakas's heuristic introspection.

Creative arts therapy has the unique opportunity to demonstrate how the long-separated empirical and introspective research traditions can be integrated. Because we cannot fully practise our profession without combining these two elements, there may be no alternative to integration. However, departmentalism is the ruling doctrine in our academic institutions and this inevitably manifests itself in approaches to research. Often institutions charged with generating knowledge are the primary obstacles to creative inquiry. Our emerging research tradition needs to reflect the interdisciplinary spirit which gave birth to the profession. The following pages will suggest that the pursuit of practitioner-research in creative arts therapy may already be well on the way to realizing the necessary union.

§

Practitioner Research

Creative arts therapists can look to education for guidance on how to critique rigid doctrines of research. Teachers are beginning to view the classroom as a 'research community' and they are presenting themselves as 'teacher-researchers.' In keeping with Robert Landy's notion of the 'double life', it is felt that research activity in the classroom furthers the effectiveness of teaching and vice-versa. Karen Gallas (1994) writes about how teachers no longer have to view themselves as 'aborigines' who depend upon outsider-researchers to validate what they are doing. I am especially pleased with the way the teacher-researcher movement is accepting the arts and literature as models for inquiry. Karen Gallas describes how she uses literary and 'ethnographic' methods to describe what happens in her first grade classroom, and she contrasts these techniques with academic research methods that have little to do with her daily life as a teacher.

Creative arts therapy will benefit from a new focus on practitioner-research. The belief that research is an activity conducted by specially trained experts working under controlled conditions encourages a continuous separation from practice.

Therapeutic performance can be re-visioned as a life-long mode of research. The perspective of research brings the discipline of thorough study to practice.

The practitioner-research model will make many positive contributions to professional education. Graduate school is an ideal place in which to instill values which stress the interplay between intellectual inquiry and skillful practice as contrasted to the current tendency to separate the two. This isolation of research and practice is unusual when compared to other professions in society. People working in finance, marketing and professional athletics are always conducting research as an integral aspect of their ongoing practice. Research informs and guides performance. In addition to helping me perform more effectively, I have experienced how researching my professional practice

heightens appreciation for what I do as well as generating a sense of renewal. When I read studies conducted by other therapist-researchers they inspire me to investigate my own experience in a similar way. They show me how it is possible to integrate what our professional educational systems split apart.

As an educator I strive to instill the discipline of research into every phase of training through rigorous methods of discovery, trial and error, observation and description, comparison and constant evaluation. Everything I do as an educator has an experiential basis and this orientation makes it possible to blend research and practice.

We tend to talk routinely about theory and practice rather research and practice. Theory is approached as an isolated entity to be acquired. But it is a highly static approach to theory that prevails in much of professional education. I prefer to speak about research and practice because of the active and transformative emphasis on inquiry rather than the more passive acquisition of theories. As we investigate and reflect upon direct experience, we are in a position to *compare* what we find with the experiences of others. This comparative theoretical analysis assures that we will be able to put knowledge to use. I have discovered that learning is furthered when we connect ideas to our experience. I have also consistently found that trying to fit my experience into another's theoretical framework results in missing opportunities for perceiving the experience in a new way.

Karen Gallas's book, *The Languages of Learning: How Children Talk, Write, Dance, Draw, and Sing Their Understanding of the World*, can be paraphrased to encourage 'the languages of research' and 'how creative arts therapists talk, write, dance, draw, and sing their understanding of the world'. Gallas focuses on the use of narrative as her primary mode of inquiry. She tells her story of what she sees happening in her classroom in the tradition of Elwyn Richardson, Sylvia Ashton Warner, John Holt, and Kenneth Koch.

The practice of case study research in creative arts therapy corresponds to the narrative mode of research. Bruce Moon has moved the narrative account into a new artistic dimension with his poetically written 'stories' about his experiences with clients (1990, 1992, 1994). Moon's literary way of describing what takes place in a therapy session breaks with the tradition of creative arts therapists writing case studies according to medical and psychological formats. More recently, Moon has been taking his storytelling process to a new artistic dimension through live performance.

For years my graduate students have been dancing, drawing, singing, and performing their thesis projects in keeping with Karen Gallas's notion of the 'plural' languages of learning. We investigated ways of conducting supervision of their work with patients through the arts. The students made paintings,

wrote stories and poems, engaged in musical and dance improvisations, and constructed environmental artworks, all dealing with confusions and conflicts generated by their work as therapists. The most useful form of creative inquiry tended to be performance art which integrated all of the different artistic modalities. Performance has an unique ability to engage the full spectrum of thoughts and feelings that a person is experiencing. It is also a highly focused art form that generates tremendous energy which is typically transformed through the process of the event. I found that performances helped students to make significant shifts in their perceptions and attitudes. A situation that was originally felt to be hopeless might take on a new meaning as a result of creative enactment. Performance art was especially helpful in changing rigid attitudes and fixed opinions since it is difficult to avoid changes in consciousness when we enter the dramatic space in an open and committed way. The process of performance gives hardened opinions the opportunity to change themselves in a creative way.

While students explored their personal artistic expressions as ways of inquiry, the work was easily disparaged by advocates of conventional creative arts therapy research who insisted upon the exclusive use of scientific language. However, I feel that the discipline of creative arts therapy is now ready to explore voices that emanate from artistic expression. Karen Gallas's critique of educational research corresponds completely with what is occurring within creative arts therapy. She declares:

> The language of most educational researchers uses the tone of the academy and the explicit intent of science. It is distanced, authoritative, oriented toward wider meanings and generalizations, and often implies that there are right or wrong ways of teaching. It does not speak the voice of uncertainty, does not acknowledge the changeable, instinctive, and intuitive character of teaching. (1994, p.2)

Gallas describes how she and other teachers tell stories about the way in which children learn how to read. They learn from one other and systematically try to improve their methods for teaching reading but they know that there is no definitive way to account for the way a child learns to read. She says, 'We know that the measurement of variables, coefficients, and reliability will not help us as teachers of reading' (Ibid., p.3).

I don't believe that Gallas or any other critic of the current research environment intends to dismiss or challenge the 'measurement of variables, coefficients, and reliability' as a useful and sometimes preferred approach to studying human experience. She is simply saying that these tools and ways of

knowing do not apply to every research activity, and that the everyday practice of teaching may be the most important arena for educational research.

Let me try to demonstrate the primacy of practitioner-research within the context of my own professional experience. As I review my practical work over the past twenty-seven years, I see that I have systematically explored different ways of relating to images produced in art therapy.

When I first began my work as an art therapist in a mental hospital environment serving adult psychiatric patients with severe perceptual disorders, I quickly learned that I could not rely on familiar ways of relating to people and engaging them in purposeful activity. I was forced to experiment and discover something new. As the cliché proclaims, 'Necessity is the mother of invention'.

In order to function as an art therapist I had to research what would work within a particularly challenging context. At that time the only purportedly 'scientific' and widespread research being conducted and applied to the therapeutic treatment of these particular types of psychiatric conditions was in the area of chemotherapy which had little bearing on what I was doing in the art studio. I also discovered that the experimentation with drugs during that era of mental health treatment was often more random than my relatively systematic and orderly investigations of how people could interact with art objects.

The patients were not capable of making introspective reflections on their artworks so I engaged them in the process of reflecting on the perceptual qualities of their paintings and drawings. Based on my observations of the patients I felt that if they could perceive order in the products of their artistic expression, they would experience a corresponding experience of order within themselves (McNiff, 1973, 1974). Since we discussed the perceptual qualities of artworks together as a group, I also surmised that the group would internalize this experience of perceptual order.

My emphasis on the organization of visual perception was a reaction to the severe perceptual disorder that characterized the behavior of the patients in the hospital. Because the patients found it difficult to participate in a conversation with another person, we began to experiment with using their artworks as stimuli for spoken language. I found that patients were more prone to speak about an object they had made than about other objects in the environment. Even with the most withdrawn and chronic psychiatric patients, there was typically some kind of special link between the person and the object which became the basis for treatment.

Reflections on the art objects had a stabilizing influence on the patients. There was a story to be told about how the object came into existence that only

the maker could tell. As we focused on the perceptual qualities of the artworks produced by the patients, there was a distinct increase in our verbal communications. I discovered in my first experiences with creative arts therapy how expression in one medium (visual art) stimulated expression in another (speech). And ultimately talking about art helped to further artistic expression.

The making of art and the discussion of the finished images were modes of treatment that achieved the desired objectives of helping the patients to express themselves in a purposeful and organized way. This increase in perceptual and expressive order served as an antidote to the confusing forces of emotional disturbance. Our objective was not a cure of the disturbances. We wanted to offer the patients a dignified and orderly way of interacting with each other and with the physical world. In many cases I observed that what we were able to achieve in the art studio had a corresponding effect on the overall behavior of the patients.

This early practitioner-research that I conducted with psychiatric patients was largely compatible with behavioral science theory and research methods. The therapeutic objectives and outcomes were behavioral. I identified a certain type of expressive and perceptual fragmentation that I hoped to improve through the infusion of new behaviors into the patients' lives. The pathological behavior was clear-cut and the improved perceptual, expressive, and social interactions were equally apparent.

In my early research with psychiatric patients I was frequently able to document distinct parallels between development in a person's artistic expression and overall changes in behavior. The artistic images offered graphic evidence of change. When a previously isolated and confused person moved from making impoverished and stereotypic images to the creation of elaborate, well-crafted and aesthetically stimulating artworks, we could once again document changes in behavior. The artistic expressions could be approached as behaviors and studied through behavioral science research methods. Change was palpable and measurable (McNiff, 1975a, 1976).

My early practitioner-research could be viewed as a modified version of operant conditioning. By giving patients the opportunity to work as artists within an imaginative and aesthetically pleasing environment, I observed that their behavior and their sense of themselves began to change. They accommodated themselves to the new environmental demands and opportunities. They experimented with novel and healthy behaviors which changed their self-images and ultimately had a corresponding effect on their overall behavior.

With severely handicapped people the treatment goals and measures of improvement are easily observed and defined in terms of behavior. This was

not the case when my creative arts therapy practice began to involve people searching for creative satisfaction and a deeper sense of meaning in their lives. Seldom was the specific objective or goal known in advance nor was it established by the therapist for the person seeking help. The therapeutic experience became a mode of discovery, a journey into the creative process. Because the participants were able to clearly articulate what they liked and did not like about the different things experienced in creative arts therapy, I was able to shift my research focus to assessments of participant satisfaction.

Constant dialogue, together with formal and informal evaluations about the way different aspects of the creative process affected participants, helped me to shape my approach to practice. For example, I discovered that the average person benefits from as much freedom as possible in the process of making art as contrasted to the more disturbed or confused person who needs guidance and structure. When working with motivated people capable of initiating and sustaining expression, I discovered that assigned themes and exercises generally restricted and biased the process of discovery. However, I learned that the structure of the studio environment has a significant impact on the expressive process when people work freely.

In addition to speaking to participants about their reactions to different aspects of the creative arts therapy experience, I was constantly making my own observations of therapeutic efficacy. My conclusions were based upon a mix of information that I received from participants, my personal assessments, and the evaluations of outside observers who visited my studios.

My primary research interest continued to be the exploration of ways of relating to images produced in art therapy. I hoped to provide alternatives to analyzing, labeling, and explaining pictures.

The practice of creative arts therapy has always been my essential mode of inquiry. A major incentive for new experimentation in my personal practice has been the belief that an integrated use of the arts will generate a more animated and satisfying creative experience. Where my first experiences with art therapy focused on helping emotionally disturbed people to experience perceptual order in their artistic expressions, my practice began to shift toward helping people find more imaginative and emotionally gratifying ways of engaging their images.

Explanation of images and literal descriptions of what happened during the process of creation have their place within the process of responding to images in creative arts therapy, but I typically found that when we talked about images in this way we left the realm of creative expression and the feelings that it generates. By contrast, when we responded to art with art, the immersion in the creative imagination was sustained and participants almost universally found

this mode of inquiry more satisfying and illuminating. When they stayed attuned to creative expression, the process of discovery continued because the unexpected emanations of imagination were sustained by different media of expression. By contrast, explanation tended to reinforce what they already knew about their expression.

I discovered that the therapeutic impact of a painting is generally amplified when people respond poetically and creatively to images. Artistic responses to images focus and further their expression. Of course, the quiet contemplation of artworks will always be the primary way of responding to them. But when responding to art within a therapeutic environment with other people, other modes are required. I have found that imaginative dialogue 'with' images (McNiff, 1992) is a way of speaking which significantly deepens our emotional involvement with the object of contemplation. In poetic dialogue the discourse emanates from the heart as contrasted to analytic explanation.

Talking also has it limits and I have learned through my experimentation that responding to images through creative movement enhances their expressive energies in unique ways. Movement responses to paintings by the artist can sometimes help me to understand their expressive intent better than words. Since paintings are kinetic expressions, creative movement is able to establish a closer correspondence to their energetic structures than spoken language which tends to solidify perceptual qualities into verbal concepts. People watching artists respond to their paintings through movement describe how this way of interacting with images 'makes them more three dimensional' and the artists report how the process helps them to know the paintings kinesthetically and through the body.

We also respond to paintings through vocal improvisation, ritual and performance art. These artistic ways of responding to artworks establish correspondences and relationships which activate creative energy. An overall environment of expressive vitality is established and participants internalize its qualities.

I have recently discovered that physical objects made in the art therapy studio have especially potent powers for stimulating ritual, performance, and creative movement. They become props, talismans, and ritual objects. Through practitioner-research we learn more about their different expressive properties and how they affect the people who engage in them.

Movement between media generally has a stimulating impact on expression which has not been systematically researched. Different art media stimulate one another. For example, an art teacher told me how having fifth graders make gesture drawings of yoga positions after practising yoga, has a significant

impact on the expressive quality of their work. The possibility for generating research projects on the synergistic relations amongst art media are endless.

People constantly tell me how they have a much more profound and intimate engagement with their artistic expressions when they respond to them in a ritual way in the presence of other people who provide a supportive and safe circle for their enactment. Ritual and poetic expression do not operate according to linear and literal structures of communication. A basic condition for this 'profound' experience is an unplanned interaction with the artwork which allows for the emanation of significant meaning. If the performance or ritual is totally planned, its results are controlled in advance. There is no room for surprise and unexpected arrivals which are the basis of art. The process of explaining an artwork tends to immediately dissolve the ritual or poetic atmosphere whereas the imaginative response to a person's creation heightens the mytho-poetic spirits and medicines which emerge when we connect these different spheres of experience.

Throughout my career in creative arts therapy I have researched interactions amongst different artistic media. For twenty years I worked closely with Paolo Knill (1995) and other colleagues in established ways of practising integrated creative arts therapy. My orientation to integrative practice was established in my first clinical experiences where I consistently observed how withdrawn patients were stimulated by the process of shifting amongst expressive media. Like the shamanic 'shapeshifter' who passes between different worlds of spirit to restore the lost soul to a person or community, I discovered that movement between expressive faculties animated the person and the environment.

My work in creative arts therapy has revealed that the medium of communication is a substance through which expression is conveyed. In the arts we observe how the material qualities of the particular medium will have a dominant impact on what is transmitted. Expression is always conveyed by the structure of the particular art form. The medium is not simply an agency through which thoughts and emotions pass. It is a major participant in the process of expression and as Marshall McLuhan suggested, it may even be the alpha and omega of the message. Therefore, the physical structures of artistic expression demand that we research them empirically. We can also observe and document the palpable effects that artistic media have on human behavior.

However, expression in any medium draws on emotions and ideas which are not part of its physical structure. The expressive act is always an interplay involving many different contributors. The making of a painting involves movement, touch, ideas, and feelings. It is never a purely visual process. Although the finished painting may express itself completely through its physical structure, the process of creating the artwork always involves varied

sensibilities. I also need these different expressive and perceptual media to respond to a painting. I make a painting and I perceive it through my total range of faculties even though its expression is exclusively visual.

At the present time, my practitioner-research is focused on responding to paintings through movement and sound improvisations. After many years of exploring the use of performance art as a way of reflecting on paintings and carrying their expression further (McNiff, 1992), I am now intrigued with the use of immediate bodily and vocal improvisations, or mini-performances.

Every time I work with a group of people I am experimenting with new ways of responding to images and the participants in my studios are often the sources of new insights into therapeutic and creative methods. I am fascinated with Paul Newham's therapeutic work with the voice (1993, 1998) and I am exploring how sounds and vocal vibrations can respond to the energies and expressions of paintings. Newham feels that it is the highly sensitized medium of sound which takes us into the essence of imagination. He describes the animality that people invariably take on when improvising with sound and how this aspect of the work calls for a safe and disciplined context for expression.

I have discovered how movement and the voice convey subtle thoughts and feelings that are inaccessible to words. These energetic and vibrational communications help me to understand the expression of a painting in new and intimate ways. I experience the expression of the artist in a more emotional and personal way through the timbre of the voice and gestures of movement. The realization that all of our sounds and movements have significance as communications, may help to relax the inhibitions that we are especially apt to attach to these modes of expression. I realize that my practitioner-research keeps expanding toward personal areas of expressive restraint and inhibition because this is where I have always found the greatest creative energy ready to be released and transformed. As I work with others in these areas I am simultaneously working on expanding my own range of expression.

I might mimic the breathing of a figure in a fast moving bicycle and shift to making the sounds of the bike, spinning both arms quickly as if they were wheels.

Sounds can be made in response to non-representational paintings. A person might respond to a bold painting with sounds and movements which express exertion or exhilaration. A delicate painting might be engaged with subtle, soft, and repetitious sounds. Or perhaps I might chose to interact with the bold painting by making soft and subtle sound, highlighting the expression of one medium with contrasting utterances in another. All of these

exercises are always directed toward making contact with the imagination and its expressive medicines.

In a recent studio where an artist was making vocal improvisations to her painting as the group watched, one of the group members expressed an interest in responding to the artist's sounds by trying to 'echo' them. We discussed how these echoes might also amplify or soften the sounds. Two or more people might make sound together in response to the artist or the entire group might echo the sounds as a chorus, all of these responses reinforcing and supporting the artist's expressions.

This example from my studio suggests how innovations in therapeutic technique emerge from practitioner-research. In my early years as a creative arts therapist I kept detailed records describing what I did after every therapy session. I noted variations in my methods together with those elements that remained the same and which ultimately became the basis of my particular style and way of working. I kept portfolios of patient art which were the basis for all of my early publications and theoretical statements about the art therapy process. The therapeutic art studio was thoroughly focused on research without interfering with the integrity of treatment. I actually found that my research interests helped to heighten my observations and my attentiveness to what was happening during the art therapy experience.

Today I am not as apt to keep copious notes on every session that I conduct but whenever something significant happens I do maintain a written record. I actually find the everyday work of creative arts therapy to be a more realistic and useful forum for research than strategically designed experiments, although the latter certainly have a role to play within certain areas of art-based research. Practice continues to be my basis for research and I find that I am continuously changing and experimenting with new ways of combining different modes of expression in order to further the vitality and imagination of studios.

The research that I am describing is always focused on the creation of new methods of creative arts therapy practice. I experiment and assess what works for people, what is most successful in accessing the imagination, what is most effective in transforming difficult and threatening feelings into satisfying creative expressions, and what qualities of the work being conducted indicate directions for future exploration.

My most difficult experiences with practitioner-research have been concerned with my evolving uneasiness with using the creative expressions of other people for my research. After many years during which I did not show the artworks made by other people in my publications and lecturers, a person confronted me about the way I used her dream in a public forum. Although I

felt on some level that no one of us owns a dream, and that once a dream is told, it is in the air and accessible to all, I felt that I had trespassed into a private sanctuary, that I had 'used' something that belonged to another person. This respect for privacy raises many issues in relation to the therapeutic history of case study research and each of us must find a way to negotiate our interests in collecting research data with the rights of subjects.

I remain comfortable with my early publications and exhibitions of patient artwork where the emphasis was placed on their artistic achievements during periods of illness. These research outcomes display the resourcefulness and aesthetic potential of the individual person and the collective human spirit. However, I have never been comfortable showing the contents of another person's private expressions even if releases are signed, names together with other identifying information withheld, and all the formalities of human subject research fulfilled. In addition to the rights of individual persons, I am sensitive to the confidentiality of the images themselves.

After many years of struggling with these issues I began to invent ways of presenting data in art-based research which avoided using other people in any way. My first invention was classically artistic in that I realized that a fictional case study, based on my real life experiences, could be just as effective in demonstrating what happens in therapy as a literal account. I understand that Freud made good use of this technique.

In my book, *Fundamentals of Art Therapy* (1988), the graduate student, with whom I converse throughout the entire first section, is a creation who is a composite of people with whom I have worked. In addition to circumventing confidentiality issues, the fictional method allowed me a broad range of movement. I did not work with illustrations of artworks in this fictional presentation so there were few limitations as to what could be discussed.

artworks introduce a complicating factor although they can no doubt be created fictitiously for public presentation just as I invented a character through narrative. Making the art and telling the story only serve to further the creator's identification with the characters, conditions, and methods being described. There are no doubt many other advantages for both training and research when creative arts therapists immerse themselves in the creation of fictional characters. We use them to deepen our empathy and our ability to understand the range of experiences taking place within a therapeutic context.

The fictional case study might also be a good way of getting beyond the ponderous literalism that tends to pervade clinical work. Creative narratives open up new ways of viewing situations. They enable us to do things that we are unlikely to do in our actual practice of therapy. As we immerse ourselves in the imaginal realm and research its possibilities, new ideas and ways of

practising therapy emerge from the inquiry. Artistic reflection becomes a basis for discovery.

Those who insist on literal descriptions of case experiences might consider questioning the extent to which things presented in a clinical account truly reflect the circumstances of a person's life. We believe that we are giving verbatim reports although the narrative form requires that we fit experiences into its structure and select material which suits its particular way of presenting information.

I do not wish to question the value of discussing actual case materials in supervision, in a class with other students, or within the clinic where the work was done. The concerns that I have with confidentiality are raised whenever private or privileged case materials are presented in a public forum.

I also want to emphasize how helpful fictional case creations can be as a teaching and research tool within clinics and confidential teaching situations where actual case materials are also discussed. The fiction is an art-based mode of inquiry. It helps us to access aspects of experience that may not be available to us within actual situations. When we see ourselves as researching the creative process and the healing powers of the creative imagination, we realize that these phenomena are not limited to the literal life experiences of an individual person.

As I continued to struggle with issues of patient confidentiality and the difficulties involved with using another person's artwork in my research, it occurred to me that I could use my own artistic expressions in my studies. I have described how experimentation with my personal art allows me to engage the therapeutic affects to the creative process 'first-hand' rather than always having to give accounts of another's experience in art (McNiff, 1992). But the most decisive shift in my approach to art-based research occurred when I realized that the object of my research was the process of expression and the objects it generated. I did not have to focus my studies on the reactions of another person. The artistic experience, materials, modes of expression, and images became the phenomena to be examined in my research.

When I am researching my own experience with the artistic process I can take risks, discuss private material, express feelings directly, and move with a relative absence of restrictions in showing what takes place within an experimental situation. I do not have to obtain releases to show my paintings and I can be true to the process in a way that I do not feel is possible when describing another person's experience. It must be emphasized that case descriptions of what another person thinks, feels, and says are always second-hand. I also discovered that the experience of making art and its effects on a person were what I needed to understand.

My research focused on how I could work more skillfully and imaginatively with the creative process. What medicines does it contain? How can I access them most effectively?

I assumed that once I gained this knowledge and skill, I would be able to apply it to my work with others. I felt that the research with process might actually benefit from a degree of separation from applications in therapy.

My experience in supervising the research of graduate students made a significant advance when we began consciously to view the 'creative process' as an autonomous force and the object of our reflections.

The separation of the process as a distinct entity began as a result of thesis students writing about their struggles with it. In this respect the student therapist, like the candidate in psychoanalytic training, benefits from a personal encounter with the procedure being studied. Practitioner-research with the materials and dynamics of art will help us to be more skilled and capable in our work with others.

We do not have to include every aspect of creative arts therapy experience in a practitioner-research project. I can examine the artistic process in my research and work on my sensitivity to other people in a separate training session and trust that the different elements will cooperate with one another when I return to the practice of creative arts therapy.

In addition to the research benefits attached to understanding the creative process as an autonomous force, the therapist in training profits from a personal immersion in the dynamics of the discipline without having to be concerned with the needs of another person. When we connect creative arts therapy research exclusively to clinical work with other people, the wellbeing of the other will always take precedence and we are never free to make the creative process our primary concern.

My many years of educating creative arts therapists have convinced me that first-hand research with the forces of the creative process are a vital element of training and a passage rite into the profession. In my experience it was the student who experienced the most intense conflict with 'trusting the process' of her thesis research who ultimately made the greatest contribution to my understanding of this aspect of creative arts therapy.

As I worked with the student over the course of the academic year, I observed the way in which she became entangled in the often disturbing and discouraging aspects of the creative process. As her thesis advisor and the person who was supporting this type of inquiry, I became caught in the web of transferences and counter-transferences which emerge whenever there is conflict, vulnerability and uncertainty. In this respect, process-oriented research corresponds to the relationship between therapist and patient as well

as the connection between the patient and the art experience. If conducted within an academic setting, this type of thesis research is challenging for both the artist-researcher and the supervisor. Yet my many years of working with students in this way indicates that the benefits of the process are commensurate with the emotional effort extended by both the student and supervisor.

The major learning that emerged from this aspect of art-based research is the importance of approaching the process of creation as a self-regulating force. This perspective on process has a corresponding importance in therapeutic practice. I have learned that my role as a therapist and as a research supervisor involves establishing safe and inspiring spaces where people can undergo their personal relationships and journeys with the creative process. Through my personal research with the creative process, I learn more about its unpredictable ways. I learn that the more I can trust the process, the more I can support my students and patients in their personal encounters (McNiff, 1998).

The thesis student who taught me the most about the essential element of creative arts therapy made a total commitment to her thesis research and when she became lost in the labythrine ways of creation, her expressions howled with anger. She felt hopelessly stuck and her anger was often directed at me. I sensed that she was saying to herself, 'I trusted him. I have given everything to this work and I am in worse shape than I was at the beginning. It's going nowhere. I'm empty. I've wasted my time. I should have done something more predictable and planned. I want to be told what to do. I need an outline to follow, something certain and regular.'

As the student passed through the alchemical crucible of her thesis investigation, it seemed that the positive effects of the artistic transformation were in many ways proportionate to the energy that she gave to the process. Artistic inquiry rarely follows a linear and certain path. Her research can be likened to a shamanic initiation in which she traveled into the vicissitudes of the creative process in order to know and understand it. In creative arts therapy we have a tendency to emphasize the positive aspects of creation and we don't talk as much about the destruction, dissolution, uncertainty and alchemical breaking apart that are fundamental to the process. We don't give as much attention to the shadows because we are so busy trying to do good things for our patients. If we become personally involved in art-based research, we experience how the deeper transformations of creation often involve a shamanic or Dionysian dismembering of the way we view ourselves and our existence. In keeping with the example of the archetypal shaman, how else can we learn about these processes unless we experience them? Art-based research can be viewed as an initiation for practice.

The engagement of 'process' as an object of research is particularly useful for music therapy, dance therapy, drama therapy and other forms of creative arts therapy which do not result in the creation of fixed entities. Art therapy's advantage in generating permanent art objects also results in a tendency to analyze and label which does not so strongly characterize the other creative arts therapies. Therefore, art therapy may need more process-oriented research in order to realize its full potential.

Process is a force which is shared by all art modalities. It is a common concern in which we generally speak a similar language. If we focus more on process as the object of research, I trust that we will be more prone to look upon ourselves as a collaborative discipline and relax the separations which currently exist between art modalities. The thesis student whose work I have described is a music therapist who also worked with poetry, painting, movement and performance. I sense that her intense focus on process may have been the expression of an effort to integrate her commitment to all of the art forms.

In my classes on art-based research, artistic inquiry became the primary vehicle for discovering the thesis theme to be investigated. I would say, 'What is the theme you are living and cannot see?' We used different art forms as a way of encouraging the emanation of the theme. Even if a student had a clear sense of what the thesis theme was going to be, the artistic experimentation process always provided a new dimension to the inquiry. More typically, people who were 'sure' in advance of what they wanted to do, tended to discover another direction through their artistic expression. In this respect we found it useful to use artistic methods as a way of conceiving the thesis.

The process of art would generally uncover or reveal something different from what the reasoning mind planned. The students liked to hear me say, 'If you write, sing, move, paint and perform, *it will come*'. Immersion in the creative process became a fundamental condition of art-based research.

As I continued to research the use of art as a mode of inquiry in my thesis classes, group collaboration became a major part of the work. Rather than just doing an individual research project, each of the twelve group members were intimately involved with each other's work. The group became a laboratory of the creative process. People worked cooperatively on exploratory artworks, witnessed one another's expressions, constantly gave feedback and support, and collectively inspired one another. Because art-based research typically involves considerable uncertainty and creative risks, it is helpful to go through this process with other people who affirm the objective and universal nature of the challenges. It is reassuring to know that these difficulties are inevitable 'parts of the process' and not just personal afflictions.

Once the student had settled on a thesis theme, we continued to use the arts as ways of exploring how to construct a method of inquiry. Performance art was especially useful. In keeping with my therapeutic use of performance art (McNiff, 1992), the students would be encouraged to plan only the basic theme of what they were going to do. Inevitably, the performance space became an oracle from which new ideas emerged. Insights emerged from the process. Tension, stage-fright, and desire all resulted in a major focusing of energy on the creative process which generated outcomes that could not have been planned in advance. The emphasis was on the discipline of being present and responsive to the forces and insights that would emerge through the process of performance. These experiments underscored how respect for uncertainty and trust in the process are fundamental to artistic inquiry.

These investigations of the creative process affirm that research is not something that we do exclusively at the end of a graduate training program or in a course on research methods. Research is an ongoing aspect of every day practice in creative arts therapy as well as every component of a graduate training program. The model of the practitioner-researcher illustrates how research is a way of being in the world, a way of practice, a way of examining experience. Whatever we learn in our formal research courses, thesis projects, and doctoral dissertations ultimately furthers practice.

One of my most gratifying career moments came when I read an article written by Stephanie Grenadier, a former thesis student, in the journal *The Arts in Psychotherapy*. The article expressed the essence of what I had been striving to do in my daily work with students and patients throughout my career. Grenadier wrote:

> When we abandon the clear-cut formula of current trauma theory, we are thrust into a perplexing tangle of unanswered questions and unclear destinations. We no longer lead; we follow and we don't really know where we are headed. But there is faith. Faith in Psyche's own predilection toward what needs to be or come into being. Faith is not science and it is humble, not arrogant, yet it has its own power. (1995, p.401)

I knew that Stephanie Grenadier was speaking from the authority of her experience. Her convictions about the creative process and her trust in its powers were based on sustained experimentation with patients, herself, and the making of art. Research and practice in all areas of creative arts therapy continuously inform and support one another. The expansion of the research spectrum to include experimentation with our own experience with the artistic process together with the experiences we have with others will initiate a new era of depth in the work. The missing link has been sustained first-hand

inquiry into the creative process and its materials which is then used to further practice and research with others. This loop of connections needs to be encouraged within our training programs and presented as the basis for lifelong practice. In keeping with the idea that new disciplines require innovative modes of inquiry, we can no longer afford to overlook, omit, and belittle the creative arts therapist's direct research with the creative process.

The 'process' of making art is a complex interplay of elements such as memory, imagination, and creative forces which cannot be reduced to what is observed in a person's behavior. Therefore, we are feeling the need to invent research methods which are capable of engaging all aspects of the subject matter. Just as today's physicists are exploring a new quantum logic, creative arts therapy research needs to recognize that the 'creative process' is a living force from which outcomes emanate in unpredictable ways. This approach to the process of creative emergence inverts the most fundamental principles of traditional scientific logic which are based upon control and predictability.

The problem-solving strategies of classical gestalt psychology as advanced by Max Wertheimer might be helpful to process-oriented research (1959). Wertheimer documented how creative problem solving encourages perception of the overall structure of a situation rather than following a linear set of rules and methodological steps. Insights and resolutions occur when we comprehend the structure of a situation and the forces moving within it. In the case of creative arts therapy, many of the structural forces are kinetic and not subject to visual or verbal analysis. They are felt in our bodies and we act on intuitions and nuances. The process moves in ways that cannot be traced according to linear steps and logical rules. Rather than criticizing science for the restrictive vision that fails to appreciate these complexities, we can attribute the difficulty to a limited vision of science.

Although traditional empirical science has defined itself through an opposition to speculation about things that are not literally present, science may prove to be an important ally in finding ways to study the complexities of the creative process. Creative arts therapy needs to align itself with the most imaginative and advanced strains of scientific thought. Why not consider 'reaching' for those frontiers of science which are striving to expand our perspectives of reality? Why is it that we limit ourselves to the relatively linear dimensions of behavioral science rather than emulate the methods and thought of physics? The complexities, contradictions, and subtle movements of the creative process can only be properly investigated through research methods which resonate with their structure.

Literature, like physics, generates cognitive structures and ways of communicating that correspond to the dynamics and frequencies of the

creative process. In my work with graduate students in creative arts therapy, I have consistently observed how they innately turn to poetic expression to convey the complexities of their creative experience. The language and thought of positivist psychology does not correspond to the inner states that they experience during the process of creation. Linear psychological thought analyzes only those aspects of creative expression which fit into its framework. In keeping with Wertheimer's thinking, it does not convey a sense of the overall structure of the situation that is being experienced.

Leonard Shlain believes that 'art precognitively anticipates science' (1991, p.42) by creating images that express the most complex ideas before they are elucidated by physicists. Both artists and scientists create from what Shlain views as a collective imagination that links all ideas.

As students venture more deeply into the labyrinths of the creative process and confront the inevitable challenges of the journey, the reliance on poetic ways of viewing and expressing the experience grows stronger. We begin to see parallels with the mytho-poetic continuities of culture. Mythological thinking and its stories embrace paradox, complexity, and continuous movement and it may be closer to the methods of advanced science than we realize.

To some this approach suggests a reversion to an archaic and pre-scientific faith in spirits that must be propitiated and maintained. There is some truth in the criticism, but we are now looking back at history with a new scientific frame of mind which might be more appreciative of ancient practices. No longer intent on dominating nature, science is now focused on understanding and supporting her intelligence. This is the spirit of inquiry that must pervade creative arts therapy research. The arts offer natural and ancient medicines and transformative powers that we have only begun to access.

As a creative arts therapist I have never followed strict rules of scientific treatment. My way of viewing life and therapy is more poetic and guided by aesthetic values. I 'feed' and 'sustain' a living process and 'trust' that it will find its way to natural and transformative outcomes that cannot be planned in advance. I am a 'keeper' of the therapeutic space which is the primary agent of therapeutic transformation.

Today my practitioner-research is focused on organizations as well as individual people. I am involved in my third year as the provost of a college where I strive to apply the lessons learned from creative arts therapy research. For many years I have yearned to extend the principles of creative arts therapy to community and institutional settings in order to examine whether aesthetic ways of interpreting experience can further productivity and collective creativity. I have been given a new opportunity for practitioner-research

through this position which enables me to test ideas in a senior leadership role. I have always been convinced that what we learn in creative arts therapy must ultimately be returned again to the world and the best way to research these possibilities is through professional practice and application.

As I proceed in my current project I have daily encounters with what Stephanie Grenadier calls a 'perplexing tangle of unanswered questions and unclear destinations' (1995, p.401). I continue to stay totally involved as a creative arts therapist while functioning as a provost. I am exploring whether or not the core principles extracted from my discipline apply to organizational life.

These principles include: creating and keeping a safe space for others; openly engaging and creatively transforming conflict; viewing pathologies and symptoms as significant messages which carry suggestions for change within themselves; letting others come forward to express themselves; believing that people will perfect themselves and their expression when given the opportunities, resources, and proper supervision and support; listening, witnessing, and attending to others and the images they create; cultivating the creative spirit of the organization; showing the creative works of others; and, most important, trusting the process in times of difficulty.

I have a conviction that these creative arts therapy ideals are applicable to institutional life and my experimentation to date supports this belief. As Grenadier, my former student, says, the idea is leading me and I follow it, not really knowing what will happen. There is a hope that this novel experiment will generate significant outcomes such as creative arts therapists realizing that, in addition to clinical practice, we can discover new ways of applying our discipline to the world.

I long to expand the marginalized identity of the creative arts therapist and find ways of infusing what we do into the mainstream of life. Another of my graduate students, Bob Gilroy, completed his studies in creative arts therapy and went on to become a Jesuit priest and he now conducts spiritual direction through the arts, practising and researching a new area of application for our discipline.

Because I have always felt a primary identification with the artistic process, I have never been satisfied with the exclusive identification of creative arts therapy with medical science and its research methods. As a creative arts therapist I want to connect my discipline with all aspects of daily life. I realize that most creative arts therapists will continue to practise their craft in relatively specialized settings, but I am interested in researching the widest possible applications. I want to dispel the assumption that what we do in creative arts therapy is interesting but restricted to an idiosyncratic context which is

perceived as isolated from life. My way of realizing this goal is through real life experimentation. My subject matter is the creative and therapeutic transformation of the vicissitudes of individual, family, community, and organizational life. Daily practice in the world is the laboratory for researching these phenomena.

II

Review of
Art Therapy Research

§

Breadth of Inquiry

If we approach art therapy research from an expansive perspective, defining research as a disciplined inquiry into any aspect of practice, then virtually everything published in the field's scholarly journals and books can be included. In reviewing the first articles and books published on art therapy there is a definite and ambitious research quality which permeates the literature. During the late twentieth century many different types of investigation have accompanied the increasingly systematic professional use of art in therapy. These research activities include: case studies, historical accounts, attempts to understand the communications of art, classifications of different kinds of artistic expression, efforts to correlate particular types of artistic expression with different psychological conditions, attempts to establish therapeutic efficacy, and efforts to discover links between contemporary and ancient uses of the arts in healing.

As we focus more directly on research at this moment in our professional development, it is necessary to acknowledge the considerable achievements of those who established the foundations of the art therapy discipline. Their pioneering investigations and publications offer an important legacy of research from which our current studies emerge. The value of research is always assessed by its presentation and persuasiveness, its results which include contributions to the discipline and the world at large, and the extent to which the research generates new issues for future study. On all of these criteria the inquiries and publications of art therapy pioneers have been most effective.

Because the pioneering studies of art therapists have been conducted according to research methodologies which emanate naturally from the work being done and not according to the prevailing doctrines of positive science, there has been a tendency to assume that we are not conducting research within the profession. In viewing research exclusively as the generation and examination of quantifiable data according to the standards of behavioral

science, we miss the significance of the investigations that have created our profession.

I do not deny that the value of research is closely connected to its use of procedures which are respected by scholars and the professional community. In addition to conducting inquiries which fit the standards of current behavioral science research, I feel that we will benefit by educating the academic community, and ourselves, about the significance of our unique research tradition and methods. Historically, art therapy studies have been systematic, rigorous, keenly attuned to evidence, persuasively presented, and conducted with methods which fit research objectives.

Advanced researchers always instruct beginners to use methods that emerge naturally from the conditions of their discipline and to reject methodological doctrines. This flexible approach to research is reflected in the advice C. Wright Mills gave to young researchers: 'Avoid any rigid set of procedures...let theory and method again become part of a craft' (Mills, 1959, p.224).

Ironically art therapy, which tends to express a sense of inadequacy in relation to research, is probably still close to the ideal of practitioner-research that Mills extols. As a relatively new discipline we have yet to 'advance' to the stage where professional researchers separate the process of investigation from the 'the practice of a craft'. Before making the mistake of trying to become something other than what we truly need, we might reconsider whether or not our profession is already at the place to which Mills encourages social science to return. The primary obstacle to innovative and comprehensive research within art therapy is our own inability to appreciate how theory and method continuously emerge from the unique practice of our craft. The most important step in building a more comprehensive professional approach to research is the acknowledgment of the depth and intelligence of what already exists.

In the art therapy literature 'research' began to be addressed with increasing frequency in the 1980s as graduate programs matured and aligned themselves with the research requirements of psychology and other established methods of conducting mental health research. This almost exclusive identification with the research traditions of fields such as psychology and medicine is the primary reason why we do not fully appreciate the research achievements that continue to grow from within our discipline.

It is interesting to reflect upon whether or not the quality and scope of original inquiries in art therapy have been advanced by this new focus on research as a conscious objective. Research activity may have been more productive and imaginative when it was less institutionalized and still thoroughly integrated with practice.

The increased interest in art therapy research has a tendency, as in other professional disciplines, to separate research from practice since it is commonly assumed that research is a discipline unto itself, carried on by professional researchers. I view the pioneers of art therapy as practitioner-researchers who were always concerned with furthering public understanding of the healing qualities of artistic expressions. These pioneers documented and published their observations, their data, and their theoretical conclusions about the nature of the work they were doing. The early findings were primarily descriptive and they fit within what is currently described as qualitative behavioral science research.

I recommend viewing the foundations of the art therapy research tradition as including activities that may not have been consciously conducted as 'research'. This inclusiveness will have many benefits as we now strive to expand the spectrum of research opportunities. The positivistic bias toward 'research' within our culture results in a tendency to view this activity as something done under experimental laboratory conditions and subject to quantitative analysis. We are apt to restrict the definition of research to projects which are intentionally planned, executed, and presented as controlled scientific investigations.

I would like to see art therapy adopt an inclusive definition of research which expresses an enlarged sense of what the art therapy experience is. What are the phenomena being studied? Is art therapy a process that is totally contained by established psychological concepts and prevailing definitions of psychotherapy?

Many of us within the art therapy discipline feel that artmaking and the forces constituting the creative process are the fundamental elements of a therapeutic use of the arts. If therapeutic practice is directed by these art-based principles, then research activities should correspond to the processes and aesthetic phenomena being studied. I venture to say that most of the essential features of art therapy experience are inseparable from practice. Therefore, there is little material of major significance which can be studied with depth by a person who is not fully engaged in practice of some kind. Sophisticated insights into the nature of the experience require a corresponding sensitivity on the part of the researcher.

One of the major confusions regarding the definition of research in art therapy is that many people feel that 'research' is an activity conducted exclusively by professional or academic researchers who specialize in this work on a relatively full-time basis. In medicine, industry, and academic psychology these professional researchers are supported by grants and investment moneys which are appropriated to support technological innovations which will, one

hopes, improve service and/or increase profits. Because art therapy has until now been almost exclusively identified with the theory and practice models of medicine and psychological positivism, it has been assumed that 'research' is limited to activities that fall within this relatively narrow scientific sphere.

It can be documented that the major innovations and advances in art therapy practice from the beginning of its formation do not emerge from inquiries carried out by professional researchers. Yet we continue to express the need for research conducted according to these conventional ideas, all the while overlooking the true research activities that have been conducted since the writings of art therapists were first published. We have not yet found a way to view the actual innovations within our profession as research.

A more realistic model for art therapy research is Donald Schön's reflective practitioner who constantly explores the significance of whatever occurs within the realm of practice (1983). We might also expand our list of practitioner-researcher role models to include creative artists whose practice is based upon an ongoing process of inquiry in the studio.

There are many examples that currently exist within art therapy which enable us to build a research tradition upon the basis of previous inquiries emanating from the essential practice of the discipline. Rather than moving away from our primary experience in order to accommodate stock definitions of research, I suggest revisiting what we have already done with the goal of extracting its yet-to-be declared research basis. This investigation will be in keeping with that aspect of art therapy experience which finds meaning in unconscious communications. As in the history of scientific discovery, major innovations frequently arise from outside the stated purpose of exploratory activities. Researching the history of art therapy practice and publications will encourage immersion in the core qualities of the profession.

I believe that a liberally defined approach to 'art-based research' has always characterized the practice of art therapy and the literature reflecting upon these experiences.

My sense of art-based inquiry is not limited to the actual use of art by the researcher to investigate the art therapy process. Art-based research includes the use of the creative process as a way of understanding experience and it is defined by its close relationship to the practice of art therapy. In addition to actual creative expressions, art-based research might involve descriptions of art therapy practice, reflections on creative objects with the goal of understanding their aesthetic and psychological significance, investigations of a person's relationship to the process of making art, studies of the art therapy environment, and so forth. In all of these research projects art is embraced as a primary mode of understanding and therapeutic transformation.

Reflections on artistic processes and phenomena are an essential component of art-based research. What distinguishes these inquiries from conventional behavioral science research is that the former do not translate the artistic experiences into theories originating from outside the realm of artistic expression or the practice of art therapy. Art-based research utilizes the methods of art therapy practice as the essential tools for understanding its significance. Since the entire art therapy enterprise is grounded upon experiential interactions between people and images, artistic processes have never been far removed from our research interests.

The basic commitment to art-based research flows directly from the mainstream of art therapy thinking. Judith Rubin has consistently said that the core theory of art therapy will 'emerge from art therapy itself' (1987, p.xvi) and Harriet Wadeson has expressed hope that 'the creativity which is the essence of the profession will be applied to new means of exploration of the human condition' (1980a, p.331). Both of these authors respect what can be learned from behavior scientists but as Wadeson says, 'they are not necessarily sensitive to the special attributes of communication through art expression' (Ibid., p.318). Ideas from other disciplines will always help us discover what is unique to our own profession as well as those features that we share with others. Art therapy has been so successful in understanding others, opening to their influences, and respecting their contributions, that we must now complement this strength with a discovery and presentation of our own unique assets.

§

A Showing of Imagery and Experiences

Before discussing the recent art therapy publications dealing with research issues, I would like to illustrate in this chapter how it is possible to find universal features that characterize all of the different ways of practicing art therapy. My goal is to demonstrate how we can view everything about our profession from perspectives which unite rather than separate practitioners.

No single angle on research can address every aspect of our work. However, it is interesting to observe how every conceivable way of practising and researching art therapy ultimately reflects upon the physical phenomena of the art experience which include art objects, the experience of creating them, and relationships between therapists and clients. No matter how different we may be in our theoretical orientations and the narratives we tell about therapy, we are united in our commitment to making and engaging physical images within a therapeutic relationship of some kind. We all tend to show images in our scholarly presentations and we refer to them in our reflections on therapeutic outcomes. We similarly create narrative accounts of how they were created, how they relate to the emotional composition of the people making them, and how they emerged from a particular therapeutic context.

There appears to be an essential orientation to core phenomena which unites all sectors of art therapy practice. It is also fair to say that every approach to art therapy is to a large extent 'phenomenological' in that the goal of sound clinical practice always involves a commitment to showing visual data and describing therapeutic experiences with the intent of allowing them to speak for themselves as much as possible.

The formative research which led to the creation of art therapy showed many artworks. The early books of Margaret Naumburg, for example, generously display intriguing artistic images. It is interesting how recent periodical and monograph literature is becoming increasing conceptual and

less attentive to the visual image. Naumburg also offered extensive narrative descriptions of her experiences with patients in art therapy.

Interestingly enough, it has been the diagnostic approaches to art therapy which have shown the most consistent tendency to analyze visual data. However, the visual phenomena are reduced to principles of largely unrelated psychological theories. The art diagnosticians identify visual phenomena but quickly transfer them to verbal constructs. Those of us advocating artistically-oriented approaches to practice have tended to focus more on telling stories about the way in which people move through the art therapy experience. We are careful not to label images psychologically but we need to do much more in articulating their visual expressions. The art-oriented researcher might take a cue from the art diagnostician who tends to work exclusively with visual data. However, art diagnosticians might significantly improve the accuracy of their assessments if they begin to pay attention to the dynamics of therapeutic relationships which have been given little attention in their appraisals. Since the art therapy relationship is a partnership between artistic and interpersonal phenomena, we need to find ways to conduct research which engage both elements.

In this chapter I offer a selective sample of art therapy literature and related writings such as those of Rhoda Kellogg and Hans Prinzhorn with the goal of encouraging more research into the perceptual qualities of our work. Kellogg and Prinzhorn demonstrate how to research visual phenomena but they do not address the experiential dimensions of the art therapy relationship and the therapeutic process. Art therapists have for the most part emphasized the latter while paying less attention to visual research. In keeping with the spirit of phenomenological thought, I include mental images, behaviors, relationships, and spaces in this reflection on phenomena. Art therapists, such as Mala Betensky and Arthur Robbins, who focus on visible as well as invisible experiences, have helped our discipline to enlarge its realm of significant data. But even when dealing with inner phenomena we art therapists are characterized by a desire to present experiences. The simple act of showing and contemplating what is made and experienced, so basic to the visual arts, can be viewed as a fundamental element of art-based research.

I also hope that this chapter suggests how art-based investigations apply to all of the different schools of art therapy practice. Although I am constantly experimenting with new approaches to art-based inquiry, the essential dynamics of this method are not new. They are lodged in the history of our discipline.

Every approach to research must familiarize itself with the published literature in a discipline and I believe that an open-minded examination of

different approaches to art therapy will affirm a common commitment to creative inquiry in all sectors of the art therapy community. Through this chapter I hope to demonstrate how an artistic idea or behavior, in this case the process of 'showing', can be traced through many different ways of practice. A focus on the 'things themselves' unifies the different approaches to practice while giving us a more objective view of the varieties of phenomena generated by our discipline.

In this chapter 'art-based' simply means looking closely at the art and other data generated by art therapy. Research methods described in this book which use the artmaking process as a mode of inquiry are simply an expansion of research options and methods. It is inconceivable to imagine art therapy research without its narratives, case studies, and more conventional clinical modes of investigating the work we do. These methods of inquiry complement direct experimentation with the art experience. Each engages different aspects of our discipline. As we approach conventional practices and ideas from art-based perspectives, our research framework will expand. We will discover different ways of assessing what we do and we will open new territory for future research.

§

The practice of art therapy generates a desire to 'show' data on the part of both participants and therapists. The presentation of imagery is a natural extension of the therapeutic process and a primary feature of artistic activity. In showing images produced in art therapy we also reflect upon how they connect to experiences we have with clients in therapy. Art therapy professional presentations are regularly accompanied by slides showing artworks and the distinguishing feature of art therapy literature is the considerable presence of visual imagery. Yet there has been relatively little attention given to distilling the unique research aspects that permeate this process of showing imagery.

The tradition of phenomenology offers art therapy an important link to the psychological discourse on the nature of research. Every art therapy study is apt to show images and other data and there is invariably a descriptive narrative of some kind which paints the picture of the therapeutic process as experienced by the therapist and sometimes by the client, all of which fulfill the primary criteria of phenomenological inquiry. The tendency of many art therapists to view experience through different theoretical abstractions diverges from the phenomenological ideal which strives to 'bracket' explanations, but the constant physical presence of materials and imagery keeps even the most

theory-driven therapists close to the phenomena which truly lead the way in the experience of art therapy.

As art therapists have shown imagery over the years there has been a consistent tendency to attribute meaning to the expressions of others. We frame our presentations of imagery within our particular psychological constructs and typically we use the artistic expressions to advance various clinical and interpretive viewpoints. This occurs because the practice of psychotherapy is couched within a narrative view of reality or *weltbild*. Case studies fit nicely within this narrative world view and this accounts for their preponderance in the creative arts therapy literature. I have likened case studies to stories that we compose to give meaning to experience and in this respect they participate in the process of creation. The process of gaining understanding through personal descriptions of experience is also an essential feature of phenomenological inquiry.

In reviewing the art therapy literature I have discovered little research and few writings dealing with the purely visual qualities of imagery. Art therapists have shown an almost universal tendency to attribute verbal, narrative, or psychological meaning to imagery produced in therapy. We either fit images into psychological categories and labels or we incorporate them into the messages conveyed by our narrative accounts of therapeutic processes. These tendencies are reinforced by the fact that we are communicating through the literary media of books and journals in which color reproductions are rarely available. I predict that the Worldwide Web will change these patterns by enabling colorful visual and multi-media communications to take their natural place in the showing and interpretation of data. The Worldwide Web will be a major catalyst for art-based research in varied fields of study as well as art therapy. The conservatism of previous art therapy research may be largely due to the inability that we have had to show imagery within the traditional textual communications used by academic systems.

If we look 'behind' or 'through' the most traditionally clinical and densely psychological writings in art therapy literature, we will find that they have been composed from a narrative perspective. As a visual art field our *weltbild* has been literary. Biography and linear history have been the primary frameworks for organizing experience. I realize how my own work has fit into this literary and psychological genre even as I have endeavored to expand the spectrum of research to include the therapist's autobiographical and firsthand accounts of experiences with artistic processes.

What would happen to visual art therapy research if we began to conduct studies from a visual *weltbild*? The Worldwide Web offers opportunities to not only show images but it enables us to communicate the process of creation and

interactions between therapists and clients through multi-media. The impatience shown by this new mode of communication for lengthy text may help to activate the visual thinking aspect of art therapy research. Where the traditional text calls forth verbalization, the Internet prefers images and terse text.

I am not suggesting that the narrative mode be eliminated or overlooked as a way of viewing experience in therapy, only that we consider suspending its dominance in an effort to look again at the imagery emanating from the art therapy experience. I can imagine projects that revisit all of the published literature in art therapy from a purely visual basis and which interpret therapeutic 'data' from a new and more aesthetic perspective. When we view these phenomena or data outside the context of the stories authors tell about them or the meanings attributed to them, we discover that they have the ability to speak for themselves. In following C.J. Jung's advice to hold fast to images, the interpreter is challenged to become more perceptive in reading the expressions of the physical world.

The message of phenomenology is for me best conveyed by Martin Heidegger who described how 'the thing things'. Objects and images express themselves independent of the theories and thoughts that we have about them. Our ideas and concepts are ways of relating and responding to the 'thinglyness' of things.

Revisiting all of the imagery in art therapy literature from a visual point of view will offer alternative ways of organizing and interpreting the artifacts. As Hans-Georg Gadamer said, our individual bias is our opening to the world. We have not done enough in creative arts therapy to encourage looking and interpreting from multiple perspectives. We have not even examined our data from the artistic perspective from which they emerged.

A colleague once described a study he did in which dreams were interpreted without any reference to the case histories of the people who reported them. However, the interpretations of the researchers went about fitting the dream imagery into theories and psychological conditions that were based on what I would describe as narrative or literary world views – i.e. the Marlon Brando figure riding the motorcycle in an old man's dream is expressive of the dreamer's youthful sensibility or his longing for youth, adventure, or power. We don't give enough attention to how these interpretations explain visual or bodily experienced images with literary metaphors.

Of course, I value these poetic ways of engaging images and the mix between visual art and literary sensibility is essential to my personal work. I also predict that since the collaboration between narrative and visual expression has been so fundamental throughout the history of art therapy, that

it will continue into the future as a primary feature of practice. However, there is still a pressing need to continuously revisit purely visual expression within art therapy. And while respecting and sustaining the interplay of language and visual image, we can explore alternatives to narrative.

Ironically, those who imagine themselves conducting scientific research with visual imagery typically approach the objects of inquiry from a literary perspective, utilizing the explanatory tools of metaphor and narrative. A more scientific inquiry might focus on structure, kinematics, visual tension and equilibrium, constancies and variations, correspondences, the relativity of perception, and so on. Virtually nothing has been done in the art therapy literature to document the physical medicines generated by the making and perception of art. The pioneering work of Dutch art therapists focusing on the different therapeutic properties of artistic media has been totally overlooked by American art therapists because we have located art therapy almost exclusively within the context of verbal psychotherapy with its narrative *weltbild*. Because the Dutch approach has been closer to occupational therapy, its contributions have been overlooked by art therapists elsewhere.

In the United States our psychodynamic bias has resulted in the absence of attention being given to researching the medicines of media – what the clay does, the different kinds of paint, the varied painting surfaces and sizes, the use of wood versus sand, repetitious expressions versus quick gestures, small exacting expressions versus sweeping movements. The pressure that art therapy has applied to itself to be identified with psychotherapy as opposed to occupational therapy in no small part accounts for the lack of attention given to researching therapeutic properties of media.

Ultimately, our research tradition must sustain the partnership between visual artmaking and interpersonal relationships. In order to meet the needs of the art therapy profession, visual media and psychodynamic qualities must continue to inform one another. I fear that because I draw attention to the lack of attention given to visual expression in art therapy research, the literal-minded person will say that I do not support researching the therapeutic relationship. I am committed to research which addresses the interplay between the two.

Science tries to discover universal principles and it is characterized by the classification of phenomena into different categories. If we look at the attempts to conduct scientific research in art therapy, the classifications of imagery have been done according to narrative- and metaphor-based theories of experience in which the visual image always represents something other than itself. The research of Rhoda Kellogg (1970) and Hans Prinzhorn (1972) offer excellent models for creative arts therapists who want to explore perceptual ways of

approaching the imagery generated in their work. Before providing an overview of how art therapy literature can be perceived as a showing of data, I would like to review the 'visual' research of Kellogg and Prinzhorn. By including these two important researchers into our tradition, we will incorporate their values and methods into future reflections on research.

Kellogg's analyses of approximately one million drawings made by young children are based on structural and aesthetic factors. Her work is phenomenological in that she is always concerned with the visual qualities of her data and their significance within a particular pictorial language. Kellogg distinguishes her research from that of Viktor Lowenfeld whom she sees as attributing psychological meanings to drawings based on the individual child's emotional state. She writes, 'My analysis indicates that the child art has its own discipline, controlled in the child mind by perceptions quite different from those that enable the child to recognize men, women, children, costumes and various human characteristics' (1970, p.100). Kellogg describes how young children are guided by aesthetic and structural principles when they create art and she documents the universal constancy of gestures and configurations which include what she calls 'basic scribbles', 'placement patterns', 'emergent diagram shapes', 'diagrams', 'combines', 'aggregates', 'mandalas', 'sun's radials', 'humans' and 'early pictorials'.

Kellogg can be viewed as a fervent art-based researcher because of the way she strives to correct an imbalance in our perception of children's art. She tries to show people how we rely too much on contemporary psychological trends and theories, as well as culture-based interpretations of symbols to interpret universal and archaic phenomena. We are more apt to project our attitudes and beliefs than study the structural elements of aesthetic expressions. It is sadly comical when distortions in a drawing of a female figure are attributed to the artist's fear of 'The Great Mother' or when sharp edges are seen as expressing castration anxiety. Kellogg describes her irritation with these concerns which obscure an investigation of 'the esthetic compositions per se'.

Rhoda Kellogg describes how art is 'a visual necessity for achieving mental stability' (Ibid., p.235). In art therapy we have been too quick to label her as an 'art educator' or to dismiss her because she 'is not a clinician', perhaps because her findings did not fit contemporary psychodynamic theories. Meanwhile she conducted the most ambitious work ever undertaken in the systematic research of children's drawing and one of her primary concerns was emotional and mental well-being. Kellogg's work and the lack of attention it has received from art therapy illustrate the fundamental problems with art therapy research. Her approach can be viewed as a correction and as a response to the one-sided

avoidance of purely structural considerations by contemporary psychological interpretations of children's art.

Symbolic, poetic, and even highly projective interpretations of artworks have their place within the creative process and within the practice of art therapy. However, when we are functioning within a metaphoric, biographical, or projective mode, we have to be clear as to the bias inherent in our point of view. A careful consideration of Kellogg's research will reveal what we have overlooked in our literature and in our inquiries into the significance of the art therapy experience.

In citing Roger Fry to illustrate why people have difficulty seeing the significance of formal configurations in art, Kellogg gives us the main reason why her work has been neglected by art therapy. Fry described how people unable to appreciate the purely visual expression of images have a tendency 'to translate a work of art into terms of *ideas* with which they are familiar' (1962, p.14). Rather than following the dictum of both imaginative science and art to make the familiar unfamiliar and venture into realms of uncertainty, art therapy research has been more apt to interpret visual expressions according to the most prosaic of psychological conventions. We 'translate' visual phenomena out of their unique context in order to read them according to stock theories of behavior.

Rhoda Kellogg's research of drawings is only the beginning of what can be done in the area of children's art. Her focus was primarily on the qualities of line. Future studies can apply the same systematic analyses to color, painting, sculpture, and other three-dimensional creations. Kellogg offers art therapy research an important model for inquiry. She quotes the philosopher Ernst Cassirer to suggest that the artwork is 'a realm not of living things but living forms' (1954, p.154). We need to understand much more about the expressive qualities of artistic forms and colors in order to further their therapeutic effects.

Art therapy has been more generous in including the research of Hans Prinzhorn into its standard accounts of twentieth-century origins because he collected and studied the artworks of mental patients. However, because his work was primarily concerned with structure and form, it has, like Kellogg's research, drawn little attention from contemporary investigators who have been more concerned with interpreting the personal contents of creative expressions.

After gathering approximately five thousand artworks produced by psychiatric patients in Germany, Austria, Switzerland, Italy and the Netherlands, Prinzhorn's analysis of these data was focused on structural and perceptual characteristics. He was not concerned with the diagnosis and biography of the individual patient, but rather studied the formal qualities and

psychological implications of the images themselves. His method integrated scientific and artistic modes of inquiry. Like Kellogg, his primary concern was the analysis of visual forms and he backed-up theoretical conclusions by showing his data.

Some will complain that Prinzhorn's disregard for clinical information about patients makes his work irrelevant to art therapy. Ironically, this lack of interest in the clinical details about the people whose art Prinzhorn collected may be one of the factors that makes his research so useful to those who want to use the arts in clinical work. Prinzhorn was more interested in what 'the art did' and what creative expressions said about universal human needs and urges. From a research perspective, he examined the artistic variable rather than mixing everything together as we typically do in our case study analyses. He made formal comparisons between the artworks of psychiatric patients and the creations of children and prominent artists. In this respect his methods were more rigorously scientific and objective than the current behavioral science research methods that constantly subordinate artistic imagery to psychological theories and research methodologies borrowed from disciplines that have little expertise in dealing with expressive imagery.

Rather than fitting artistic imagery into pre-existing theoretical frame-works, Prinzhorn generated a simple and comprehensive theory from the phenomena he observed. When we concern ourselves primarily with the biographies of patients as seen through a particular theoretical lens, we are apt to generate endless variations of clinical conditions. In contrast, Prinzhorn, like a true scientific researcher, focused on universal conditions such as the tendencies toward order, ornamentation, and repetition that he observed in patient artwork. He maintained that the creative expressions of psychiatric patients were are manifestations of a universal 'expressive urge' (1972, pp. 12–13) which served as an antidote to the autistic qualities of emotional illness. Where so much of the psychotherapeutic history of art analysis has been exclusively concerned with finding signs of illness in a person's expression, Prinzhorn was more concerned with aesthetic achievements which occurred in spite of the afflictions presented by the disease.

Searches for pathology in artistic expression will inevitably lead to futile attempts to categorize the endless variations of expression. The primary assumptions of art psychopathology theories are unreliable since, as Prinzhorn shows, emotionally troubled people are capable of producing wondrous artworks which compare favorably with the creations of artists and children. These analyses of human differences are incessantly variable whereas the search for more positive and universal outcomes of artistic activity suggests that mentally ill people can use creative expression to transform and overcome the

limitations of their conditions. This appears to be a firm and universal basis on which to build a creative arts therapy research tradition.

As art therapy was being formulated in the United States many felt that a 'creative' approach to art, as opposed to viewing art as 'communication', would undermine the development of art therapy as a psychotherapeutic discipline. This unnecessary dichotomy has lessened the place of Prinzhorn in art therapy history and it has obscured his contributions to a depth psychology of the artmaking process. As the art therapy profession has matured, it has left behind divisions between art as therapy and art in therapy. We can have both and more. The therapeutic relationship includes communications and transferences between therapist and client as well as the medicines of the creative process.

Fifty years after the publication of Prinzhorn's research, Mala Betensky's 1973 book, *Self-Discovery through Self-Expression*, affirms how art therapy is based upon a partnership between artistic and experiential phenomena. Betensky described how her positive and humane therapeutic method gave patients the opportunity to express themselves artistically and transcend autism. This action-oriented aspect of the therapeutic process was comple-mented by the self-discovery and awareness that occurs by reflecting upon artistic productions and then communicating perceptions to another person. Making and contemplating art are the fundamental means of helping people become more conscious of their experience. Betensky's research method was simple and direct in that she offered ten case studies with extensive illustrations of artistic imagery to demonstrate how this three-fold process of expression, discovery, and communication furthered awareness and therapeutic change during therapy sessions with children and adolescents.

Betensky's inquiry succeeds in simplifying complex therapeutic experiences into universal and consistent theoretical qualities and in this respect her work follows the traditional scientific method. She reflects directly on the phenomena of therapeutic experience and extracts characteristics of expression, discovery, and communication that can be found in all positive therapeutic outcomes. Betensky describes her work as phenomenological and one of her primary therapeutic methods involves having patients make art and then describe what they see; the goal is interaction between the person and the physical world. After describing the visual characteristics of the artwork, the patient is then encouraged to make more personal connections. This exploration of individual feelings is in keeping with phenomenological methods since the definition of phenomena includes both tangible and inner images (Betensky, 1977, 1987, 1996). While she shares many concerns with other writers who are utilizing phenomenological research methods, Mala Betensky introduces the tangible phenomena of the visual image and its

process of creation to the psychotherapeutic process. The phenomenological circle is greatly expanded by the creative process and the artifacts it generates.

The significant difference between the phenomenology of Betensky and the research of Kellogg and Prinzhorn is that the former includes the therapeutic relationship as a primary object of inquiry. Betensky integrates the verbally-oriented phenomenology of mental imagery with the more palpable contemplation of the visual image and the artistic act. She shows all of these features in her work.

The realm of phenomena may be larger for art therapists than it was for Kellogg and Prinzhorn, yet we cannot overlook how they have contributed to our ability to research essential elements of our professional practice. We can do so much more to understand the interplay amongst the various constituents of art therapy which include the process of creation, relationships between people, relationships between people and objects, the space, and so forth.

When I began my work as an art therapist with hospitalized adult psychiatric patients in 1970 I found myself engaging patients in much the same way as Betensky. We would make art and then talk about what we saw (McNiff, 1973, 1974). The movement away from autism and into an active engagement with the physical world, other people, and the self was the primary feature of my early art therapy practice. The work with patients elicited engagements with things and it perplexed me why the art therapy profession was so reluctant to deal directly, creatively, and psychologically with these phenomena which were constantly overlooked in a search for hidden meanings and messages.

In *Clinical Art Therapy: A Comprehensive Guide* (1981), Helen Landgarten offers what I consider to be one of the most truly 'comprehensive' showings of art therapy data within a single publication. Although the term phenomenology is never mentioned in the book I believe that this one of the best illustrations of phenomenological and practitioner-research within the art therapy literature.

Landgarten's method involves the presentation of extensive data documenting art therapy experiences with very little interpretive speculation or attempts to fit images into pre-existing conceptual classifications. The author offers one scenario after another, including illustrations of artworks, and she allows them to speak for themselves. She is consistently focused on showing a spectrum of situations which define art therapy practice through their diversity. The manifold phenomena delineate art therapy and not a theory or personal approach to treatment.

Clinical Art Therapy documents what a therapist and her patients did together in a wide variety of situations. The book does not focus on theories but rather 'shows' what occurred as an experienced art therapist encounters

diverse situations and applies her best clinical judgment. The stated purpose of this book is the creation of an instructional text for professionals but it can also be perceived as a research study presenting years of clinical casework. Landgarten's book models the process of practitioner-research in that she helps readers understand how art therapy practice involves sustained observation, documentation, and reflection on the process of therapy and the imagery it generates. Landgarten guides and instructs by researching her experience in art therapy.

We learn about the practice of art therapy by viewing and studying what Landgarten did with her patients. Instruction occurs through immersion in the data. This broad exposure to clinical situations yields a sense of familiarity and understanding which informs future practice.

In her book on *Family Art Psychotherapy* Landgarten once again shows the outcomes of her work in evaluating and treating families who are given a series of art tasks to complete. The tasks reveal communication patterns and other family dynamics. Landgarten describes her method as 'showing a variety' of clinical examples 'within the various types of institutional settings' (1987, p.xix). The seventeen 'points for observation' provided by Landgarten exemplify how art therapists have consistently been involved in empirical research: 'Who were the initiators? Who were the followers or reactors? How much space did each person occupy? Did the members take turns, work in teams, or work simultaneously?' (Ibid., p.15).

In *Art Psychotherapy* Harriet Wadeson also chronicles a wide range of case materials and shows artworks produced in therapy. Wadeson describes how her patients were her most important teachers and that she learned how to practice art therapy 'through the accumulation of experience' (1980a, p.30). When describing how formal training is just the first phase of professional development, Wadeson gives a working definition of practitioner-research by urging the graduate 'to seek out new information, to process new experience, to reflect on previous experience, and to be ever attentive to his or her own personal and professional development' (Ibid., p.29). Research can in this respect be approached as constant reflection on experience and a showing of the results.

The early writings by Margaret Naumburg and Edith Kramer similarly reflect on therapeutic experiences and present outcomes. Naumburg's books present lengthy and in-depth cases studies where Kramer's method, in her influential book *Art as Therapy with Children* (1971), is more anecdotal, using clinical vignettes to illustrate core psychodynamic ideas such as sublimation, defense mechanisms, and aggression. Naumburg's narratives are academic and solidly identified with the psychiatric genre whereas Kramer was able to write

the first art therapy text successfully published in a trade book format (Ibid.). Consequently, the style of Kramer's inquiry is adapted to reach a broader audience and in this respect the expansion of the targeted group of readers begins to change the process of reflection and communication. Nevertheless, the abiding process of contemplating experiences in art therapy and the showing of data have permeated every phase of the art therapy literature.

Margaret Naumburg's detailed case studies exemplify the majority of 'research' activities and publications which fueled the early growth of the art therapy field in the United States. Her book *An Introduction to Art Therapy* (originally published in 1947 as *Studies of the 'Free' Art Expression of Behavior Problem Children and Adolescents as a Means of Diagnosis and Therapy*) is the outgrowth of a research project investigating 'the possible use of 'free' or spontaneous art expression as an aid in both diagnosis and art therapy' (1973, p.iii). Naumburg presents six case studies in which the artistic process is a vehicle of expression in the more general psychotherapeutic experience. Naumburg clearly takes on the persona of analyst rather than artist and her pioneeringartwork had a large effect on the first phases of the shaping of the identity of the American art therapist.

In contrast to Naumburg's psychiatric method of research, the British art therapy pioneer, Edward Adamson, went about his work as an artist working with patients in a hospital studio established in 1946. In the European tradition of Prinzhorn, Adamson collected 60,000 paintings, drawings and art objects made by patients which are on display for the public. Adamson's book, *Art as Healing* (1990), is organized to show and take delight in colorful visual images as compared to the more typical art therapy text in which words and narrative are more dominant. He describes how the artistic images 'speak for themselves' and 'provide a more eloquent testimony' for the healing effects of art. The formal presentation of Adamson's book corresponds to his therapeutic method which echoes Prinzhorn's belief that art is the manifestation of an 'universal human creative urge' through which the spirit treats itself. In his hospital studio, Adamson facilitated an environment in which residents 'were accorded the dignity of helping to cure themselves' (Ibid., pp.1–2). This primary emphasis on artmaking and its medicines resulted in Adamson receiving little attention in the United States during the formative years of art therapy when the dominant concerns were clinical legitimacy, psycho-therapeutic identity, and a reluctance to be associated with creative enhancement as a therapeutic goal.

We can revisit Adamson's work and explore how the relationship with the more general studio environment is an alternative to exclusive focus on the patient–therapist relationship. Adamson can be credited with expanding the

experiential phenomena of art therapy and enlarging the circumference of art therapy relationships.

In accord with the growing therapeutic studio movement in the United States, Adamson felt that he was a keeper of the therapeutic space and creative atmosphere which enabled the medicines of artistic expression to emerge. Adamson perceived himself as an artist working in the mental health field and he exemplifies the ideal of the 'artist in residence' advocated by Pat Allen (1992, 1995). The therapeutic studio movement is based on the belief that creative work in the company of other people generates a transformative and healing energy that finds it way to people in different ways. Patients are perceived 'as artists' (McGraw, 1995) and the studio becomes a therapeutic community of images and creative energies which treats participants through an ecology of forces (McNiff, 1995).

Ultimately, as Adamson says of the art made in his studio, everything generated by the increasingly expansive art therapy literature 'speaks for itself'. Whether the published texts rely largely on words and use pictures as occasional illustrations, or place the primary emphasis on images with words being used to provide simple contextual information, all of the art therapy research models are based on the process of 'showing' artistic and therapeutic outcomes. We cannot escape the phenomenological basis of the art therapy experience. There is a great need for research which investigates the experiential phenomena of a therapeutic studio space.

When I began my work as an art therapist I quickly began to view everything I did as research and I believe that this attitude characterized the work of all the early pioneers. I remember feeling that I was taking some liberty with the word 'research' because it was not conducted in a controlled laboratory but I was pursuing systematic inquiries, supervised by Rudolf Arnheim and guided by his writings. I was doing 'practitioner-research' even though that term would not enter my vocabulary until twenty years later. The essential component of my inquiries involved observing the formal qualities of artworks made by patients in the hospital studio and watching for correspondences between their art and their more general life patterns, thus affirming the essential partnership that defines art therapy. This fascination with phenomena, or appearances, characterizes every worker in the art therapy field in spite of the vast differences that characterize our theoretical approaches to treatment. The 'phenomenological aspect' of the work is a universal quality that we all share. Even those who label and classify artworks according to diagnostic categories are basing their activities on visual characteristics of data.

Ideally, art therapy and the other creative arts therapies will be able to continue the tradition of the practitioner-researcher who explores the

connections between artistic phenomena and the people who make and experience them. Universal and constant research will sustain the creative imagination and the intelligence of practice. When we give research over to specialized professionals, we will be abandoning one of the most distinctive qualities of our tradition. But in order to sustain and improve our legacy we must become more aware of its particular dynamics. Unfortunately, this uniqueness is in danger of being lost through the narrow definitions given to research in graduate programs which are moving closer to behavioral science and away from the distinctive modes of inquiry that have characterized art therapy from its inception. Research pursued according to these external standards often overlooks the core interplay between image-making and therapeutic experience which defines art therapy.

Arthur Robbins has been one of the most consistent researchers of relationships and psychological space within the art therapy experience. In 1973 he introduced the person of the therapist as a rudiment of the art therapy experience. He described the potential boundlessness of the art therapy experience and said: 'The limitation of this journey may well be the therapist's capacity to experience a whole range of difficult and complex feelings that may accrue either from the patient or in himself' (Robbins, 1973, p.184). Robbins focuses on the creativity of the therapist and begins the formative era in the training of professional art therapists during which we have become increasingly aware of how 'one's subjective inner life can affect the develop-ment of a theory and practice of art therapy' (Robbins, 1987, pp.16–17).

Robbins introduced the 'showing' of many new elements into the art therapy literature – the person of the therapist, the therapeutic relationship, and the therapeutic space. He insists that in-depth insights into the unique dynamics of art therapy can only be generated by a person who understands both the processes of psychotherapy and creative expression. Robbins describes how the future art therapist will have a 'keen understanding of the dynamics of the creative relationship' and be capable of a 'deep harmony not only with his patients, his artwork, the community, but also himself' (1973, p.184). The experiential aspect of the therapeutic relationship is perceived as an object of aesthetic reflection by Robbins, thus integrating the two primary aspects of the profession.

The experiences of art therapy require a new research and a new knowledge, especially when the work involves artistic and interpersonal depth. The increased complexity of the art therapy relationship and the skills it demands can be likened to what happens in science when the observer's frame of reference is no longer adequate in understanding new phenomena.

Arthur Robbins' 1973 paper demonstrates how the art therapy researcher can no longer stand outside the therapeutic relationship and observe what is happening. Participation in the process being investigated is required. As we discover from the new physics, the phenomena of the art therapy experience 'are only meaningful in the context of the object's interaction with the observer' (Capra, 1975, p.140). Reality in physics and art therapy is a complicated web of connections amongst participants.

The assumption that fixed meanings of any kind can be given to a human expression or experiential situation belies a reliance on a long outdated scientific view of the world based upon simple determinism and mechanical constancy.

Quantum physics teaches us that interactions between measuring instruments and objects cannot be neglected since they are part of the phenomena being researched (Bohr, 1987, p.4). These advanced principles of physics are strikingly close to what I consider to be common-sense qualities of art therapy practice. It has always felt strange to me that people would be able to overlook how the particulars of a context will always influence experience and the process of interpretation.

Just as Werner Heisenberg made it clear to physics that atomic systems will always be affected by interactions with the apparatus used to observe and measure them, Arthur Robbins called art therapy's attention to the primacy of relational and environmental influences. In physics and art therapy, the world can no longer be viewed as fitting into fixed categories. We now understand that reality is an ongoing process of relationships which as Robbins predicted will be limited chiefly by our ability to engage the possibilities offered by our experience which constantly shapes and reshapes the work we do (Robbins, 1987, p.22).

The polar elements of art and interpersonal relations are inseparable in art therapy. We cannot relate to one aspect of the experience in isolation from others. Robbins focuses on the total context of the therapeutic space through aesthetic contemplation and play. 'I stand on the outside observing and allowing myself completely to be but a small part of what is happening. As I lose some of my conscious control, I constantly seek ways of blending or fusing into this totality. Gradually I discover the various nonverbal roots that can establish this early form of relatedness' (1973, p.182).

Robbins approaches art therapy as an aesthetic process of 'giving form to diffuse energy or ideas, breathing life into sterile communication' (1987, p.22). The play within the totality of the art therapy space that Robbins describes is a professional discipline that is achieved only through considerable research into the process. In his classic *Truth and Method* Hans-Georg Gadamer wrote,

'Seriousness in playing is necessary to make the play wholly play' (1994, p.102). Research that strives to understand the unique dynamics of the art therapy experience may find play to be a more useful form of inquiry than many of the research methods being used today.

Art therapists might consider researching the process of losing themselves in play while heightening their consciousness of the psychological and physical space. For example, Robbins asks himself whether a patient is ready to hear how he is being perceived. Robbins answers his own question in saying, 'Maybe all that is necessary is for me to know deeply what is going on, which will in and of itself be a communication to the patient' (Ibid., p.183). These are the subtle entanglements of the art therapy experience which require a research sensibility which corresponds to their nature. The practice of art therapy involves an ongoing interplay amongst people, the creative process and the environment which call for a new kind of research modeled by the inquiries of people like Arthur Robbins.

We can apply the dynamics of relating to the psychological space of the therapeutic relationship to an engagement of the aesthetic space of the artworks we contemplate. Visual images can be perceived as fields of energy and interacting forces. The literal and highly controlled way in which we have attributed psychological meaning to pictures has obscured their structural and aesthetic expressions. What Robbins says about relating to the psychological space also applies to the contemplation of images – making ourselves small, letting go of 'conscious control,' and becoming immersed in the overall expression of the artwork in order to open ourselves to the energetic medicines of its expression.

Because innovators like Arthur Robbins do not refer to their therapeutic experimentation as research, do we omit their discoveries from our research tradition? Narrow doctrines of research disconnect art therapy from its most important discoveries.

Meditation on the physical qualities of images and spaces (Bachelard, 1994) is a relatively unexplored area for art therapy. As medicine becomes increasingly receptive to the effects of meditation on physical well-being, art therapy might research its unique ability to contribute to this area. In Britain David Maclagan notes 'the paucity of attention given to the actual material characteristic of an image' (1995, p.217). Maclagan feels that an increased focus on physical qualities will have a 'grounding' effect on art therapy and he assures the profession that 'psychological effects' are 'inseparable' from aesthetic considerations. artworks generate and 'show' considerable energy through their physical expression and we have not seriously studied how to access and channel these emissions in art therapy (McNiff, 1995a).

The psychoanalytic orientation to the art therapy experience has been rigorously advanced by Myra Levick's work as a pioneering practitioner and educator. In the training of art therapists we have found that the most fundamental and unique aspect of our professional education involves personal experimentation with artmaking in a context focused on art psychotherapy principles. Levick's 1975 paper, 'Transference and Counter-Transference as Manifested in Graphic Productions', initiates many directions for future art-based research. In keeping with the pattern of showing in the art therapy literature, Levick presents artworks created by graduate students, patients, and herself and she discusses how they express transference and counter-transference feelings. Levick also describes sessions where she draws together with her patients and this method can be yet another focus for art-based research projects.

Levick's paper documents how graduate students learn about transference phenomena through their own spontaneous drawings and paintings. This process of gaining an understanding of essential art therapy principles through art expression, although widely used in training programs, receives surprisingly little attention in the art therapy literature. It is an area which suggests many future research projects which can compare outcomes from art-based learning to verbally oriented instruction. Although our literature is beginning to show ways of exploring and understanding art therapy principles through expressive art modalities, our training programs tend to maintain conceptual separations between the making of art and the study of psychological dynamics. 'Theory' is consistently presented as something other than what we do in making art.

In art therapy supervision I have always focused on the making of art which responds directly or indirectly to feelings and conflicts the therapist is having in relation to clinical work. In her 1975 paper Levick anticipates the primacy that 'counter-transference art' would ultimately have in the training and supervision of art therapists. In discussing drawings that she made in response to her clinical work, Levick describes how her 'spontaneous drawings communicated therapeutic distance and support more quickly than any verbal expressions'. She goes on to emphasize the place of artmaking in the education of art therapists: 'Bringing these transferential feelings into consciousness through drawings facilitates the student therapists' awareness of their own responses and sharpens their recognition of these manifestations in their patients' drawings' (1975, p.215).

The art therapy literature is full of discoveries like the ones Myra Levick describes in her 1975 paper. These insights tend to spring spontaneously from clinical practice conducted according to rigorously systematic and carefully

documented procedures. Publications such as these constitute an important body of research that we must continuously revisit and expand through future experiments. I can imagine hundreds of different and highly useful research projects in which art therapists gain insights into their clinical work through personal artistic expression. In keeping with what Levick describes in her article, we might also assure that personal artistic expression is a feature of art therapy education. If art is sustained as a primary way of knowing in the process of training, it will be more natural to extend it into research. The basis for future research must be established in the every day activities of a training program as described by Myra Levick.

If art accelerates and clarifies the communication of thoughts and feelings in therapy and in the training of therapists, it is reasonable to assume that the same outcome will occur if we apply the creative process to research. We will begin this new application by exploring unknown realms just as we did when first introducing the use of art in therapy. I trust that the results will be as significant in research as they have been in practice.

As we begin to give attention to defining what kind of research our profession needs, I hope that we will seriously consider the work of art therapy pioneers as the basis of future inquiry. Strength, wisdom, and credibility emerge from intact traditions. We can refine what they did, expand upon selected themes, contradict, revise, and start anew, but there must always be an awareness that we are building upon the unique origins of what has gone before us in art therapy practice. Can we accept the most carefully researched work of our founders and leading practitioners as the basis for a research tradition, or do we have to continue going outside ourselves in search for legitimacy through behavioral science? I hope that we will select the former and create theories and methods of research which are truly indigenous to art therapy.

All of the different theoretical approaches to art therapy have an underlying commitment to making art and working therapeutically with the resulting images. This is our unifying, and art-based, core. I suggest that we initiate the new era of research within our discipline by revisiting the most basic ideas about practice. As Thoreau advised, we have to simplify. There are too many things that currently distract us from looking directly at the phenomena of our discipline. As we come to an understanding of the generally accepted principles of practice, an outcome which could comprise a useful empirical research project, we will be better prepared to continue the process of creative discovery through the unique media of our work.

Can we identify simple outcomes which unite every aspect of art therapy practice?

In looking back at the different perspectives on art therapy presented in this chapter I identify three areas:

1. Personal changes, insights, and inspirations gained through meaningful relationships with the process of artistic expression in varied media;

2. Interactions with images and the objects of expression;

3. Relationships with therapists, other participants in the therapeutic experience, and the more general therapeutic space or environment.

In certain art therapy practices all of these objectives are addressed whereas in other approaches only one or two may be engaged. None of these objectives or outcomes reveal a theoretical orientation.

I believe that we can identify essential phenomena of the art therapy experience in a way that transcends theoretical differences. I have tried to illustrate our commonalties by reflecting upon how the making and showing of imagery and experiential phenomena characterize all sectors of our discipline. There are no doubt many other unifying themes to be explored such as the search for meaning in expressive gestures, the encouragement of spontaneous expression, the exercise of imagination, and the utilization of more than one mode of communication in art therapy.

These suggestions for future research require that we begin to examine the discipline as a whole while simultaneously conducting our individual and idiosyncratic inquiries. What is it that we all do? What values and commitments do we share throughout the art therapy community? What phenomena bring us together?

If we can keep these questions in the forefront of our preparations for research, we will move closer to establishing a tradition of inquiry which shares goals and methods.

We must move into a new phase in which we examine the profession as a whole, engaging ourselves, the artistic process, and the dynamics of therapy, as well as our clients and their art, as the objects of systematic inquiry. Art-based research is a way of constantly returning to the phenomena of our discipline with a desire to find new ways of reflecting upon them.

§

Research as a Focus in Art Therapy

During the 1980s research began to be addressed with increasing frequency within the art therapy literature. This increased attention was mainly driven by the large number of masters and doctoral programs that were requiring art therapists to become involved in systematic investigations of their clinical work. In some ways this new direction has brought a separation between research and practice that is unnecessary. I will try to show through a review of key writings in the new art therapy literature on research, how our profession continues the practitioner-research model of the pioneers, albeit with a heightened sense of the research aspect that permeates reflective practice. Perhaps the pioneering writings in art therapy rarely mentioned 'research' because they were too busy researching the phenomena as they worked. An inevitable result of the growth of a new discipline is that there are now increased opportunities for more academic investigations of the experience. A focus on research also brings a respectability and professional seriousness that art therapy desires.

Prior to the focus on research in the art therapy literature many of us published the results of research projects that used artistic tasks as a way of generating data about different psychological conditions (Wadeson, 1980a, p.320). For example, in the early 1970s I supervised the work of a graduate student who was interested in documenting the different inner images that people generate in response to fear. We also hoped to gain a better understanding of how fear motivates artistic expression. Our data included hundreds of drawings made by 188 people including adults, professional artists, mental patients and children. We identified recurring themes in the artwork and we discovered that mental patients were not apt to express more 'pathological' themes than the other participants. People involved in the study also described how the process of making these drawings helped them come to a better understanding of their fears (McNiff and Oelman, 1975).

Although this study ultimately yielded insights into the nature of the art therapy experience, its primary purpose was to 'use' art to understand psychological states and the project epitomizes the utilization of art as data in psychological research. In response both to a critique of my research within the art therapy field and to the challenges of my graduate students, I began to address the issues of how we must explore ways of practising research which correspond to the methods of art therapy practice (1986a, 1986b, 1987b, 1989, 1993).

Debra Linesch has emerged during the 1990s as a major contributor to art therapy research. She has catalogued the different types of research being conducted and, more important, she has encouraged art therapists to use their unique skills as a basis for investigations of the art therapy experience. Linesch describes how art therapists are often uncomfortable with the idea of research because they have not yet realized that there are many alternatives to the methods of Western scientific positivism. Art encourages varied and contradictory ways of looking at the world and art therapy therefore requires research methods which affirm these differences.

Linesch has initiated research projects about the subject of research in art therapy. She explored the way in which research is addressed in art therapy graduate programs in the United States and concluded that there is considerable tension between desires for the use of creative research methods and more traditionally acceptable research procedures. Linesch also documents how students entering art therapy graduate programs do not realize that research can be something other than quantitative scientific analysis. Her study of art therapy graduate programs documented how the case study was the most frequently used research method because of its ability to express the dynamics of the creative process in therapy.

Linesch confirms the existence of a 'complex interplay between clinical training, creativity, and scholarship' within art therapy graduate programs (1992, p.134). She encourages the art therapy profession to establish attitudes and approaches to research which allow for the integration of the creative process and scholarship. The increasing variety of research procedures being explored today within psychology support art therapy's efforts to make its unique contributions to the research community. Linesch affirms this sense of opportunity: 'It is my belief that a wide range of research methodologies offers exciting opportunities for art therapy inquiry. Such a range will allow art therapists to maintain a fundamental commitment to the creative process while engaging in rigorous scholarly work' (Ibid., p.134).

In a paper written with Maxine Borowsky Junge, Linesch incites art therapists to discover their own voices and identities as researchers by utilizing

their metaphoric and intuitive views of reality as the basis for rigorous scholarship (1993). The authors describe how they offer their art therapy graduate students opportunities to study different approaches to research and to then decide which strategies suit their personal interests and styles. Rosalie Politsky repeats this call for a 'more integrated' approach to research 'that is more fully representative of the range of knowledge' embodied by the different creative arts therapies (1995c, p.313).

In their 1993 study Junge and Linesch identify nine different research 'cultures' which may fit with the interests of art therapists.

- *Phenomenological studies* in which the researcher strives to understand the objects of inquiry and experiences as they are lived while minimizing *a priori* assumptions and theories about these things.

- *Heuristic studies* which investigate phenomena with a focus on the inner experience and discovery of the researcher.

- *Hermeneutic studies* which emphasize the interpretive dialogue between the researcher and the objects of inquiry while accepting the inevitable influences of personal, cultural and historic biases. In a 1994 paper Debra Linesch documents how the hermeneutic approach to contextual engagement furthers the interpretation of psychotherapeutic dialogue and helps art therapists see 'where the imagery points rather than what meanings lie behind it' (p.195).

- *Ethnographic studies* immersing the researcher in the particular cultural environment being studied.

- *Empirical/analytic studies* which quantify and measure the objects of inquiry according to the methods of scientific positivism.

- *Action research* which uses the investigation as a way of encouraging change within a particular setting.

- *Comparative/historical research* examining phenomena over periods of time in keeping with the discipline of history.

- *Theoretical research* focusing on the theory as the object of inquiry and striving to create new theory and/or a critique of existing paradigms.

- And finally, *evaluation research* which generally uses behavioral science quantitative and qualitative methods to assess the effectiveness of programs.

This inventory of methods is enormously useful to art therapists who are offered a spectrum of practical possibilities for research. Junge and Linesch emphasize how definitions of acceptable research are embedded in changing

cultural values. Their goal is an expansion of art therapy's perspective on what research can be and they challenge colleagues to become more relaxed, creative, and engaged with the many possibilities for scholarly inquiry.

My experience with the categories of research methods described by Junge and Linesch reveals that they invariably mix and combine with one another. However, it is essential to understand the different aspects of research as presented in the Junge and Linesch essay, and then to use them as required by the particular circumstances of the study. Too often, the theoretical approach dominates the research project as contrasted to the systematic study of a situation or problem with whatever tools further understanding. In the case of art therapy, it is the process and imagery of creation which are the basic conditions of inquiry rather than research theories. If we keep these phenomena at the heart of our investigations, we will no doubt discover that the methods of research will emerge in relation to the needs of the particular study.

The list of categories in the Junge and Linesch essay does not include artistic inquiry, revealing how lists are simply guides to understanding situations in a comprehensive way. They are never totally inclusive. The omission of art-based research also results from the fact that art therapy still relies exclusively on external disciplines in order to define its approaches to research.

Although useful in expanding our ideas about research, operational typologies are only indicators of how many different options we have. Adherence to a 'type' of research should never take precedence over using whatever tools best suit the problem we are investigating. The names that we give these various types of research are fleeting whereas the process of disciplined inquiry persists.

In the 1970s Frances Anderson and Sandra Packard conducted what I consider to be one of the most useful and intriguing research projects published in the art therapy literature. They compared similarities and differences between art therapy and art education (Anderson and Packard, 1976; Packard and Anderson, 1976). How do we label this type of research? Does it fit into an existing category or do we invent a new name such as Comparative Analysis? The placement of the inquiry into a research category might dilute its impact.

Debra Linesch makes another important contribution to art therapy research in a 1995 paper documenting a study in which she explores the attitudes of five art therapists toward research. She documents the art therapists' personal backgrounds in relation to research, the extent to which they integrate research interests with clinical work, obstacles they experience, and factors that sustain interests in research. Linesch explains how attitudes

and *a priori* judgments limit possibilities for research. She describes how her reluctance to give a definition of research caused difficulties in the study but ultimately it was this suspension of meaning that offered a 'fertile ground for the emergence of new understandings of the research experience in the field of art therapy' (1995, p.264).

In keeping with Pat Allen's 1992 paper on the clinification syndrome in art therapy, Linesch documents how narrow, conservative, and insecure ideas about the nature of art therapy scholarship restrict the creation of more imaginative approaches to research. She describes how:

> All five respondents originally held the preconceived idea that research in the field needed to be traditional, quantitative, and reductive. This idea seemed to both dominate and discourage the desire to do research and was reinforced by the interconnected idea, also held by all five respondents, that the art process somehow resists the research process... One (respondent) expressed her frustration that the art process was too subjective and consequently evaded the legitimacy and validity that 'proper' research required. (Ibid., p.264)

All of the participants in the Linesch study described how their research interests are closely connected to their clinical work. This finding emphasizes how important it is for art therapy to support the practitioner-researcher model within graduate training programs so that skills may be developed for use throughout a person's career. The close connections between theory and practice also suggest that research methodologies will ultimately reflect the unique processes used to further understanding within the art therapy experience. However, before art therapy can realize its potential for innovative research, we must improve upon the profession's perception of its ability to contribute to scholarship through its unique modes of inquiry.

In her work supervising masters theses at Mount Mary College in Milwaukee, Lynn Kapitan has experimented with creative ways of reframing the entire research experience in order to encourage confident, enthusiastic, and imaginative projects. She analogizes research to the archetypal process of hunting. Students are trained in the skills of pursuing a moving and elusive quarry. They search in the library and in the field with calculated strategies, imagination, and alertness. Kapitan describes the sense of 'powerlessness' that drives art therapy's insistence that it must prove itself and assure its survival according to the standards of scientific positivism. She uses the metaphor of the hunt to challenge students to re-conceptualize the process of research as something that is instinctive to all of us. In teaching research methods she describes how the search is initiated to satisfy hunger. Hunting is likened to art:

In all forms of inquiry, both hunter and artist use one sense or tool more than any other, and that is the sense of sight or vision. The hunter researcher is disciplined in knowing how to look and look again – at all times, in all circumstances, in all directions, disengaging preconceptions, bracketing off biases, delimiting attention, controlling variables, and bringing all these elements into acute focus. The hunter does not know where and when the critical moment is going to occur, nor what is going to happen. Thus he or she prepares an attention which does not consist of riveting itself on the presumed but consists precisely on not presuming anything and avoiding inattentiveness – in sum, alertness. (1998, p.25)

Kapitan's hunting innovations illustrate how we can use the creative imagination to revision everything about research. She addresses art therapy's need to overcome phobic and unrealistic fantasies which misconceive the research process. Her artistic transformations exemplify how research can extend naturally from experience and the unique qualities of our discipline. Kapitan's vision of research incites me to find a new language as well as unique methods of inquiry. But most important, her re-conception of the entire research enterprise suggests how far we can go if we put aside presumptions and trust the process of creative discovery.

Judy Rubin also acknowledges the problems created by stereotypic preconceptions about the process of inquiry. She encourages art therapists to approach research in 'less esoteric terms' and to discover creative ways of asking and answering questions (1984). Rubin hopes that art therapy will avoid an 'excessively narrow perspective' on research and she suggests cooperation with art education, special education and other related fields. She cites Kenneth Beittel's research in art education (1973) as confirming that 'understanding and evaluating the art process are complex challenges, which need to be tackled with a more phenomenological and less quantitative methodology' (Rubin, 1984, p.185).

The complexity and variability of the art experience, both of which are significantly amplified when linked to the corresponding intricacies of psychotherapeutic experience, may be a primary reason why art therapy has been slow in consciously articulating its own research tradition. Yet Rubin also gives examples of issues which can be measured by traditional research methods. She urges art therapists to conduct outcome research which will validate 'changes that all art therapists feel sure take place but cannot easily communicate without less biased evidence' (Ibid., p.185).

Rubin emphasizes that there are many areas of 'objective' behavior that can be assessed during a therapeutic session, such as the number of times a person

steps away from an easel to contemplate a painting and the number of times a child asks for help (Ibid., pp.184–185). Any number of relatively objective factors can be identified within the art therapy experience and these can be counted and measured within the context of empirical research methods. Quantitative analyses will undoubtedly generate insights and new questions that inevitably emerge from focused and systematic inquiry. Empirical methods of this kind are 'parts' of the total approach to research within art therapy.

Counting brush strokes and the number of times a particular color appears have their place within a comprehensive approach to research. Although many art therapists will not be interested in this type of measurement, I have learned that every conceivable mode of inquiry tends to contribute to the overall enterprise. A statistical analysis of brush strokes may appear to many to offer little direct help to the person receiving art therapy treatment, but I have learned from experience that every sincere study ultimately makes a contribution to the whole.

In an effort to introduce more experimental rigor into the writing of case studies by art therapy graduate students, Marcia Rosal supports the use of 'single case experimental research design' (1989). Patients are observed during a 'baseline phase' and during the 'treatment phase' therapeutic outcomes are documented. Rosal believes that the narrative case study is an 'outmoded and ineffective' way of evaluating therapeutic efficacy because it does not target 'specific behaviors to measure as the dependent variable' (Ibid., p.73). From the perspective of identifying and measuring behavioral change the narrative case may indeed be inadequate, but as Rosal states in her article this method of investigation does make other contributions to our understanding of therapy. Shirley Riley has recently emphasized how narrative and story-making processes are the means through which people construct meaning and 'invent' the worlds in which they live. If the purpose of therapy is viewed as retelling 'old scripts,' then the outcomes of clinical practice are as Riley suggests 'tailored to the individual client or family and to no other' (1997, p.284).

Although some art therapists have used paintings, drawings, and graphic expressions as a diagnostic tool for years, many of these practices have questionable value. These procedures have been conducted in the absence of credible psychological theory and data supporting reliability and validity. Those who persist in presenting assessments of personality through art as the only true research being done within art therapy, have not convincingly addressed the fundamental conditions of empirical scientific inquiry – replicable results based upon random and extensive data; general agreement within the art therapy community that there are ways of linking artistic expressions with character traits; and the existence of uniform and generally

accepted outcome measures which justify diagnostic art practices. In the past, the diagnostic analysis of art has been almost exclusively based on idiosyncratic theoretical constructs which do not originate from the mainstream of art therapy practice. In 1993 Elizabeth Leigh Neale and Marcia Rosal did undertake a review of literature on projective drawing procedures used with children, discussing issues of reliability and validity as well as the many problematic areas related to these techniques (Neale and Rosal, 1993).

When research projects set out to analyze diagnostic art materials in a quantitative manner, they are using valuable methods of scientific investigation to study highly non-objective data. For example, a diagnostic test assumes that drawing a human figure in a certain way has a particular psychological meaning. Studies are then conducted with groups of people to confirm this position. Even though the majority of people in the research group, all of whom have the same psychiatric diagnosis, might draw figures in the same way, there is no objective basis on which we can say that a particular type of artistic image has a definitive psychological meaning. Studies of this kind attempt to quantify interpretations of interpretations. The 'data' are purely speculative.

Harriet Wadeson has said 'that a piece of art does not tell it all' (1980a, p.328) and there are many other signs within the art therapy literature that suggest a correction of the earlier tendencies to approach images through pre-existing theoretical meanings. The phenomenological device of 'bracketing' which involves the withholding of judgment when approaching objects of inquiry, is being widely mentioned in recent art therapy literature about research (Quail and Peavey, 1994; Fenner, 1996). Phenomenology encourages us to withhold the instinct to attach an explanation to experience and to let the image work on our thoughts. Rubin describes a similar approach when she encourages looking '– with an openness that does not categorize or label – at the experience of art therapy, until the central themes...begin to take shape' (1987, p.xvi).

The early art therapy assessments made exclusively through the analysis of drawings and paintings have taken art therapy down the wrong path with regard to outcome data. Laura Burleigh and Larry Beutler conducted a critical analysis of art therapy literature and state that there is no objective evidence gathered from scientific studies that establishes the efficacy of art therapy treatment (Burleigh and Beutler, 1997).

I realize, however, that diagnostic assessment is a vital aspect of therapeutic practice and the art therapy profession has begun to implement art-based methods for clinical evaluation which give careful attention to reliability and validity and which strive to integrate varied theoretical points of view (Cohen, Mills and Kijak, 1994; Knapp, 1994). Although the standardization required

by diagnostic drawing instruments is contrary to the essential dynamics of art, I recognize that there may be benefits to limited use of a standardized protocol in terms of generating comparative data, observing patterns, and addressing issues of reliability and validity (Malchiodi, 1994). However, I urge art therapists exploring links between art and behavioral science research to avoid placing people into categories constructed from the analyses of data, and to be wary of boxing art therapy into a set of compulsive procedures.

The most recent literature on diagnostic drawing assessments is showing a refreshing sensitivity to the entire context of the art therapy experience as contrasted to earlier tendencies to label images according to a particular theoretical construct without reference to the process of creation. There is an increasing realization that an acceptable approach to assessment must be able to include the spectrum of philosophies within art therapy and 'reflect the affective and behavioral changes of the client throughout the session' (Cohen, Mills and Kijak, 1994, p.105). Assessment must ultimately be based on the total context of what a person does in a situation and never on an interpretation of isolated images. Researchers studying the process of clinical evaluation must remember that images can never be given objective and definitive meanings outside the realm of their particular expressions.

I welcome and encourage empirical studies which are based upon procedures and outcomes that represent the shared beliefs of the art therapy community. The lack of comprehensive outcome data may in large part be due to the significant clinical and conceptual differences that exist within the profession as to the very nature of art therapy and its outcomes. I will suggest possibilities for empirical research in the next part of this book and I believe that these studies can be conducted in ways that support and respect the goals of art-based inquiry. As soon as we come to a better understanding of what it is we want to measure, I trust that verification studies can be seen as complementing exploratory research through artistic inquiry. The former mode of research can be geared toward producing evidence of efficacy whereas the latter is a means of discovery. These different approaches to research can be perceived as partners and not as antagonists. We need them both.

The art therapy community as suggested by both Linesch and Rubin has to reframe its ideas about research. Art therapists continuously raise the following five points whenever issues of research are discussed: the need for changes in attitudes about the nature of research; the lack of basic outcome data; the need for methods of inquiry which are compatible with the art experience; the benefits of openness and collaboration with other disciplines; and the realization that practitioner-research may be the most universally useful model of inquiry for the profession.

Art-based research may be conducted in ways that address all of these concerns but first we must establish an aesthetic epistemology which validates what we instinctively know. We have to find ways to communicate the truths that we experience within the art therapy experience. The following chapter offers examples of recent initiatives within the art therapy field which contribute to the articulation of this new epistemology.

§

Artistic Knowing in
Art Therapy Literature

No factor is more important to the future success of art therapy research than the creation of methods of inquiry and a more pervasive culture of experimentation which emerge from the essential dynamics of the art therapy experience. Our research must also continue the profession's commitment to practice as the basis of inquiry. However it is necessary to expand our vision of what practice constitutes. Debra Linesch believes that art therapy research 'is an extremely personal, process-oriented endeavor that needs specific kinds of encouragement to overcome deeply rooted resistance' (1995, p.265). It is the profoundly personal nature of our work, which in my opinion generates an avoidance of the more intimate and reflective inquiries, which will ultimately reveal the essential qualities of art therapy. We are apt to incorrectly view research as impersonal and requiring an objective distance which runs contrary to the nature of the phenomena being studied by a profession whose appeal lies largely in a subjective immersion in experience. Graduate students and the art therapy profession need considerable 'encouragement' in order to realize the fact that research in this new profession might require the kind of personal immersion and self-expression that traditional scientific research discourages. To the extent that art therapy's ways of communicating offer alternatives to analytic, linear, and impersonal methods of therapy, I feel that our research tradition must now begin to catch up with the innovations that characterize practice.

A colleague was just describing to me how she would like to research the issues related to determining when a painting is finished. She was considering using her own artmaking process as a basis for this inquiry and of course this research can be expanded to include the experiences of others. We talked about how statements reflecting upon the process of ending could be recorded at the

completion of each painting. We also discussed how it might be interesting to stop randomly in the middle of a painting and comment on the degree of completion of the work and why it is not time to stop. She described a technique that she uses in art therapy groups whereby one person paints and comments on the process of painting while another person observes and records the reflections. A therapeutic technique of this kind can be transformed into research through systematic application, the generation of data, and the analysis of what takes place with the goal of identifying patterns and other significant discoveries. Whether or not these experiences become research projects is largely determined by the way in which the inquiry is conducted and the goals regarding the communication of outcomes.

When I published two books using my personal artistic expressions as the basis of reflecting upon art therapy dynamics, I crossed a new threshold in art therapy inquiry (McNiff, 1989, 1992). Although Freud used his dreams as subject matter in his research and Jung included his dreams and drawings in his studies, art therapy inquiries had been characterized by strict separations between therapists and clients. I feel that this subject–object dichotomy was in no small part created by the early tendencies of art therapists to evaluate the expressions of others in the search of pathological indicators. Based on the innovative research being done by my graduate students for many years, I felt that first-hand engagements of my own art were necessary in order to gain a more direct understanding of the processes that characterize the art therapy experience. The key shift in this approach to research is the realization that the process of art and its expressions are the primary objects of research. The consciousness of the artist-researcher is a necessary means of understanding these other phenomena.

As art therapy began to see the limitations of being identified as a diagnostic adjunct to primary therapy, more emphasis was placed on the use of art within the psychotherapeutic process. In keeping with the prevalent theories of psychotherapy, art therapists focused on the transferences between therapists and clients, with artistic expression offering opportunities to expand communication in the therapeutic relationship beyond words.

There is more to art therapy than the therapist–client relationship. Our research must also investigate the process of making art and responding to it in therapy. When one views the art therapy process from artistic and archetypal perspectives, the energies of the creative process begin to take on a new importance as agents of healing and therapeutic change. In order to come to a better understanding of these processes our research needs to engage them as directly and immediately as possible, which may not be possible when we focus on the experiences of another person, who is typically a client.

The most decisive affirmation of a new direction in research comes when one sees others beginning to use similar methods. I experienced the publication of a research project documenting Rosalie Politsky's engagement of her own paintings as a decisive turning point in this new way of approaching research through artistic inquiry (1995a). Patricia Fenner later published an account of a research project in she which worked with forty-five images that she made over a two-month period as 'diaristic entries' (1996). She entitled this inquiry 'Heuristic research study: self-therapy using the brief image-making experience'.

The strongest affirmation of a 'first-hand' artistic research came with the publication of Pat Allen's book, *Art is a Way of Knowing* (1995a). After writing two books based on showing and engaging my art, I felt in reading Allen's book that she took the process to another level of directness that I have described as being 'true to the passionate and turbulent movements of the soul in the process of creation'. Allen takes the ultimate step into art therapy research through personal examination of artistic 'knowing'. She shows her paintings and describes the process from which they emerged with the goal of taking art therapy to the core of the art experience. Allen's paintings are spontaneous and direct expressions of emotion. The visceral and animated qualities of the images themselves can be viewed as evoking a new type of complete examination and showing in art therapy research. As I look at Allen's paintings they inspire me to be more direct, open, and immediate in my graphic expression.

Allen models the commitment to expression and reflection on the life that we want to see happening in art therapy. She inspires others to do the same; to express themselves authentically and with a trust that the creative process will take them where they need to go. Art therapists in training as well as experienced practitioners need to keep returning to the personal wellspring of artistic knowing and to research its depths. As an accomplished and experienced art therapist Allen confesses that 'Although I have studied and practiced art therapy for many years, my most significant experiences have come through using materials to discover and follow my own streams of imagery' (1995a, p. xv). She demonstrates through an extended documentation of her artmaking how a personal myth emerges from the sustained process of creation. This exploration of the unknown is an exemplification of what art-based research can be. We learn more about life, ourselves, art therapy and the ways of the creative process.

Pat Allen researches what materials do within the art therapy experience: 'If your intention is clear to use art as a way of knowing, materials will cooperate in an amazing way to serve you' (Ibid., p.14). We create together with the media

and the environment and therefore art therapy needs to become more aware of the extended array of forces participating in the creative process. We don't simply go into ourselves; we work with the total context of creation.

In the realm of method, Allen's inquiry affirms how we rarely know in advance what will emerge from artistic activity but we can trust that the process will generate what needs to be engaged. Through the documentation of her personal experience with artmaking Allen affirms how the creative act enables us to aesthetically contemplate difficult emotions and memories:

> artmaking is a way of dwelling in whatever is before us that needs our attention. There is a universal tendency to turn away from difficulty. Image making allows for staying with something while making that staying bearable through the pleasure available in the use of the materials. It isn't necessary to make a picture about the problem; you have only to form a clear intention to know something and then simply take up the materials and begin. (Ibid., p.17)

Experimentation with the process of interpreting our own art will reveal how images can never be given definitive meanings. Based on her experience Allen concludes that 'to come to an absolute conclusion about an image is to rob it of its power as a guide' (Ibid., p.59). She approaches the image as helper and companion on the journey of discovery. Allen's experimentation confirms how depth occurs in the art therapy experience when we enter the imagination of an image and continue the process of creative discovery.

Pat Allen's inquiry in *Art is a Way of Knowing* is not presented as research and in this respect the book reminds us how the most significant advances in our profession continuously come when we follow and trust the innate wisdom of the creative process. As we become increasingly concerned with research in art therapy, we need to be wary of its potential to interrupt the creative flow of the art therapy process with overly technical methods and jargon which distance us from the language of images. Allen fears that the increased professionalism of art therapy 'robs art of one of it most potent properties, the ability to dissolve boundaries and reveal our interconnectedness with one another, as well as reveal the dignity of our uniqueness' (1995a, p. xvi). As we generate different approaches to art therapy research, we must add *Artistic Knowing* to the top of the list of research methodologies and assure that our professional growth continues to emerge for the core of the art experience.

The artistic method of inquiry used by Allen in *Art is a Way of Knowing* is close to the case study. Where the typical case study views experience from a biographical perspective, Allen's inquiry utilizes the autobiographical genre

which offers distinctly different insights than the narrative account of another person's experience.

In their 1994 research project documenting 'a client's experience' of art therapy Quail and Peavy introduce yet another vitally important frame of reference which allows them to 'stay close to the experience and meaning systems of the client' (1994, p.45). Their research suggests that as the client tells the story of what happened to her during the art therapy process, her awareness of the experience expanded. By telling the story of therapy from the perspective of the client, Quail and Peavy invert art therapy's history of therapists attributing meaning to other people's experience. We need many more of these accounts of the therapeutic experience which help to correct art therapy's historic suspicion of the client's interpretations of experience. Our theories of defence, resistance, and avoidance have resulted in the omission of a primary perspective on the therapeutic experience. We have too often assumed that therapists are more capable of describing what is happening in therapy than clients. This distrust of the client's contribution is based largely on the mistaken assumption that there can be a single and authoritative perspective on the therapeutic experience. We need all of the points of view, all of the different stories and genre, and each will generate information about the total complex of an experience that will never be contained by one frame of reference or one way communication.

Maxine Borowsky Junge's study of images of doors (1994) is one of the most illuminating examples in art therapy literature of how a research project can emerge naturally and simply when one applies different disciplines to the contemplation of a particular phenomenon. The study takes its shape from the image being studied. The author examines images of doorways created by twentieth-century painters and she reflects upon how these artists demonstrate how the only boundaries between ourselves and the surrounding environment are those that we artificially construct. Images of doorways are not encapsulated into assessments about the artists who made them: rather they are perceived as openings to a more expansive practice of art therapy which integrates art history, art, environmental psychology, poetry, philosophy, and architecture. All of these disciplines are focused on the study of the archetypal image of the door.

What strikes me as so real about this inquiry is that Junge is not trying to prove anything. She is striving to deepen our sensibility of the many psychological and physical qualities of doors. The study demonstrates how research can help us expand our understanding of the phenomena we engage in art therapy. Paintings are themselves approached as doorways between inner

and outer worlds. Junge encourages us to study the experience and paintings of artists and to learn more about art therapy from them:

> This inquiry suggests that information from diverse sources and disciplines may offer art therapists knowledge about the essences of relationship between humans and the natural and built environment, and that we can look to artists for how we have lived and how we might live and for insights about our work. (1994, p.356)

Junge's paper makes me realize how infrequently art therapy draws upon artists and their paintings as sources of understanding about the art therapy experience. Art therapists have been known to analyze the work of artists in connection with their studies of psychopathology of expression, but never have I experienced such a direct and refreshing challenge to engage artists as teachers, as guides, who will further our understanding of the deeper mysteries of artistic expression and the significance of intimate spaces. The identification of art therapy with the paintings of Edward Hopper, Alice Neel, Georgia O'Keefe and others, acts a doorway into a new connection to the works of artists that were previously cast in a separate role from art therapy. These separations between art therapy and art are as Junge states in her article 'artificial boundaries' between a profession's perception of itself and the larger landscape of art.

Junge's study of doors can be amplified in many different ways because it uncovers a rich vein for artistic inquiry. Future studies can involve art therapists in exploring the theme of the doorway through their own paintings, creative writings, and performances which will create even more direct connections to the world of art. The imagination of the doorway can be expanded through the study of shamanic literature and practices documented by seminal texts, such as Stephen Larsen's *The Shaman's Doorway* (1977), which document journeys of passage from one world to another. I believe that the power of the Junge study results from its focus on an archetypal image, which combines a particular form with a more universal and interior image that touches a responsive chord in every person's imagination and personal life. This direction can be expanded to include research into the significance of other archetypal images such as windows, bridges, mother and child, and so forth. Many links can be made between these images and other disciplines, as demonstrated by Junge; but the fact that the study is based upon the examination of particular visual images assures that the research process will stay closely linked with artistic knowing.

Maxine Junge's study of the image of the door illustrates how the 'archetypal' method involves a certain way of looking at the world; what I experience as an appreciation for links between specifics and universals. As

Gertrude Stein might say, 'A door, is a door, is a door,' but we amplify the particular image by contemplating its broader symbolic, poetic, cultural, and psychological implications. In their essay 'Images of the heart: archetypal imagery in therapeutic artwork', Judith Kidd and Linney Wix illustrate how art-based research can reflect upon therapeutic imagery from historical and cultural perspectives. I welcome this form of interdisciplinary inquiry which does not exclude psychological and traditional clinical perspectives. As we reflect openly on doors, hearts, and other 'universal' images, the objects of our inquiry will require that we move beyond highly specialized systems of knowledge. The personal significance of the image is actually furthered by an increased understanding of its place in the world.

Kidd and Wix describe how the image of the heart began to appear in the art of their clients and in their personal artistic expressions which they pursued as a way of understanding experiences. The authors were stimulated to establish a 'context' for the heart images. They describe how they explored 'historical research of the heart's appearance in art, myth, literature, and religion' and that this 'research in turn has informed their understanding of heart imagery emerging in client artwork' (1996, p.108).

I encourage research projects such as these because they not only connect art therapy to historical and cultural research, but they invite personal meditations upon the particular image. If the image of the door, or the heart, emerges from both personal artworks and those of clients, we are anchored to immediate experiences as we investigate more global patterns. The research of Kidd and Wix also demonstrates how personal explorations through art can be combined with clinical reflections on a client's art and scholarly research. I am delighted to see the art therapy literature opening to the significance of history, religion, literature, mythology and other cultural disciplines as contrasted to exclusive identification with psychology and medicine.

Research projects focused on ways of working with images can grow from James Hillman's Inquiry in Image essays (1977, 1978, 1979) and Patricia Berry's influential essay offering image-based methods of interpreting dreams (1974).

The core method of archetypal psychology is attributed to Rafael Lopez Pedraza who said: 'We must stick to the Image!' In art-based research we 'want to inquire by sticking to the actual phenomenon (Hillman, 1977, p.67). Precision for Hillman is characterized by attentiveness to the image. In keeping with the discoveries of quantum physics, he feels that scientific objectivity is impossible with this type of research because 'we are always ourselves in the image' (Ibid., p.75). These methods continue Jung's commitment to holding fast to images.

Research with images involves an active engagement with them. It is a process through which the images reveal themselves to us. Hillman and Berry offer many practical methods or 'gadgets' to be used in engaging images, each of which could form the basis of an art therapy research project – 'restatement', 'amplification', 'elaboration', 'exploring intra-relations' (Berry, 1974) and 'contrasting', 'singularizing', 'keeping images' (Hillman, 1978). The research methods of archetypal psychology involve an active 'making' of meaning by exploring the 'particular' qualities of the image in many different ways. This approach to research is focused on the ongoing process of creation and the realization that an image can never have a final and fixed meaning. In this regard archetypal psychology liberates art therapy from its history of labeling images.

Archetypal psychology's methods of engaging 'images' are closely attuned to the phenomenological approach to describing 'experiences' precisely as they present themselves. However phenomenological psychology distinguishes its commitment to 'soft' data, what Amedea Giorgi describes as 'lived and experienced' phenomena (1985), from the traditional scientific exploration of physical things. The experiences of phenomenologists are dependent on language in order to exist as data. In contrast, the study of artistic images and the process of artmaking combine both material objects and experience. Where phenomenology relies upon the verbal description of experiences, art-based research also involves the study of objects which present themselves as data without any dependence upon language. Therefore, 'sticking to the image' in art-based research is something distinctly different from the methods described in the literature on phenomenological research. Art-based research requires methods of inquiry that extend directly from the physical presence of the image as well as the person's experience of it.

Rosalie Politsky's study of disturbing imagery expands art-based research from the dyadic orientation of a person's experience of a physical object to a tertiary interplay of person, object, and social/collective group (1995b). Politsky feels that the offensive imagery expressed by Robert Mapplethorpe and other artists can be viewed as an attempt to transform the 'impoverishment of religious symbols' in the larger social context. She embraces the expressions of 'pathologized' images and examines the needs they convey and their ways of 'ministering to us in an act of last resort' (p.116).

In keeping with the principles of archetypal psychology Politsky approaches the shock effect of artistic imagery as an expression of a desire to communicate, focus attention, and 'breathe new life into the dead or dying symbols of today' (Ibid., p.117). The purposeful way in which a viewer is seized and awakened by troubling images corresponds to how a disturbing

dream focuses attention. This important essay illustrates how the methods and values of our discipline can be adapted to the healing and transformation of the collective psyche. Politsky suggests 'that the presence of dark art is actually functioning as a collective psychic symbol series, which, in portraying the elements neglected by the collective conscious, is providing a curative and healing effect' (1995b, p.116). Like Thomas Moore's study of *Dark Eros* (1990), Politsky's essay challenges the reader to revisit imagery and experiences which we shelve and repress by designating them offensive. I find these explorations to be particularly useful in my practice of art therapy where I have been challenged to see the value of engaging images that I may have previously labeled as morally unacceptable. Art therapists might benefit from research projects which identify and reflect upon the communications of personally offensive imagery. As we encounter, contemplate, and artistically express controversial or repulsive imagery, we will, one hopes, expand our ability to accept their place in art therapy practice.

Rosalie Politsky's exploration of the inseparable nature of collective and individual healing images opens a major frontier for art therapy research and she demonstrates how the discipline can apply itself to the problems of the broader social context. Rather than focusing exclusively on statistical outcomes as a source of social justification, art therapy might consider how creative and provocative research can draw society's attention to art therapy. Just as art inverts and shines a light on disparaged aspects of experience, art therapy research can offer new ways of looking at collective imagery. We bring tools that expand upon art history, social psychology, and other ways of examining cultural experiences.

Rosalie Politsky's study demonstrates how art therapy can enlarge its focus beyond therapeutic treatment within the conventional framework of clinics. Our methods have significant potential for broader social application. The emerging interest in how art therapy can operate within community studio settings is another significant expansion of the discipline's parameters.

Cathy Malchiodi describes how the extended 'time' given to artmaking within a studio environment and the relatively non-directive environment needed to support individual artistic exploration, result in a 'more in-depth experience with the art process' (1995, p.155). She describes how the studio approach contrasts to clinical methods which 'often encourage quickly drawn, rudimentary sketches or hastily pasted collages within a 50-minute hour' (Ibid., p.154).

The increased practice of art therapy in studios offers many research opportunities. Images made in clinical settings can be compared to those made in studio environments. The time factor addressed by Malchiodi can be

researched as well as the effects of environments and spaces. Cathy Malchiodi describes how she was first drawn to art therapy through her personal experiences with artmaking. It would be interesting to explore whether art therapists working in studio environments feel closer to the artmaking process than art therapists working in clinics. Art therapists and clients working in studios might also be asked how they compare art therapy experiences in these art environments to experiences in clinics.

Cathy Malchiodi reports personal satisfaction in 'exhibiting and sharing my work with others' (Ibid., p.155) and she comments on how the studio environment can 'build community' (Ibid., p.156). I believe that the studio approach to art therapy is introducing a new paradigm of therapeutic treatment, closer to the therapeutic community ideas of the social psychiatrist and ecologist Maxwell Jones (1953, 1982) than the conventional strategies of clinical treatment. Through participation in life enhancing environments with other people, we experience change. The studio spaces, the work of other people, the artmaking process, and the images we make, all contain and transmit life enhancing energies that effect change in individuals as well as communities. Art therapy animates and encourages us to go on living with increased vitality generated by the creative process.

I was recently discussing the purpose of art therapy with a group of undergraduate students. We were surrounded by colorful and expressive paintings that they had just made. As I sat there with the students, I was struck by the way in which art therapy virtually ignores the energetic medicines of images, artmaking, and studio spaces. The room where we were meeting was full of vitality and the students were expecting me to talk about art therapy as a way of determining what the pictures 'mean'. I spoke to them about how art therapy offers the medicines of art to people. The images made in art therapy do in fact express things that cannot be conveyed in words, but why is it that we feel the necessity to translate artistic expressions into words and verbal concepts? Why can't we come to a better understanding of how images express themselves in their particular languages? I asked the students to explore how we can more effectively open ourselves to the life-giving energy in the pictures and the space around us.

Pat Allen is currently researching new ways of envisioning the practice of art therapy within the urban community. She describes her experimentation with a studio approach that relaxes and sometimes eliminates the boundaries between staff and patients. The founders of The Open Studio Project in Chicago make art together with participants with the goal of creating an energy that fosters new levels of creative expression, the dissolution of barriers

between people, and the creation of a more compassionate environment. Allen maintains that:

> The primary attribute to an open studio is energy. Energy is drawn into a place by a variety of factors. The main source of energy is generated by the artists working in the space... It has seemed to me that not only the space, not only the materials, but the energy of those working in the space is the crucial, yet ineffable ingredient. Discovering how to tap into creative energy is my primary learning goal at The Open Studio. (1995b, p.164)

Allen describes the work that she and her colleagues are doing within The Open Studio Project as a 'great learning process of experiential research' in which they 'eschew therapy concepts and practices' (Ibid., p.166). They have shifted from the making of 'transferences' to the making of 'art' and this is precisely the kind of bold, art-based research that the art therapy profession needs in order to test itself, renew itself, and establish transformative outcomes that are unique to the art experience.

My personal practice of art therapy has been based in studio settings over the past three decades and I have similarly discovered from my observations and those of the studio participants that the creative energy of the group environment is the decisive factor in creating a safe and transformative environment. The energy has yet to be scientifically measured, but it is palpably present and capable of being experienced. It is a new and vital phenomenon being generated by creative arts therapy practice that needs to be researched through experimental settings like The Open Studio Project. It is intriguing how prominent art therapists in the United States are returning to the studio and the neglected methods of pioneering art therapists like Edward Adamson (1990) who were concerned with the healing effects of art without regard to the particular psychotherapeutic and psychological theories. We are once again giving serious attention to the creation of inspirational studio environments in which groups of people generate a universal creative energy that finds its way to people who are receptive to its influence.

The studio is the appropriate place for research focused on the therapeutic dimensions of artistic knowing and yet there is very little consideration given to studio expression and inquiry within art therapy graduate programs. Our educational standards focus almost exclusively on the theoretical and psychological aspects of art therapy and consequently the studio, the basis of artistic inquiry, is often absent. Both Allen and Linesch suggest that this tendency to overlook the essential styles and methods of artistic knowing are expressions of art therapy's uneasiness with itself.

Increasing numbers of art therapy graduate programs are striving to integrate personal studio work into their studies while strengthening the artistic identities of their students. The place of studio can be augmented when we tie it to research as well as self-expression and learning about materials.

The new research mantra of the art therapy profession can be 'Get thee to a studio'. Go there and learn about how to generate artistic energy; how to gauge its effects on you and others; how to discover your personal style of artistic expression and how to integrate it with therapeutic practice and research; how the artistic expressions of others affect you and how your art influences them; experiment with yourself and your colleagues; explore unfamiliar art materials and work with familiar ones in new ways; contemplate others as they work and welcome new impressions; respond to your art with creative imagination and watch how your dreams interpret your paintings; and through it all keep creating and see how one expression relates to the ones before and after it; identify themes and continuities and discontinuties, and keep all of these things in your creative cooking pot which will continuously nourish and expand your practice of art therapy with others.

As we research our experiences in this way, we can ask the question broached by Rudolf Arnheim, 'But is it science?' (1992). There are many within the art therapy community that may not be concerned with whether or not art-based research is scientific. Yet I trust that many others, perhaps the majority of our profession, do want to conduct their inquiries in ways which are acceptable to the scientific community.

Empirical research tends to yield insights and new information largely as a result of the process of looking systematically and concretely at a particular phenomenon. The reliability of methods of inquiry is critically important in terms of project organization and the credibility of results. But yet we must keep in mind that every question we ask and every research method we follow should leave room for discoveries which may emerge from outside the research project's original frame of reference. Michael Polanyi's classic study of tacit knowing (1966) describes how 'explicit' knowledge in science and relatively closed methods of inquiry limit the generation of new knowledge by blocking access to what we know 'tacitly'. Within the arts, tacit or unspoken knowledge permeates virtually every thing we do. Polanyi makes it clear that the insistence on 'exact' and 'comprehensive' knowledge will result in the eventual 'destruction of all knowledge' (1966, p.20). He describes the 'futility' of the search for 'strictly impersonal criteria' of scientific validity since every inquiry is based on a 'personal' and 'solitary' belief that there is a truth to be revealed. Scientific research proceeds from hints of something yet to be known. Those

outside the realm of science often do not appreciate how significant subjective inklings can be within the process of discovery.

Arnheim's phenomenological approach to research bridges art and science. He feels that researchers must have confidence in their abilities to 'view certain appearances objectively and relevantly' (1992, p.181). Although Arnheim's inquiries have not been subjected to formal experimental tests of validity, he feels that every position he takes should be evaluated and criticized by other scholars. He suggests that his interests in the psychology of art have been too complex to be reduced to 'the level for which we now have experiments' (Ibid., p.181). Rather than avoid the complexities of the art experience and restrict his inquisitiveness, Arnheim has taken the following stance with regard to research methods:

> Without remorse I have settled for the most careful observation and description of which I was capable, this being my definition of science. The ostensive method, the pointing with the index finger, the 'Don't you see that…?' is not without risk, but, particularly in teaching, it has always been my choice. (Ibid., p.181)

In keeping with Arnheim's declaration, Gerald Holton, a professor of physics and an authority on the history of science, documents how important rhetoric is in advancing a scientific position. We are so accustomed to thinking about scientific inquiry as objective and dispassionate that we overlook how forces of persuasion are always required to bring about paradigm shifts within an academic discipline. Holton describes how the impact 'of a seminal paper in science is plainly rhetorical: that its readers come to share the author's excitement… The chemist Dudley Herschbach has christened it "the spiritual effect" of good new science' (1993, p.84).

Holton documents how every innovation in science is advanced by its ability to articulate a world view that supports its acceptance. Those who want to advance the position of artistic knowing in art therapy might give careful consideration to their rhetoric. Art therapy needs to be awakened to its distrust of its inherent genius and creative intelligence. Just as Albert Einstein exclaimed: 'It is a magnificent feeling to recognize the unity (*Einheitlichkeit*) of a complex of phenomena which to direct observation appear to be quite separate things' (1901); art therapists may similarly declare: 'It is a wondrous feeling to realize that all of the creative energies of the art studio (*gesamtkunstwerk*) generate a therapeutic complex which cannot be directly observed from a single vantage point.'

Art therapy must generate more self-confidence and proclaim its 'spiritual effects' in order to advance. If scientific proof is subject to the aesthetic effects

of rhetoric, then it follows that art therapy's experiential inquiries need to bolster their persuasive powers.

§

An Overview of Research in an
Art Therapy Graduate Program

In order to better understand the research interests of art therapists I decided that it would be useful to study the thesis materials produced by a graduate program in which I have no direct involvement in the thesis experience. I selected the art therapy masters program at Ursuline College in Ohio because thesis program activity has been carefully documented since the first research projects were completed in 1989. In addition to its collection of theses, Ursuline produces an annual handbook of thesis abstracts (Ursuline College, 1989–1997). The Ursuline materials offer a database against which I can compare my twenty-five years of supervising masters and doctoral research in art therapy. Sr. Kathleen Burke, Founder and Director of the Masters in Art Therapy Program; generously made the Ursuline thesis documents available to me and she has actively participated in guiding my interpretations of them.

My primary objective in studying the entirety of the Ursuline College thesis program is to gain an understanding of the types of thesis research that art therapy students select when given choices amongst varied options. There are graduate programs that will only allow quantitative/experimental studies because there is a strong belief that this is the only true way to conduct research. Other programs work exclusively within the context of behavioral science methods. The faculty at Ursuline instructs students in different approaches to research and encourage them to select a method that matches their interests. This approach is based on the school's mission as a liberal arts college which encourages diverse ways of knowing. The liberal and open approach to research practised at Ursuline is in keeping with the writings of Junge and Linesch which encourage a wide range of methodologies within art therapy (1993).

Ursuline's relative lack of bias with regard to methodology creates an opportunity to sample student research interests. In my review I examine whether or not the Ursuline thesis data reflect the more general concerns about research that characterize the art therapy community. Is there a particular kind of research that the majority of art therapists consistently choose? Are student researchers truly free to choose research topics and methods even if the school strives to encourage this goal? To what extent does the mode of research instruction shape the student's choice? How are students in a graduate program affected by external pressures and persuasion to produce a certain kind of research?

A review of the thesis abstracts and the completed thesis materials revealed that there are three distinct categories of research taking place within the Ursuline College masters program: narrative case study with individuals and/or groups; a hybrid of qualitative/quantitative inquiry; and heuristic art inquiry.

After reviewing the theses, I interviewed Sr. Kathleen Burke and Katherine Jackson, who teaches the graduate program's research seminar. They agreed with my identification of the three categories of research pursued within their program.

Burke described how all of the thesis materials are essentially qualitative and that the quantitative dimension, which has significantly expanded over the past four years (1994–1997), may result from a new faculty member teaching research methods with a quantitative leaning. Burke said:

> We are doing qualitative research approaches which sometimes include quantitative research strategies. The quantitative methods are typically introduced with the goal of verifying qualitative data. We felt that our program needed more of the traditionally scientific research discipline and we hired Katherine Jackson to provide this in 1994. What you see in the theses chronicles the struggle within the profession regarding research methods. Prior to the arrival of Katherine, there was considerable uncertainty in our program about how to approach research because so many of our graduate students with backgrounds in the arts didn't have previous research training. (1997)

Katherine Jackson is an art therapist who is trained in quantitative research methods and she was charged with making Ursuline's thesis research more 'well-rounded'. Jackson describes how she strives to introduce students to the different types of research activities described in the American Art Therapy Association guidelines for research (Wadeson, 1992). In keeping with the philosophy of the Ursuline program, Jackson encourages students to select the

Overall Total, 1989–1997

Narrative case study with individuals and/or groups	75
Quantitive analysis of therapeutic data	31
Heuristic art inquiry	20
Client case study with researcher's heuristic art inquiry	1
Grand total of theses	127

Totals before and after faculty change 1989–1993, Before

Narrative case study	38
Quantitive analysis of therapeutic data	3
Heuristic art inquiry	13
Total	54

1994–1997, After

Narrative case study	37
Quantitive anaylsis of therapeutic data	28
Heuristic art inquiry	7
Client case study with researcher's heuristic art inquiry	1
Total	73

Annual Totals	1989	1990	1991	1992	1993	1994	1995	1996	1997
Narrative case study	7	8	7	6	10	9	10	12	6
Quantitive analysis of therapeutic data	1	1	0	0	1	4	5	12	7
Heuristic art inquiry	0	1	5	4	3	2	1	2	2
Client case study/researcher's heuristic								1	
Total	8	10	12	10	14	15	16	27	15

Figure 1. Summary of Ursuline Thesis data

kind of research they wish to do. In response to my question as to why there has been a significant shift toward quantitative research after she began teaching in the program, Jackson stated: 'It's my interest and I think students pick up on my enthusiasm, but I want them to know that they can do different kinds of research' (1997).

In analyzing the Ursuline thesis data I came to the following conclusions: the case study has been the pervasive mode of inquiry throughout the history of the thesis program; the values and teaching approaches of faculty members and advisors have a considerable impact on the type of research being conducted; heuristic art inquiry is consistently selected as a mode of research by a particular type of student no matter what the faculty advisor's perspective happens to be.

Fifty-nine per cent of all Ursuline theses written from 1989 to 1997 (n=127) were 'pure' narrative case studies and the remainder of the thesis materials used case study methods in some way (see Figure 1 for thesis program data summaries). This case study method was by far the most pervasive mode of inquiry over the entire course of the thesis program. There was also a relative consistency in the number of narrative case studies conducted from year to year. Before 1994, seventy per cent (70%) of all theses were narrative case studies as contrasted to fifty-one per cent (51%) after this date. However, in addition to the instructional change, the decline in the narrative mode might also be due to the fact that the previous faculty member was more apt to encourage this type of research.

Prior to the 1994 faculty change, six per cent (6%) of all thesis materials utilized quantitative methods as contrasted to thirty-eight (38%) after the change occurred. This shift indicates that a faculty member can have a major effect on the kind of research students chose to do. There was also a statistically significant decline in the number of heuristic art inquiries after the change in faculty. Prior to 1994, twenty-four per cent (24%) of masters theses utilized heuristic inquiry as compared to ten per cent (10%) after the change in staff. Katherine Jackson describes how she comes to art therapy with a background in behavioral science. 'I don't have a background in art inquiry,' she said. 'I strive to prepare students to work in clinical settings.'

In comparing the degree of deviation in the types of studies after the change in faculty, the divergence was lower in the category of 'heuristic art inquiry' than in the area of 'quantitative analysis'. This may suggest that heuristic art inquiry is innate to the experience of art therapy. This possibility is reinforced by the fact that there has been little emphasis in art therapy or behavioral science literature on this type of research as compared to considerable pressure for quantitative studies coming from inside and outside the profession. I

believe that heuristic art inquiry springs naturally from the experience of art therapy and the desire to understand it more deeply.

The Ursuline College thesis data suggest that there are many factors influencing student choices of research topics and methods. These inducements might include: the unique and changing conditions of the graduate program; perceptions of what the art therapy profession views as valid and useful research; the values and needs of potential employers; the existing standards of the broader research community; the personal interests of the students themselves; and the interests of other students involved in the thesis program. I urge an increased commitment to letting students select their topics and methods of research, but with an increased understanding of the competing pressures they face together with the considerable influence that faculty and methods of instruction have on student choices.

Choice does further uncertainty. But Ursuline College has maintained its commitment to varied options as emphasized by Sr. Kathleen Burke: 'We do not dictate the type of research that students do. This is a liberal arts college and students must have intellectual freedom.'

Burke described how she was the primary thesis supervisor and research faculty member in the early years of the Ursuline program and, during this period, the majority of theses were narrative case studies. Before and after the change in research faculty, students have always been free to choose a research method. In spite of this freedom, thesis data seems to conclusively indicate that the style and values of the research faculty member will have a significant influence on the selection of methods, even in an environment which promotes choice. Larger graduate programs which share Ursuline's liberal arts approach to research will promote choice and variety by offering research seminars taught by faculty with different approaches. This is generally difficult to do in the art therapy field where graduate programs tend to be small and focused on moving a single cohort group through a program of studies.

Students at Ursuline take a research methods course that approaches the thesis process in terms of quantitative and qualitative inquiry. Burke believes that all the theses produced in the program are 'art-based' because artistic expression is at the core of every project and methods that do 'injustice to art' are discouraged by the College. Even though art may not be used as a mode of inquiry by the typical researcher at Ursuline, every method of research reflects on artistic expression and art objects. This focus on artistic subject matter and processes is offered by the College as a definition of 'art-based' research.

The Ursuline thesis data conclusively show that no matter what the perspective of the faculty member might be, the case study method continues to be the primary vehicle of research. In this respect, the Ursuline thesis

program is consistent with the national pattern documented by Linesch (1992). Pat Allen and Erin Reeves similarly report that research conducted by their masters thesis students at The Art Institute of Chicago largely consists of narrative case studies (Allen and Reeves, 1998).

In the Ursuline thesis program quantitative methods are often used as a way of analyzing data generated by cases. Heuristic art inquiry also continues to take place no matter how the overall tone of the thesis program fluctuates in terms of the qualitative-quantitative dichotomy. But it can also be argued that the heuristic analysis of the researcher's personal artistic experience is yet another genre of case study.

Burke described how the case study is widely used because it 'fits the reality of what students find workable. It is easier and more natural to write about the work they are doing in the practicum. Research can be an abstract entity for students and the case study makes it tangible and connected to a relationship with another person.' I agree with this observation of the naturalness of the case study which accounts for its pervasiveness in the art therapy literature. When asked for her opinion as to why the case study is so popular with students Katherine Jackson said, 'It is the foundation of the profession. The case study enables students to do in-depth studies of people and their particular ways of artmaking. They can get close to people and learn how to help them.'

Burke observed how strong and committed artists will often select the heuristic mode of artistic inquiry. They have a confidence in their artistic skills and a personal understanding of how the creative process acts as a way of understanding. These students want to engage 'the artist-therapist' dilemma and they are able to tolerate the uncertainty that it generates. The theses utilizing heuristic art methods may be considered to be among the most creative works generated by the program. They show an authenticity of expression together with a commitment to the field of art therapy.

'It is much more difficult to do research through artistic inquiry,' Burke maintains. 'Many students find writing and research difficult because they find security in a "nailed-down" method. It is easier to say why the eyelid is up, down, side-ways. Many feel a need for this type of certainty.' Jackson also emphasized how students desire structure. 'They need directions,' she said.

In encouraging students to experiment with artistic modes of inquiry I have consistently found that the art-oriented thinker is quick to adapt to the creative challenge. In contrast, the person who sees art as a 'tool' within therapeutic practice is generally interested in utilizing standard methods of clinical research. On the basis of my experience, I feel that the choice of research method is significantly determined by the type of person who is conducting the research. The philosophical orientation of the student-researcher tends to

exert as much influence on the selection of research methods as the persuasive effect of the teacher or supervisor.

Quantitative research methods are most effective when generating and interpreting data that help to inform art therapy practice. I have less regard for the value of studies in which the formalities of statistical analysis give the illusion of objectivity to highly speculative theoretical positions upon which interpretations of data are based. We need to focus quantitative research on how the practice of art therapy influences what the profession as a whole views as valid outcomes and conditions. This common sense approach to quantification will avoid confusing helpful methods of inquiry with abstract research goals and idiosyncratic ideas. For example, one quantitative Ursuline thesis counted the number of verbalizations made by a group of 'older adults with mental retardation' before and after an extended series of group art therapy sessions. Verbalizations during the sessions were also counted. The researcher's goal was to determine whether or not art therapy furthers socialization (Larew, 1997). The methods of this study are grounded on solid principles of practice that have a far better chance of meeting universal standards of reliability and validity than quantitative analysis of the results of a diagnostic drawing test making assessments on the basis of a researcher's interpretations of how a subject uses colors or draws a picture of a person picking a pear from a tree.

The overwhelmingly consistent use of case study materials by Ursuline College student researchers suggests that reflection on 'cases', or therapeutic situations, is basic to art therapy practice. This observation coincides completely with the art therapy literature. The fact that quantitative research methods are commonly used to analyze case materials reinforces this primacy. Rather than moving away from the case study to achieve an expansion of art therapy research methods, it may be more productive to expand our definition of this form of inquiry.

The Ursuline College thesis outcomes indicate that students will select from among research models that they know and understand. These models are typically presented to them by faculty. The Ursuline data reinforce for me how important it is for our profession to explore and promote innovations in art-based research. We have to counter pressures for quantification with the insistence that there are many essential elements of art therapy that cannot be quantified. A rigorous research tradition in art therapy cannot be built exclusively through measurements. The proven popularity of the case study and the inherent disposition toward this type of inquiry reinforce the need to teach other methods of research in order to augment possibilities for innovation. Sr. Kathleen Burke described how, 'We not only need to do

scientifically valid research but research which grapples with and explores the in-depth qualities of the creative process'.

I predict that once art-based research becomes better known and recognized, the range of artistic inquiries will greatly expand beyond the realm of self-inquiry and the use of the currently recognized 'qualitative' mode of 'heuristic research'. I also predict that greater numbers of art therapy graduate students will freely choose art-based methods of inquiry if the merits of this way of working are conveyed to them through courses in research methods. Student-researchers, like every group in society, respond to pressure, persuasion, and instruction. The 'case' needs to be made more convincingly for art-based research.

In keeping with the national trends reported by Linesch (1992), the majority of art therapy research projects that I supervised for many years used the case study method. During the past ten years as I have actively explored and encouraged art-based research, this way of working has been embraced and advanced by my students. No doubt this shift is a reflection of my personal commitments and interests as a supervisor and I do not recommend the institutionalization of a individual perspective. Ursuline College's commitment to presenting students with different options for their research projects reflects the mainstream values of the art therapy community. The history of the Ursuline thesis program also illustrates how instruction and faculty values can contribute to the expansion of choices. As we articulate and refine the practice of artistic inquiry as a useful and respected mode of investigation, I trust that it will take its place within a 'well-rounded' approach to research supported by the entire art therapy profession.

III

Research Ideas
and Methods

Like many art therapists, what brought me to this profession is the powerful and personally fulfilling experience of artmaking... I don't believe that we will come to many favorable conclusions about the efficacy of art therapy until we recognize, investigate, and honor the unique properties of artmaking and how artmaking is best presented in service of our clients. Identifying the efficacy of art therapy will come from deeper understanding and exploration of media, the art process, and therapeutic space, and how we define these as artists. The answers to our search will not come from our clinical expertise alone, but rather from our knowledge of art and from an intimate, personal connection to our own artmaking.

Cathy Malchiodi, 1995.

§

The Method of Discovery

The most consistent problem I face as a supervisor of graduate level research is the eager student who comes to me prior to the course of study with a completed research project design. I characteristically affirm the student's initiative while suggesting that more time be taken to reflect upon possibilities for study. I realize that the deductive methods of behavioral science encourage researchers to know the parameters of their research before they begin whereas creative inquiry typically discourages 'being at the end when you are beginning'. I try to explain to students, interested in either scientific or experiential research, how a more original and workable idea is likely to emerge from a period of incubation and from exploratory dialogues with supervisors and peers. In reflecting upon scientific inquiry Michael Polanyi described how the more 'profound' realities are those which 'reveal themselves in unexpected ways in the future' and which have a 'significance that is not exhausted by our conception of any single aspect of it' (1966, p.32). Interestingly enough, it is the great scientists who consistently draw attention to the limits of narrow scientism.

Deductive methods have many benefits when it comes to organization and procedural predictability. The particulars of the study are determined in advance together with a hypothesis as to the eventual outcome and the major theoretical issues. Students typically write outlines of what they plan to do, what their research method will be, and so forth. The difficulty with this approach in relation to art-based research is that the creative process typically emerges in unexpected ways from the attention we give to objects of inquiry. This is a major distinction between traditional science and experiential research with the former approach being calculated and planned down to the smallest details and the latter employing a process-oriented mode of discovery. By contemplating phenomena we activate their ability to communicate with us

outside the bounds of a deductive scheme. The objects of inquiry and the methods of engaging them are revealed through our interactions with them.

I have emphasized throughout this book how focusing on discovery and emanation in certain research projects does not suggest an opposition to traditional deductive methods. It is a matter of selecting the right method for the particular problem. Amedeo Giorgi describes how 'the methods of natural science were invented primarily to deal with the phenomena of nature and not experienced phenomena' (1985, p.1), the former being subject to direct and objective measurements. There are many aspects of art therapy experience that can be counted and mathematically analyzed and I trust that we will never abandon the use of quantitative research methods in situations where this may be the preferred mode of inquiry.

I have always found it useful to talk with students about varied possibilities for research. I encourage them to explore different interests and to see if the original idea sustains interest after exploring other possibilities. I ask students to discover 'the thesis you are living and cannot see'. I tell them that they probably have an expertise in one or more areas, a special experiential knowledge that is unique to them. I describe how this personal intelligence can be a primary resource during their thesis research. I strive to help the researcher build a study upon the authority of experience rather than become involved in an academic exercise with little direct connection to their personal histories. In addition to knowledge acquired from professional literature, courses of study, and research activities, each of us brings a wealth of life experience which can build confidence and support us in taking innovative and distinctive positions.

Because the process of finding the right idea for a thesis is a personal as well as an intellectually rigorous exercise, I attach considerable importance to this phase of the research project. I encourage students to relax the need to arrive at quick and premature closure. It is better to 'cook' with an idea, discuss it thoroughly with others, test it through preliminary experimentation and keep options open for other possibilities and revisions. The idea that survives this exploratory process tends to be augmented and refined by the give and take with others and it is more likely to sustain the researcher's commitment through the inevitable periods of uncertainty and doubt that arrive at various phases during the extended course of inquiry.

My experience with art-based research suggests that the method of inquiry is the most important sustaining factor through the extended process of investigation. Ideas emerge from the method which is the experiential bedrock of inquiry. In my work with thesis students I encourage empirical work with the art experience, likening the studio environment to a laboratory. I demonstrate through examples of previous research projects how everything

will emerge and fall into place once the method of inquiry is established. Since the fruits of the creative process tend to arrive unexpectedly, it is essential to establish a methodological structure which will define and contain data within a purposeful context.

Theoretical explanations, practical applications, and comparisons to the work of others, will emerge naturally from the experimental work in the studio. When our research is pursued according to a consistent method, we are always working in partnership with a physical and external structure which ensures an objective and empirical focus for the inquiry. The method carries us. In this respect, the way of conducting research corresponds to the workings of the artistic process in which the use of media affects the final outcome.

As a general rule, a simple and clear method of inquiry will give the creative process the opportunity to move freely and imaginatively. I say to my students, 'The simpler, the deeper'. A clear structure gives the artist-researcher a sense of security and constancy which tempers the inevitable precariousness of the creative process.

In the practice of creative arts therapy I similarly find that there must be a structure which offers a sense of safety to participants. If I am to take risks with creative expression and 'trust the process', the overall environment must generate a sense of purposefulness.

For example, in my research with the process of dialoguing with images, I began with the idea that I needed to investigate alternatives to responding to paintings with descriptive language (McNiff, 1992). My exploratory research focused on the process of interacting with paintings through poetic and imaginative dialogue and I discovered during this experiential and aesthetic inquiry that my relationship with the paintings became significantly more intimate. The outcome of this experimentation was a closer relationship with my paintings. I accessed new qualities through imaginal speech and reflection. None of these outcomes were suggested in advance of the process of inquiry which was an ongoing experience of creative emergence. I noticed and actually 'felt' conversations shifting from the head, or thinking mind, to the heart. The process of inquiry can be likened to an environment which continuously acts upon the researcher and shapes ideas. In this case, the method was relatively simple, consistent, and capable of sustaining exploration over an extended period of time. I made paintings and then engaged them through imaginal dialogue which was recorded, transcribed, and edited.

In my editing of the dialogues I took artistic liberties with the text and treated it as a piece of creative writing which I shaped in order to achieve the maximum expressive effect. My goal was not literal transcription as practised in behavioral science research. In art-based research, we are creating throughout

the process of inquiry, responding to an artistic work with artistic reflection and expression. I approached the text as a poetic statement and I sometimes made changes in the creative dialogues because I wanted them to have the qualities of natural conversation. In this case, accuracy is perceived as the best possible expression rather than as a verbatim account.

I realized after concluding my inquiry that the method was close to C. G. Jung's practice of active imagination which focuses on 'dreaming the dream' onward and inward. The impetus for my inquiry was the desire for a more satisfying and creative way to reflect upon paintings. The outcome of increased intimacy was not planned or pre-conceived. I also discovered how this way of responding to paintings made me more aware of the structural and visual qualities of the image. Enhanced perceptual awareness came from the deeply focused attention and looking that accompany the process of dialoguing with an image. The entire experience is characterized by depth, probing, and surprising discovery as contrasted to facile interpretations of images according to pre-existing theories.

This art-based inquiry can be extended at some point into a research project which measures outcomes. A researcher might compare the experiences that people undergo when talking 'about' their paintings and then compare these results to those experienced in the process of talking 'with' pictures through imaginative dialogues. The study might explore the extent to which people establish more intimate and perceptually aware relationships with the art through poetic and imaginative dialogue.

Experiential and behavioral science methods can work together. The former tend to be a creative mode of discovery and the latter are typically oriented toward the measurement of outcomes. We might discover something of interest in our personal artistic expression and then apply this to work with patients or vice versa. As a young art therapist, I discovered that the patients in the state hospital where I worked had a significant influence on my personal artistic expression. They taught me how to paint through example and they affected me more profoundly than the art I was studying in museums. The way in which the art of art therapists is influenced by the practice of art therapy is yet another possibility for outcome oriented research, experiential inquiry, or a combination of the two.

As a researcher I am interested in discovery. I tend to achieve insights in an experiential way, through what Hans-Georg Gadamer calls the 'genuine truth' of aesthetic understanding (1994, pp.83–84). When I ascertain something in this way, I generally do not need quantitative verification to affirm my belief. I realize that others may be more interested in examining outcomes through experimentation and measurements. A quantitative research project could

respond to my experimentation with creative dialogue and gauge participant satisfaction with the imaginal method of engaging images as contrasted to descriptive speech.

All of these ideas and possibilities emerge from 'the method' of approaching images in a particular way. I am currently expanding my experiential research by experimenting with voice, movement, and performance as creative ways of responding to paintings. I am discovering, through these more kinetic and physical interpretations, that I begin to see and engage the paintings as expressions of energy as contrasted to the more language-based perceptions that typically emerge from therapeutic conversations. The process of inquiry shapes the content of thought and the ideas that emerge – yet another reason to keep art-based research open-ended with the primary focus always on the method of investigation.

As we discover new facets of the art therapy experience through these inquiries, possibilities for measurement and new directions for experiential investigation multiply. For example, the perception of visual images as energetic fields opens a new frontier of discovery for art therapy. How effective can I be in opening to the energy of the painting? How does the energy influence me? How does the energy change as I change my thoughts and perceptions? As I alter my spatial relationship with the image? Over different time intervals? Can we start to view paintings and their energetic forces through the discipline of physics? Why do we rely exclusively on psychology as a way of engaging and understanding these physical phenomena? How do these observations apply to the practice of art therapy?

As we de-psychologize our interpretation of paintings and view them from different aesthetic perspectives, we discover new openings into their expression. The perspective of psychology has a constant and formative role to play in art therapy, but it can become ponderous and limiting when it is not complemented by aesthetic imagination. The persistence of conventional psychological analyses of art in therapy is largely driven by the assumption that patients and mental health systems will not accept approaches that operate outside this paradigm, a belief that has never been seriously challenged within the art therapy field. We have not asked the direct and basic questions that may prepare the way for different ways of approaching art therapy. How open are our patients in psychotherapy to different modes of treatment? How precisely do we connect the methods of treatment with assessments of needs and outcomes? Have we ever seriously examined the physical and energetic medicines conveyed by the making of art and the contemplation of images?

§

Practice of Research

If we discover the right method, the one which is in synchrony with our interests and experiences, it will constantly unfold new meanings and possibilities, provide order, and ensure consistency, while encouraging depth and complexity.

The most pervasive problem that beginning researchers face is the inclination to do too many things and engage every idea that arises through the process of inquiry and reading. I have encountered this difficulty in my own work. I have a tendency to generate many different ideas that spin off from the central concept for a research project and this can easily result in fragmentation. The discipline of research involves the selection of a theme and sticking to it. I tell myself, and my students, that the immediate project does not have to contain the total spectrum of a person's interests and thoughts.

The problem of trying to do too many things is accompanied by the inability to edit and throw things away. The inexperienced researcher wants to keep everything because the ability to discriminate what is of value has not yet been developed. It is terrifying to toss away an insight because there is a lingering fear that it may be the best idea in the research project. All of these difficulties emerge from too little focus on method as the infrastructure and basis of the research project.

Another difficulty faced by the novice researcher and artist is absorption in private concerns. The introspective nature of artistic inquiry increases the problems of self-immersion. This pitfall is accompanied by the fear that a more personal approach to research will fail to generate information that is useful to others. Our personal voices, beliefs, backgrounds, and interests are critically important contributors to experiential inquiry, but we must use these attributes to connect to others, the traditions of knowledge, and the current needs of our profession.

I have generally found that a heuristic approach to research benefits from being tempered with an orientation to other people, the medium of expression, and the objective properties of the process of creation. I have discovered that a complete focus on the self tends to generate disconnected, unfocused, and random expressions which are of little significance to a larger community of people. I try to protect beginning researchers from excessive concentration on the self by approaching the procedure of inquiry as a concrete vehicle which holds and concentrates personal explorations and makes useful connections to the experiences of others.

When confronted with these research impediments, I have found that I have to relax my need to give order and to 'save' the student. I might give examples of successful research methods but I insist to student researchers that methods of inquiry must come from them. They can certainly adapt and test the methods of others but ultimately success in art-based research is connected to the extent to which the project emerges from personal interests and experiences. Once these footholds are established in their individual areas of expertise, methods are developed to assure valid outcomes and guard against self-absorption.

My experience in working with many hundreds of graduate students on research projects confirms that people are significantly varied in terms of their internal timelines for experiential inquiries. One student might move quickly and decisively to establish a successful method and another will take an extended period of time. As a task-oriented type, I have learned let go of the need to control outcomes and this stepping back helps me to support students whose paths of discovery are more circuitous and labored. My worst experiences as a research supervisor occurred when in an effort to help students I assumed that my way of working would be good for them. I have learned to support students in their different ways of knowing and to adapt myself to their interests and styles.

In a difficult process of discovery, it is inevitable that the supervisor will become involved in the interplay. It might be necessary for the student to play against me, to struggle with my attempts to move the process along, and to challenge the guidance and order that I try to provide. The transferences between researchers and supervisors are every bit as lively as those experienced in psychotherapy.

I have found that creative expression is one of the most effective tools of discovery during the phase of research focused on the selection of a method. I have encouraged students to paint spontaneously, write randomly, move freely, improvise, and perform. Ideas and methods emerge through the process of artistic expression. As in the art therapy experience, verbal narratives and descriptions may not be the most productive modes of discovery.

In preparing for a research project we tend to suffer from impossible expectations and perfectionism and therefore limit the process of creative discovery. Again in keeping the art therapy experience, student-researchers typically benefit by beginning their work through the medium of creative play. If someone finds this to be a frivolous substitute for ambitious research, then I suggest examining the statements of history's most influential and creative scientists who affirm how insights emerge through reverie which precedes, follows, or accompanies rigorous work, attesting to the creative workings of the subconscious mind.

In *Truth and Method* Gadamer presents play as an important medium of discovery and he emphasizes 'the primacy of play over the consciousness of the player' (1994, p.104). Gadamer has poignant advice for earnest art therapy researchers who easily become distanced from the creative process in striving to justify themselves to others. He says: 'Play fulfills its purpose only if the player loses himself in play' (Ibid., p.102). Gadamer believes that play is art's 'mode of being'.

Art therapy can tremendously benefit from Gadamer's observations about the links between play and experiential discovery. We might simultaneously deepen our inquiries and enjoy them more. A focus on method in art-based research will assure the primacy of the process of inquiry 'over the consciousness' of the researcher. I repeatedly observe how the most productive research is driven by the depth and imagination of its method with the researcher entering into an interpretive dialogue and critique of the experimental activity which endlessly generates ideas and connections to new possibilities for inquiry.

The process of writing tends to occupy a large role in research conducted by graduate students. In my masters thesis seminars considerable time is given to free-writing experiences. We also read our work aloud to the group. These in-class writing exercises encourage the spontaneous formation of ideas. By writing together and sharing their expressions, thesis students create an environment of ideas. These workshops are intended to build self-confidence through immersion in the process of writing which tends to be a primary medium of thesis research. In pursuing thesis research we are apt to become so focused on the psychological idea or therapeutic method that we overlook how the creation of the project is essentially a 'literary' activity.

I encourage my students to avoid jargon in their writing. Reading aloud to one another gives us the opportunity to discover how clear and direct speech is far more effective in arousing a response from readers. Writers are encouraged to express themselves with 'authentic voices' which resonate with their natural ways of speaking. Ellen Horowitz described to me how she has her graduate

students at Nazareth College read selected authors in the art therapy field in order to study their writing styles. Students learn that effective communication through writing will significantly affect whether or not their research has a significant impact on others.

To emphasize the importance of spontaneous writing in research I take the liberty of rephrasing Gadamer's statement on play which was just cited: 'Thesis research fulfills its purpose only when researchers lose themselves in the process of writing...when there is a primacy of writing over the consciousness of the writer.'

My many years of research supervision in creative arts therapy keep reinforcing how writing and thinking are inseparable. If the researcher suffers from writer's block, there tends to be an absence of productive activity. Nothing is more essential to success in art-based research than the ability to lose oneself in the process of writing about an idea or an experience. When the writing flows with clarity, insights and discoveries emerge. The vehicle of expression is closely linked to the ultimate value of research outcomes.

§

Structure

I would like briefly to review how the art-based research projects that I have supervised have been organized.

I have mixed feelings about the standard requirement of beginning every research project with a comprehensive review of literature. I believe that it is critically important to read widely in the literature of the discipline before and during a research project. My personal approach to research is strongly oriented toward textual review. I consistently find how the writings of others generate my own creative and critical thoughts. New ideas often originate through my interactions with the text. However, I find that locating a comprehensive literature review at the beginning of research project can sometimes restrict the process of creative discovery. It is also possible that the academic tone projected by a literature review may restrict a more creative use of language in an art-based study.

Many will argue that a literature review is absolutely necessary because it emphasizes how new knowledge builds upon what already exists. I do not disagree with this respect for the traditions of disciplines and the need to know the literature of a field, but I have also seen the benefits of launching immediately into the experimental activity. In art-based studies connections to literature are often made after the inquiry is completed. The researcher discusses links with the works of others; makes observations on how the experiment may fit within a certain tradition of psychological and/or artistic inquiry; and identifies ways in which the experimental activity can be furthered by future research. Reviewing literature after the project is completed minimizes bias and helps to encourage the researcher to do original work. It may also be useful to create a 'notes' section at the end of a study where detailed reflections on writings related to the study can be discussed in a scholarly way. This format for textual analysis is particularly helpful when the primary body of the study eschews academic language.

I believe that a discussion of literature should be tailored to the unique conditions of each study. Stock formats limit discovery.

I often encourage students to begin their projects with a narrative account of how they selected their methods and themes for research. In this relatively brief chapter I suggest that they provide a sense of context – the how, what, why, and where that informs and enables the reader to enter the world-view of the researcher. How will this project be useful to the researcher and to others? What are the objectives of the study and how is this particular researcher capable of carrying them out?

In my work with graduate students conducting art-based research, the major content of the project is a description or account of the experimental activity (i.e. prints of artworks and the accompanying dialogues with them, etc.). The material can be organized in different ways with interpretations and conclusions woven into the text, offered at the end of each section, or included in a separate section following the experimental activity. There are many possibilities for organizing the material of the study and I do not want to restrict the licence of the researcher by being overly descriptive of what has been done in the past. However, I do find that it is helpful to focus on the experimental activity as the main section of the project.

I have found it valuable to conclude experimental research projects with a reflective section. I encourage the researcher to make a personal evaluation of the project and determine whether its goals have been made, the extent of new learning, and personal satisfaction with the overall experience.

During my research seminars with graduate students we spend considerable time examining potential topics and methods of inquiry. I present a wide array of themes and ways of conducting inquiries with the hope that this listing will help future researchers select a focus for their studies. I have found the critical decision in the research process to be the selection of a method and the goals for the inquiry. Once we have established the general structure of the experimental activity, the process of inquiry emerges through the unique conditions of the study. For this reason, I place my primary emphasis on the spectrum of possible themes and methods.

In keeping with my emphasis on simple and clear methods, I will attempt to describe briefly the essential features of various designs and plans of action. Ultimately, I try to help the student-researcher establish a practical method of inquiry which defines or suggests the goals of the research through the form of the investigation. As the project is being executed, we may revise our plans and sometimes make significant changes of direction, but the well-planned method will generally hold up through the entire process of inquiry while sustaining and guiding the overall sequence of activities.

I have always encouraged students to work in teams when conducting art therapy research. I have also experimented with collaborative research projects in which two or more people work together on a single theme. Typically these conjoint research projects involve periods of difficulty related to the process of working together. An almost universal outcome reported by people who undertake these collaborative research projects entails a deeper understanding of the dynamics of teamwork and group creation. Collaborative projects tend to be characterized by a clear focus and the absence of excessive statement, perhaps due to the fact that the participants experience the need to establish a structure which unifies their respective contributions.

Even when people labor alone in their research, there are many benefits to discussing the work with a group of researchers who are undergoing similar experiences. Nothing has been more valuable to me, and to my graduate students, than the criticisms and suggestions of colleagues. Research tends to be a solitary activity in which we explore our most personal questions and needs. The involvement of other people keeps us focused on how the outside world will respond to our inquiries, how useful our findings will be to others, and how we can frame our results to maximize their influence. If only one other person whose opinion I value feels a sense of excitement about what I am studying, this judgment has the ability to sustain me in my work.

The opinions of colleagues are typically the most important indicators of validity within art-based research. They help us determine whether or not our findings ring true within the context of another person's experience.

§

Artistic Amplification of Case Studies and Histories

The sustained presence of the case study in art therapy research demands that it be taken seriously as a method of inquiry. However, art-based research can creatively transform the conventional case study format to be expressive of the unique dynamics of the creative process. The case study can be combined with the increasingly popular 'portfolio' method of documenting change in education. Educators are finding the developmental assessment of works collected over an extended period of time to be the most realistic and accurate way of demonstrating the achievement of outcomes.

Keeping a portfolio of creative expressions has obvious benefits to art therapy. The creation of a clinical portfolio has been complicated in the past over the issue of who has the right to 'keep' artwork produced in art therapy. Advocates of client ownership of creative expressions now have access to digital cameras, scanners, and other mechanisms for keeping online portfolios.

The sustained popularity and usefulness of the case study approach reinforces the practitioner-researcher model as the primary more of inquiry in the art therapy field. Case studies foster close connections between researchers and the process of therapy. Rather than viewing art therapy's historic reliance on case studies as a weakness, art therapy research might examine the unique benefits of this type of study, determine why it suits the examination of our professional experiences, and explore more creative applications of the method.

In striving to fit into the paradigms and procedures of behavioral science, art therapy has assumed that it must encourage research which produces generalized results gathered from a varied and random sampling of people. In keeping with the desire for predictability which is the basis of scientific method, it is hoped that research findings will be 'reliable' in that another art

therapist will experience the same results using the identical approach in corresponding circumstances. However, the situations of art therapy practice are infinitely variable. The direction of therapy is more likely to follow the therapist's and client's intuitive inclinations than the unchanging procedures which characterize scientific research. Art is by nature a process of variation and therefore it requires methods of documentation, such the case study, which articulate its unique dynamics.

The music therapist David Aldridge has written convincingly about the value of 'single-case research designs' in creative arts therapy (1993a, 1993b, 1994). Aldridge emphasizes how music therapy is a 'transpersonal happening' which is inseparable from the particular context and the style of the therapist. He describes how individual therapists will experience very different results with the same method, and this factor is compounded by the inconsistent mental orientations of clients. I would add to these variations the changes in moods and interests that every person experiences within any given situation, all of which are heightened through the introduction of creative expression. Rather than fleeing from this essential discontinuity, creative arts therapy should approach it as the unique challenge of our emerging practice of research. As with physics, the constant variations of therapeutic phenomena and processes offer opportunities for the creation of new knowledge through innovative research.

Aldridge emphasizes the importance of the professional community of creative arts therapists reaching consensus on the value of research methodologies and results which are considered valid within the group. Rather than looking outside the profession for inspiration and credibility he recommends that we begin to use one another's research as the basis for future studies (1993b).

'Internal validity' determines whether or not a particular thing is correct for a specific situation. Universal standards of validity may not be appropriate for many features of art therapy experience. For example, the color red might generate significantly different reactions in any given group of people, or at different moments during an individual person's experience.

In spite of art therapy's extreme variability, there may be a common core of outcomes that unite us all. The entire creative arts therapy field has been reluctant to shape a unique research tradition based upon consensually validated principles of practice. There are so many factors upon which all creative arts therapists agree and the first step toward establishing standards of validity within our community is the identification of these essential elements. We have to distinguish between the epistemologies of aesthetics and science

and move beyond what Aldridge describes as the crippling insecurity caused by the inability 'to tolerate ambiguity in ascertaining meaning' (Ibid., p.120).

The making of art as well as the practice of therapy require an ability to accept uncertainty and constant variation. Aldridge stresses the importance of working collaboratively with patients in exploring the nature of the therapeutic experience and he feels that efforts to objectively measure the process of creative arts therapy may have deleterious effects:

> It is almost impossible to seek out objective measures in creative arts therapies when subjective factors play such a predominant role. In the situation of improvising music, it is impossible to separate out the influences of patient and therapist one from another. The improvisation is mutual. Attempts to objectify the process of therapy disturb the therapy so that it no longer represents that which is to be measured, thus countermanding any attempts at objectivity. (Ibid., p.121)

The way in which the therapist/researcher and the patient/subject constantly influence one another, as well as the overall process of the experience, is consistent with the discoveries of quantum physics. The subjectivity and variability of the art experience are expressions of a reality that has been identified in observations of the most microscopic elements of the physical world. The case study has proven to be one of the most effective ways of documenting and coming to a better understanding of how the process of creative arts therapy works.

When I make art, a successful painting strikes me immediately with its expressiveness. It impinges upon me in a direct and personal way. There is very little in this process of assessment that can be likened to the procedures of scientific measurement. The painting and I merge in an intermediate space of perception that is quite intimate and as Aldridge suggests, any attempt to objectify this process will interfere with the natural ways of aesthetic reflection. I do not have to quantify the value of the painting nor have the results validated by large numbers of people. I generally know when a painting succeeds, but I do find it most helpful when a respected critic or colleague affirms the significance of the work.

I believe that we evaluate experiences in therapy in these personal ways and our case studies present descriptions of what we perceive as significant. The stories we tell about experiences in therapy are aesthetic assessments judging clinical situations according to our personal and idealized standards of importance. There is no absolute or objective criterion according to which a therapeutic experience can be scored. But yet the creation of case studies is continuously valuable for the people who write them, for the readers, and one

hopes for the participants in therapy. The case study helps us become more aware of what is happening within the art therapy experience. If we can accept the subjectivity of a case study, as we do a novel or short story, then we can simply judge it on its merits, open ourselves to its influences, and incorporate the experiences described.

The widespread use of the case study in art therapy can be attributed to its descriptive power, its ability to include so many of the different qualities of the therapeutic experience, and its capacity to convey a sense of process. I believe that the case study also corresponds to our culture's preference for stories as basic tools for communicating and understanding experience.

Ultimately, the effectiveness of a case study will be determined by its artistry and the power of its rhetoric. Bruce Moon's innovations in therapeutic storytelling and the major impact of his 'case stories' demand that we revisit preconceptions about the case study. Do we have to present accounts of what we perceive in our therapeutic sessions in professional jargon and abstract language? Maybe the clinics and mental health organizations that we hope to influence favorably are ready for more concrete, descriptive, and animated presentations of what takes place in therapy. Maybe our artmaking abilities can help to transform a desiccated aspect of the mental health system. Maybe art therapists can lead, and shed their long-standing adjunctive mentality. I respect the needs that professional students have to master the language and technical concepts of their disciplines as well as published research findings. But even the most conservative definition of research does not advocate teaching research 'literacy' as an end unto itself. Holly Feen-Calligan described to me how her doctoral mentor at the University of Michigan emphasized researching 'what matters' in whatever way best served the purpose of her inquiry (1998). I feel that we must give ourselves greater licence to explore the limits of the case study process in art-based research.

When we view case studies as adaptations of the storytelling process, we begin to realize how the ways of researching therapeutic experience can be as varied as the different literary genre to which we have access. The linear narrative embodies a definite bias toward an orderly sequence of experience which does not generally correspond to the actual shifts, episodes, and interior musings of the therapeutic process. In this respect the stories we tell about therapy have a certain unreality or fictive quality to them. They are real as entities unto themselves.

If we experiment with ways of researching the dynamics of art therapy that Arthur Robbins describes in his 1973 article, 'The art therapist's imagery as a response to the therapeutic dialogue', the stream of consciousness genre may have important contributions to make. After documenting material generated

by free association, we can compare the contents with information and perceptions elicited from more conventional narratives. Every mode of expression carries its particular contributions but no single way will convey an absolute or total account of what is occurring within the 'complex' of the art therapy experience.

Art-based research must continue to explore the many different ways of telling the stories of therapy. Pat Allen has explored the autobiographical genre in *Art is a Way of Knowing* where the artist documents her own experience with the process of creation. Within the context of autobiographical inquiry there can be endless variations of style and purpose. Allen's examination of her artmaking process can generate spin-off studies that will be as diverse as art itself.

I am interested in seeing someone collect autobiographical and biographical materials about the lives of art therapists with the goal of studying motivations for pursuing this career. Learning more about why art therapists commit their lives to the work may be one of the best ways of understanding and articulating its unique healing powers. Cathy Malchiodi affirms how her belief in the power of art to 'effect change, build community, and enhance one's life' is affirmed by 'working in my own studio or in others, feeling connectedness to other artists, seeing art in progress, getting lost in hours of artmaking, sharing a cup of tea with a fellow artist, or receiving feedback on my work' (1995, pp.155–156).

We've been so focused on behavioral science research that we have missed opportunities for more direct and descriptive investigations of the profession. We have yet to tell our individual stories because we have seen them as outside the domain of professional practice and this has resulted in an absence of penetrating integration of personal and clinical experience.

The creative imagination and the range of literary tools available to us may also be applied to documenting art therapy sessions with others. We might tell the story of what is happening to a person in therapy from the perspective of another person participating in the experience; from the viewpoint of an imagined figure; from the point of view of different aspects of the person's psyche; from the perspectives of Freud, Jung, or Margaret Naumburg; from a critical vantage point; from a supportive point of view; and so forth.

The total spectrum of literary perspectives and methods of writing can be applied to the case study. I can imagine writing a satire of my work in therapy, a comedy, a tragedy, an epic, poems, a play, a farce. These different ways of writing and storytelling have been created in order to expand our views of life. We might do the same with the therapeutic case study.

We might compare case studies written in the passive, formal, and anonymous narrative of clinical speech, to those written in colorful and spirited personal voices. What is the goal and the effect of a case study written in professional language? What does it tell us about the unique conditions of the therapeutic experience? Does it tell us more about the values and expectations of the clinical mind?

What do we learn from an honest personal account which may even introduce confessional material which is characteristically hidden in the formal professional report? Poets and prose writers make good use of the confessional genre to explore the depths of their experience, but in therapy this mode of psychological inquiry has been considered appropriate only for patients. Why this imbalance? Perhaps it is this way because therapists were historically felt to be 'outside' the process of scientific treatment. We now know that the real situation is quite enmeshed.

When considering different ways of telling what we see occurring in therapy we might ask: What methods bring us close to the actual experience? Which presentation is more readable? More engaging? More informative? More impactful? More useful?

I suggest writing case studies in the most formal clinical style as a way of understanding that particular way of viewing the world. The same situation could be documented in an intensely personal voice and the results could be compared. I would exaggerate each of the modes in order to heighten their different perspectives. I can imagine Woody Allen writing case studies in the most dense psychological jargon to help us understand what this type of speech does to people.

In addition to experimenting with different points of view, my graduate students often use more than one artistic mode to express their experiences in therapy. The media introduce varying perspectives on the experience. We have discovered that if the same therapeutic experience is engaged in separate expressions with poetry, paintings, storytelling, performance, and movement, each medium evokes a different aspect of what was first experienced as a singular event. Artistic knowing is unique in its ability to express and display these multi-faceted qualities of experience.

Michael Polanyi (1966) feels that 'indwelling' in the experience of something other than the self is vital to scientific knowing and not just a method which applies to the humanities. I can envision productive research projects in which art therapists construct case studies and interpretations of paintings from the perspectives of the people with whom they work. I would encourage imaginative and literary accounts of a person's experience in therapy and not just literal interviews or reports. Through empathy with another

person's life situation we see things that neither of us is likely to describe in a more straightforward narrative. The imaginal perspective of literature and looking at the world through the lens of empathy with another, expands our view of reality.

Therapeutic case study research has not been particularly aggressive in seeking out multiple perspectives on a given situation. The amplification of case materials will generate new and different questions, varied viewpoints on therapeutic value, and varying styles of observation. The different case narratives will themselves offer sources of data for comparative analysis.

Multiple narratives may focus on specific aspects of the therapeutic experience which may include: the assessment of both patient and therapist satisfaction; the identification of significant moments and turning points; difficulties and distractions; identification of periods or moments of uncertainty; unexpected outcomes; factors influencing planned and unplanned changes; effects that significant moments in therapy may have had on the patient's or therapist's life outside therapy; or the way in which concurrent factors completely external to the therapeutic experience influence the process.

I urge art therapy researchers to improvise on the case study format and perhaps look at work with a person from the perspective of the materials used in therapy, the ways of approaching images, and other methodological concerns. We have for the most part generated case studies to document changes in patient behaviors. A more rigorous and systematic research initiative will document other factors – patient perceptions, changes in art therapy methods, changes in the types of imagery being made, and so forth.

It might be helpful to tell case studies from the perspectives of images produced in therapy and other significant 'objects'. These exercises will deepen our empathy and our ability to look at life in novel ways. The writings of Wilhelm Worringer and Theodor Lipps on aesthetic empathy can be used as a psychological basis for immersing ourselves in the experiences of another person and to enjoy 'the resonance of life in an external object' (Arnheim, 1986, p.60). We can explore how the poetic mind personifies what others might perceive as 'inanimate' objects. The range of our views of the therapeutic experience will correspond to the vantage points we take and the voices we adopt. Every conceivable perspective should be explored as a way of describing what is taking place during the art therapy experience.

I agree with Amedeo Giorgi's observation that psychology is widely practised as a descriptive discipline. He states how his practice of phenomenological research, together with the entire area of 'qualitative' research, is part of a more all-inclusive tradition which he calls 'descriptive psychology'. Although this approach to research is focused on 'discovery' rather than

'verification', Giorgi believes that it is thoroughly scientific. He gives a definition of the scientific method which corresponds to the values of art-based research:

> To accept the demand to be scientific means that one wants to approach the phenomenon one is interested in investigating in a methodological, systematic, and rigorous way... The difference from traditional science is that with the latter the specific criteria are known and announced beforehand whereas with me only the general demand to be scientific is accepted initially and the concrete steps are specified and worked out in dialog with the phenomenon, rather than beforehand' (1985, p.26)

Art-based research will, I hope, evolve through a commitment to 'methodological, systematic and rigorous' procedures. 'Scientific' inquiry is a disciplined approach, a way of operating, rather than a system of prescribed operations. I venture to say that art-based research can be conducted in ways that completely support 'liberally' defined scientific methods. Giorgi helps us realize that we can support scientific ideals without giving up the freedom to discover things that emerge from outside the limits of a preliminary plan.

Scientific descriptions have assumed for many years that they give objective accounts of observations and experiments, but we are now realizing that any interpretation of phenomena changes and transforms what is observed. In this regard the artistic perspective may be more honest about what it does to phenomena; how it sometimes twists, exaggerates, and distorts while at other times viewing moments with the utmost lucidity. There are many different types of description: art openly declares the perspective of the viewer and acknowledges what the interpretation of a situation adds to the total process. Scientific descriptions also attach themselves to the phenomena they interpret but this additive effect has not been openly acknowledged. At the core of both artistic and scientific interpretations is the fact that each descriptor infuses its particular kind of rhetoric and observational style into the portrait being created.

Art can help science to become more sensitive to the transformative effects of its interpretations, and science can assist art-based research in becoming more systematic in its procedures and more attuned to the give and take between object and observer. The different ways of looking complement and expand one another.

I don't know if psychology is ready to see itself as a process of transformation which attaches itself to everything it describes. Yet I would argue that this is what all descriptions of phenomena ultimately do. During the past century scientific rhetoric has simply been more compelling than other

ways of interpreting the world. I believe that art therapy has a different kind of story to tell. As we perfect our unique ways of describing what we do, a new kind of research will emerge and I am convinced that its rhetoric will have significant powers of persuasion.

§

Ideas

I have found that beginning researchers benefit from consideration of a wide range of possibilities which then inspire their own unique interests and projects. As I have tried to show throughout this book, methods are inseparable from the particular circumstances of a research project and I have given many examples of art-based inquiries which demonstrate this principle. In the following pages I hope to generate many ideas as 'sparks' for future studies, trusting that methods will emerge from the conditions of the research projects.

My goal is to provoke ideas and identify needs from the perspective of my background and interests. I recommend reading this chapter as though I am a research adviser or supervisor who is asked for suggestions, leads, and possibilities for research and who tries to represent what might constitute worthy research projects. I have arbitrarily selected the effects of aesthetic quality, methods, histories and outcome assessments as focal points from research ideas and 'sample' projects are generated. My selections are only illustrations of possibilities and I have could have used a completely different set of issues to generate themes and problems.

Please do not take the following pages too literally. As a supervisor I tell graduate students to 'bounce off' my ideas with their own creative inclinations. I see myself as an instigator, as someone who is trying to help shape a research project that flows from a person's unique interests, life experience, and expertise.

As I review my experience with art-based research I identify two fundamental principles which I offer as guiding thoughts.

First, the most important ideas and accomplishments emerge from the process of creation, and they are less likely to be planned in advance. Even though major insights are apt to occur when least expected, it is important to set goals at the outset of a study. The original frame of reference can be compared to the first brush strokes on a canvas or the under-painting over

which an image takes shape; it is the basis from which creative discovery unfolds.

Second, the process of research should correspond as closely as possible to the experience of therapy. As art therapists, all of our research activities are ultimately directed toward the improvement of practice with the goal of helping people, and this focus is the contextual foundation which incorporates all of our creative experimentation.

In my experience as a researcher and as a research supervisor, the most difficult task is the clarification of what we want to do. Once we have a workable idea, the procedures of inquiry are apt to fall quickly into place. In art-based research the idea for research might be a 'method' as well as a problem or an issue.

In keeping with the advice of creative scientists, I do not want to attempt to lay out standard procedures for research. Every idea that I describe and those that readers add to this discourse, have the potential to evoke unique methods of inquiry. In teaching research methods to art therapists, I recommend a close reading of W. I. B. Beveridge's classic text, *The Art of Scientific Investigation*. Beveridge says: 'training in research must be largely self-training, preferably with the guidance of an experienced scientist in the handling of the actual investigation' (1950. p.x).

Beveridge goes on to state how distinguished scientific researchers have been characterized by diverse interests which enable them to make connections between previously separated entities. The writer Lawrence Durrell similarly observed how genius involves the creation of new relationships between things. In keeping with the testimony of scientists throughout the ages, Beveridge describes how insights 'have been come upon unexpectedly' and that the most significant discoveries are always associated with chance because revolutionary transformations upend contemporary frameworks of knowledge (Ibid., p.43). An insistence on standardized research methods defends against these fresh discoveries and expansions of intellectual frameworks. As Carl Rogers said, this narrow approach to research fears creation and does 'not recognize that it is out of such fanciful thinking that true science emerges' (Rogers, 1965, p.192).

Clifford Geertz describes how standard research procedures apply to only the most mechanical activities of collecting data. He feels that researching human experience is more likely to involve the engagement of 'a multiplicity of complex conceptual structures, many of them superimposed upon or knotted into one another, which are at once strange, irregular, and inexplicit' (1973, p.10).

The quick sketches of research ideas that I present in the following pages are intended to incite 'fanciful thinking' and flights of imagination.

I view the ideas as seeds for creation. Methods of inquiry are presented as creative possibilities and in keeping with art, the way of conducting an investigation and what the researcher does, is as important to my vision of art-based research as the concepts guiding action. For the art therapy researcher, the method of practice is often the essential outcome. We conduct research to improve and deepen the effects of what we do with people and art.

The effects of aesthetic quality

Assessments of the quality of expression have been a provocative subject in the history of art therapy. Values of free expression for every person have been a unifying focus for all sectors of the field. This egalitarian spirit has often been accompanied by a 'commandment' against making judgments about the quality of art produced in therapy. It is felt that if people are subjected to criticism of any kind, they will be discouraged from expressing themselves. From the perspective of creative arts therapy I do not advocate judging artworks outside the context of the creator's relationship to them. This is what distinguishes therapeutic from commercial and academic approaches to art. However, within the art therapy relationship, aesthetic reactions are inevitable. I am intrigued with the issue of aesthetic quality because it is so controversial in art therapy. Although some might consider aesthetics to be an abstract theme, distant from what is good for the patient, I believe that this subject will take us to the heart of both the creative arts therapy experience and art-based research.

Artistic expression is an activity which carries aesthetic criticism within itself. It can be said that every person making art has an inherent drive to 'get it right,' to express the gesture or feeling as effectively as possible. If we locate the determination of quality within the context of the artist's experience of the creative process, will this be more acceptable to art therapists?

Edith Kramer has consistently broached the issue of quality art within the art therapy experience, but the field has polarized her position as supporting 'art as therapy' as contrasted to 'art in therapy'. This duality has grown into a stereotype which obfuscates Kramer's challenging question:

> When products of therapeutic creative activities attain the aesthetic qualities of art, this fact is too often neglected in psychological evaluation... Since the artistic value of the work produced is a sign of successful sublimation, the quality of the work becomes a measure (though not the only measure) of therapeutic success. (1971, pp.221–223)

If we replace Kramer's Freudian reference to 'successful sublimation' with the less theory-laden and universally accepted therapeutic action of 'successful expression', then we cannot avoid investigating whether 'the quality of the work becomes a measure of therapeutic success'. If expression is a desired outcome of art therapy, its quality should be assessed.

Kramer's overlooked question is one of the most important focal points for future art therapy research. Many studies can spin off from this issue. My examples are only indicators of possibilities:

○ Explore and articulate issues generated by efforts to assess the quality of expression in art therapy. Since it is generally agreed that quality cannot be quantified, how do we evaluate this feature? Is it possible to make standards of any kind for art therapists? Can we agree upon relatively concrete 'qualities' of expression such as spontaneity, order, imaginativeness, which can observed with some degree of consistency? How do we define quality? Is it possible to offer universal definitions and standards? Is quality a purely personal interpretation? How do other fields assess quality? Is aesthetic measurement a contradiction?

A study might examine past practices within the arts with regard to the assessment of quality. The problem might be explored from the perspectives of different historical epochs, cultures, and artistic schools. Controversial issues can be identified as well as differences of opinion with regard to quality. The traditions of the arts and culture must be applied to this problem. An identification of the many issues involved with the assessment of aesthetic quality can be an important first step for the art therapy profession in dealing with this concern.

○ The arts offer alternative ways of evaluating the value of research. Does the project connect to your experience? Does it evoke something from you? Does the project stand out from others and does it initiate a new dimension to practice? Does the project convey a feeling of psychological depth? Does it have aesthetic significance? Is it memorable? Is the project appealing to others? Is it helpful to someone? Does it provoke, inspire, arouse interest? If we evaluate creative arts therapy research according to these 'artistic' standards, we operate within a completely different context of validity.

The basic test of aesthetic significance is whether or not the expression of another appeals to the person perceiving it. This is a completely different measure of efficacy than the conventional scientific criterion.

The most distinctive difference between artistic and scientific standards is the way in which the former is based upon one person's assessment of the value of an other's expression. Taste, subjectivity, and differences of opinion are assumed. Science strives to eliminate these factors. Rather than arguing

whether one standard is better than the other, we can explore what an artistic criterion of research can contribute to art therapy and other fields.

○ Art therapy has not sufficiently studied the dynamics of interpretation which are the basis for all assessments in the work we do. There are many in the profession who continue to believe that it is possible to establish laws of diagnostic and psychological evaluation. Clifford Geertz has clarified how all 'data' are interpretative fictions which are 'made' and 'fashioned' in an effort to find meaning in another person's interpretations of life (1973, p.15).

Research projects might explore the basic values and themes that inform how different art therapists interpret therapeutic experience. I can envision projects which review art therapy literature with the goal of identifying the different 'constructs' which define a 'quality' experience within varying frameworks of individual authors.

Current practitioners can be interviewed with the goal of ascertaining their personal cultures of interpretation. What beliefs and values determine their assessments of quality? How is meaning attributed to artworks?

Art therapy graduate students can be interviewed in relation to these issues. I would like to know the extent to which art therapy graduate students interpret art according to: (1) ingrained personal values; (2) principles acquired during their training; (3) a combination of (1) and (2); and other factors that might influence their interpretive perspectives.

○ A literature-based study might review publications by art therapists with the goal of determining whether some are more prone to show aesthetically interesting images than others. A definition of 'art' as contrasted to 'graphic communication' may be required as the basis for this study. Edith Kramer suggests that there is a difference between art and non-art but the distinguishing features may be subtle and unforeseen: 'The moment when scribble, stereotype, or pictograph may turn into art can never be predicted' (1971, p.222).

A study of images presented in art therapy literature might explore the creation of criteria for making aesthetic assessments in art therapy. In the art therapy literature there is scant mention of purely visual evaluations of artworks together with a general lack of attention given to how aesthetic qualities may affect the therapeutic process. The effort to give criteria for 'aesthetically interesting images' can be a significant step for art therapy.

Published literature offers a relatively constant data base which is subject to quantification. Research methods from art history could be combined with art therapy in an attempt to interpret aesthetic qualities presented by the imagery included in professional publications. A research project might approach the

imagistic data blindly and without reference to the written statements of authors and their assessments of therapeutic efficacy. This purely visual perspective would offer an entirely new vantage point on the art therapy experience. The study will provide new ways of looking at the data generated by the experience of art therapy. We are all prone to fit the images produced in therapy into the stories that we tell about the work and the theories that we use to explain or justify practice.

A major outcome of this type of study will be the effort to systematically evaluate and comprehend images without reference to the artist's personal life. When scientists study a particular disease they do not view this condition as an expression of the afflicted person's personality. The disease is researched as an autonomous entity. As we learn more about artistic images, this understanding can be applied to our work with the people who make them.

○ Are 'diagnostic art' procedures really concerned with the making of 'art'? Can these assessment activities be more appropriately described as 'graphic exercises'? A research project might explore the aesthetic differences between images made in an art therapy studio and a testing context. Is the diagnostic evaluation of graphic images truly an 'art therapy' experience?

○ In my experience with art I find that I am drawn to a particular image or subject matter that I paint over an extended period of time. I never know why I select this particular imagery and I find that I get to know the subject matter better as I continue to work with it. This experience teaches me that I can never quickly diagnose or explain what an image means when it first appears. Does the art diagnosis process contradict the nature of the art experience in which meaning emerges gradually and from sustained exposure? Is the meaning of an image ever finished or final? Does one image lead to another?

I find that the significance of an individual painting can only be grasped in relation to the ones I make before and after it. Experiment with these questions and ideas by making a series of related paintings over a period of time. One artwork always relates to others. They grow from one another. See if these principles can be observed in your personal artistic expressions or in those of the people with whom you work.

○ The writings of Rudolf Arnheim suggest that aesthetic and structural qualities of artworks do have a significant impact on expression and therefore therapeutic efficacy. Arnheim documents how 'expression is embedded' in the physical qualities of images (1954, p.449).

If expression is determined by the structure of an artwork, what are the implications for therapeutic practice? Does the art therapist coach or teach in order to further the 'quality' of expression?

Many art therapists have simply declared aesthetic quality to be off-limits and therefore irrelevant to therapeutic practice. They feel that quality inhibits pure and free expression. Is this true? Can quality be defined within the context of art therapy's desire for free, spontaneous, and authentic expression?

○ It could be useful to conduct a 'blind' study which excludes therapeutic narrative and explanation and asks different art therapists to evaluate a series of artworks on the basis of their personal definitions of quality as experienced in art therapy. The process might be replicated with a group of artists with no experience in art therapy. This type of study lends itself to quantification but the process of measurement would be used in this case to organize and interpret data. Quantification is not employed to make definitive statements about the human condition. I predict that this type of study will help us to generate a better sense of what we mean by expressive quality within art therapy.

○ Other questions related to the issues of aesthetic quality include: How do our therapeutic environments and purposes shape a sense of aesthetic value? How does the art therapy setting differ from a purely artistic context? Are there similarities as well as differences? Is it impossible to make a dualistic separation between artists and art therapists when it comes to assessments of aesthetic quality? Do patients' assessments of quality sometimes differ from those of therapists?

○ I can envision a research project which examines artworks produced by people involved in art therapy within a highly clinical setting and other works created within an art therapy studio context. Once again this investigation would be conducted exclusively on the basis of aesthetic assessment of visual data. Narrative accounts of therapeutic efficacy will be excluded. The research will help us understand the extent to which environmental factors influence the types of imagery produced in art therapy.

Comparative analysis is a fundamental element of research. We need to study the effects that different environmental factors have on the creative process. Is the 'quality' of expression an extension of the more general atmosphere in which it was created? How does the studio space affect expression? Experiment with the same art activities in different spaces. Do spatial qualities influence expression in detectable ways?

○ Many other studies can be conducted to examine factors that extend from the issue of quality. The artistic training of the art therapist, the current personal involvement of the art therapist in artmaking, and personal therapeutic philosophies can be examined with regard to their possible effect on the assessment of quality in art therapy.

○ The researcher might use personal or 'first-hand' artmaking experiences over an extended period of time to determine if there are correlations between aesthetic quality and therapeutic efficacy. This type of inquiry can draw conclusions directly from the researcher's encounter with art materials rather than making interpretations about other people's expression.

Do I feel better after making a 'successful' picture? Can a 'failed' picture generate significant therapeutic effects? Are authentic and expressive images more likely to deepen my engagement with the therapeutic process? Do superficial and stereotypic images limit my involvement in art therapy? Is it possible to find significance in any kind of expression within the art therapy experience? Does the personal experience of quality in artistic expression influence feelings of therapeutic satisfaction?

A project can be designed in which the researcher conducts an ongoing assessment of the way in which particular images and qualities of expression affect emotional states and therapeutic outcomes.

Within the context of a personal studio inquiry, are there thematic continuities that emerge over the course of time with regard to the assessment of quality? Do aesthetically 'bad' pictures that I might never hang in my house sometimes generate potent therapeutic results? Might I consider making what I consider a series of 'bad' artworks in order to explore new emotions, new ways of expanding my expression, or an encounter with shadowy and repressed aspects of my life?

In order to circumvent the judgments that we make about the quality of our personal artworks, the artist-researcher might invite other people to make aesthetic assessments of the imagery. To what extent do other people's perceptions affect the artist's feelings about the image? How do other people's aesthetic judgments influence the artist's sense of therapeutic satisfaction?

○ A more creative way of expanding the assessment of quality might involve the imaginative exercise of letting artworks evaluate themselves. How successful do they feel? Are they satisfied with themselves? What qualities do they offer? Do they agree with the artist's assessment of quality? Imaginative inquiries of this kind not only give us new ways of looking at artworks and understanding them,

but they often generate new therapeutic techniques that we can use in our work with others.

o The more conventional approach of interviewing clients and therapists might also generate useful information with regard to the way in which the feelings of aesthetic quality affect the therapeutic experience. A study might be conducted whereby the researcher intentionally avoids a definition of quality and strives to document what the interviews reveal in relation to this theme. Another approach might involve an *a priori* attempt to establish criteria for quality which the subjects are asked to examine in relation to their experiences.

o Quality can be researched from a special vantage point such as spirituality which Ellen Horowitz presents as an important aspect of art therapy experience (1994). Can we define spiritual quality in an artwork? Do images themselves convey spiritual expressions? In what ways? Is spirituality more likely to be experienced in connection to the process of making art? While contemplating artistic images? Are there degrees of spiritual intensity and satisfaction experienced in art therapy?

o Critical and historically oriented studies might examine the extent to which aesthetic factors have been positively and negatively received within the art therapy literature. The pioneering work of Hans Prinzhorn (*Artistry of the Mentally Ill*, 1972) needs to be revisited in relation to images produced in art therapy. Prinzhorn viewed the art of mentally ill people as expressing 'a uniform metaphorical instinct' (p.241). He believed that every shape or gesture can be viewed as a significant effort to establish connections with others. He said that if we seriously contemplate the simplest scribble we might find that it conveys 'universal features of psychological life.'

The strong identification of art therapy with psychotherapeutic practice and psycho-dynamic theory has obscured Prinzhorn's contributions. When we view the creative process and the objects of expression as carriers of artistic medicines, Prinzhorn takes on major importance. He demonstrates how we can conduct formal research with art objects produced in therapy with the goal of making links between them and universal human tendencies for expression as exhibited in the artifacts of art history and ethnological studies. Prinzhorn presents a wealth of possibilities for future research which will hopefully continue his investigations of visual fantasy, instincts for playful ornament-ation, universal urges for spatial order, typologies of archetypal symbolism, and other seminal ideas.

Interpret images made in art therapy according to Prinzhorn's theory and the types of imagery he described. Compare images made today with artworks

in his collection. Are there universal expressive qualities? If so, what is their therapeutic significance?

o Rudolf Arnheim describes how 'we know next to nothing about how artists convey meaning through color relations' (1992, p.183). Explore how you use color in your art to express emotion. Document color patterns in a series of paintings made over an extended period of time. Interview yourself about the color relations in each painting. Watch for continuities and changes. Are your feelings about colors constant? Does your relationship to a particular color change in terms of the overall composition of the picture?

Interview other artists. Is color one of the most relative of visual phenomena? Can we say anything universal about the expression of 'meaning through color relations'?

Are there warm and cool colors? Red and orange might correspond to the qualities of fire while blue and green compare to water. Do you experience red as warm? Blue as cool? Is it possible to have emotional reactions that invert these notions?

Method studies

o Art therapy research has given little attention to the energetic aspects of the discipline. We have been almost exclusively focused on conditions that owe their existence as well as their cures to language-based psychological theories and methods. As soon as art therapy begins seriously to align itself with aesthetic methods and theories, the realities of artistic energy become apparent. Rudolf Arnheim describes how 'what strikes the eye' transmits a 'life giving energy' (1954, p.460) and this power of sensory transmission also applies to movement, sound, and touch.

Art therapy has approached visual images as narratives which say things about the people who make them. We have been so concerned with the psychological condition of the maker of the image that we have overlooked explorations of how artmaking and engagements with images affect people energetically. How can we explore and understand the different energies and therapeutic properties of different 'kinds' of artmaking activities; of different media? How do we access the particular energetic qualities of an artwork when we work with it after it has been produced?

Research in this area might begin with simple descriptive studies which articulate what people experience when contemplating an artwork. In order to minimize the tendency to translate these impressions into psychological narratives, a series of visual qualities and energies can be identified at the

beginning of the study and descriptions can focus on identifying their presence in the images – motion, color intensities, interactions between qualities and forms, spatial relations, characteristics of line, thickness, texture, and so forth.

○ In the tradition of Dutch art therapy I envision studies that explore and compare the effects of working with wood, clay, paint, and the wide spectrum of art therapy materials. This studio-oriented research will probably be closer to what happens in the laboratories of physical science than conventional methods of behavioral science.

As media studies expand, I can imagine researchers exploring the different aspects of working with a single medium – i.e. different qualities and types of stone or wood, issues of scale, and so forth.

Possibilities for media research are vast. New and classic media can be investigated and compared. A study might compare the therapeutic implications of making digital paintings to tactile and sensory work with physical materials. What are the unique qualities and therapeutic aspects of each?

Photography has been a major media focal point within creative arts therapy (Kraus and Fryrear, 1983; Weiser, 1993). I have always viewed 'phototherapy' and the creative use of 'videotherapy' (McNiff, 1975b; Fryrear and Fleshman, 1981) as media concentrations within the larger discipline of visual art therapy. The way in which photography has generated considerable literature and research exemplifies how the therapeutic properties of other media can be examined. In *Photo Art Therapy: A Jungian Perspective* (1992) Jerry Fryrear and Irene Corbit demonstrate how a medium can be explored from a particular theoretical approach to therapy. Helen Landgarten's *Magazine Photo Collage: A Multicultural Assessment and Treatment Technique* (1993) offers yet another example of how a specific medium can be studied and related to the needs of different client groups.

○ In my book, *Earth Angels: Engaging the Sacred in Everyday Things* (1995), I explore the intimate connections that people have with objects, physical things, and places. Much more needs to be done in examining the use of objects in therapy. I can envision research projects which focus on how a single object or talisman can be used to generate an ongoing series of creative expressions and reflections. Other projects might make use of varied objects and materials, as in Jungian sand tray therapy, in order to construct environments and personal shrines.

Dana Salvo's work in photographing *Home Altars of Mexico* (1997) generates possibilities for an entire new discipline within the creative arts therapies focused on everyday altars. Salvo also demonstrates how the artist

can conduct important ethnographic research which fuses the continuities of indigenous culture with contemporary spiritual and artistic interests. As creative arts therapy follows the example of artist-researchers like Salvo in seeking out the fascinating expressions of the world's ordinary people, our methods will be enriched.

o An art therapy graduate student who is also a professional boat builder is making a wooden boat as his masters thesis project. He will explore metaphoric connections between boat building and art therapy. He is asking himself why he has been so deeply involved in this activity for many years. He realizes that his commitment is not mechanical. Something else holds his interest and he wants to discover this deeper meaning.

Another graduate student based her thesis on an analogy between therapy and learning how to kayak. As with Zen Buddhist meditation, any creative discipline can be a means of exploring therapeutic practice.

o Throughout history philosophers have maintained that universal principles are illuminated through particulars. Show how the specifics of art therapy practice manifest broader cultural, historical, spiritual, and psychological tenets.

o Artists tend to get seriously involved with images from daily life that other people overlook. Sometimes these images appear in dreams as well as artistic expressions. Find a simple object or shape from your environment and use it as the basis for a series of artistic works. Observe whether or not the series helps to further the relationship between you and the physical world. Does the intense and creative contemplation of a simple object open to the varieties of creative interpretation? If so, what are the therapeutic implications of this type of expression?

o Examine how aesthetic qualities such as symmetry or asymmetry affect the art therapy experience. A study might focus exclusively on the process of making asymmetrical and symmetrical images; the researcher might investigate the therapeutic effects of reflecting upon these qualities when they appear in the artworks; or a study can combine both making and perceiving these particular configurations.

A study might explore the making and perception of open space versus tight and crowded spaces.

These specialized research projects typically grow from the individual interests of the researcher. I might be involved in the process of making large paintings and this current interest can spur an investigation of its therapeutic properties. Another project might concentrate on the making of tiny images. In

order to understand the unique dynamics of working on a large scale, I might experiment with making art on small surfaces as a source of comparative data, or vice versa.

Does the scale of expression generate a particular energetic reaction in the artist? When is that reaction beneficial for the artist and when might it be deleterious? Helen Landgarten explored how she would have encouraged Edvard Munch to paint on a small scale rather than on a large and monumental surface when he was feeling depressed and overwhelmed. And yet the same artist might benefit immensely from working large and freely when feeling confined. Or perhaps an art therapy experience may wish to explore the confinement with the sense that direct engagement will lead to transformation within the artmaking process. Can the flexible and creative therapeutic relationship find a way of working productively with any artistic process?

○ Studies of aesthetic energies and dynamics link art therapy to homeopathic medicine in which activity in one area stimulates corresponding reactions in another. These physical principles of correspondence are largely overlooked in art therapy. How does making artworks expressive of order and balance affect the psyche of the artist? When might order be good for a particular artist? When might it be helpful for the same artist to work in a random and chaotic way? There are few absolute principles of application but there might be relatively constant effects generated by certain structural qualities.

○ An art therapy graduate student recently spoke to me about her thesis research which measures blood pressure and heart rate before and after making mandala drawings. Biofeedback mechanisms can be used together with vital sign measurements to generate data about the energetic effects of artmaking as well as the contemplation of imagery.

Art-based researchers might explore new initiatives in mind/body medicine and the effects of different kinds of artistic activity on mental and physical functioning. Herbert Benson, M.D., an authority on the interplay between medicine and spirituality, describes how imaginary events are experienced as realities by our biological systems. Different ways of making art can be explored through the examination of vital signs and then compared to one another. There are endless possibilities for art-based research in these new areas of therapeutic treatment. Those within the art therapy field who are excited about scientific inquiry and quantitative assessments might focus on this type of study which stays closely connected to empirical data.

○ My colleague Linda Klein has been experimenting with the making of large, square paintings with only three colors. At the moment she finds that the limitations are having a liberating effect.

A research project might explore the effects of working with a circum-scribed palette on the same sized surface. This restrictions help us understand the unique qualities of the particular phenomena with which we work. Shifts to a different sized surface or to a new color take on dramatic implications within these circumstances. These shifts might be studied. Another project may investigate the energetic qualities of working with many different colors.

○ Apply dance therapy's method of 'effort shape' analysis to the assessment of aesthetic qualities of art objects. This approach expands art interpretation to include kinetic dynamics such as flow and energy as expressed in paintings, drawings, and sculpture.

○ As suggested in the previous section on Artistic Knowing, research the 'gadgets' for working with images that Pat Berry (1974) and James Hillman (1978) describe – restatement, amplification, elaboration, contrasting, singularizing, and so forth. Concentrate an entire project on only one of these methods and explore many different ways of using it. Study the history of the method in psychotherapy.

Another research project might experiment with all of these 'gadgets' and others, reflecting upon the unique qualities of each. All of these techniques hold fast to the image and imagine it onward, realizing that the process of relating to an image is kinetic. Artistic knowing accepts the constancy of movement and change and the need for varied approaches to an image.

○ As I described earlier when presenting alternatives to conventional behavioral science case analysis, Bruce Moon has expanded the case study format to more creative storytelling forms in which emotion, natural language and direct speech replace the genre of psychological jargon (1990, 1992, 1994, 1997). These narratives offer many examples of how we can observe and describe aesthetic experiences with language that corresponds to the sensibility of the objects and processes of art.

Moon has written songs and poems to express his experiences with patients, and he has performed these works before large audiences at the annual conventions of the American Art Therapy Association. The enthusiastic reception of his work suggests a desire within the art therapy profession for creative ways of responding to the experience of therapy. I believe that artistic responses to the practice of therapy are personally fulfilling while they also deepen our understanding of art therapy dynamics. Research can be conducted

to explore the different outcomes resulting from art therapists responding to different aspects of their practice with personal artistic expression. Are there certain features of art therapy practice that benefit more than others from this type of expression?

○ There is a need for further studies which demonstrate and assess different ways of using language to enhance art therapy experience. We might explore the effects of different kinds of language communications – descriptive, analytic, poetic, historic, dramatic, and so on.

A researcher might experiment with brief, poetic, and imagistic responses to paintings and compare these to longer explanatory statements. What are the strengths and weakness of the respective approaches? Through these comparative studies we open our discipline to a wider and more thoroughly researched approach to practice.

Research helps us to gain a deeper understanding of the different effects produced by particular methods. We are all apt to work in a relatively consistent way because it is familiar or perhaps identified with a preferred school of psychotherapeutic practice. Art therapy will benefit from a more expansive approach to methods whereby therapists act in a particular way because they are mindful of how it may bring about a desired outcome.

○ In addition to exploring different kinds of language within the art therapy experience a study might investigate varied ways of presenting case information. Bruce Moon's case study methods may be compared to those of other excellent case study writers such as Margaret Naumburg and Helen Landgarten. The researcher might offer critical and personal reactions to the different methods. Through comparison we isolate and understand the distinctive qualities of each approach. The researcher might invent new ways of presentation and compare these to the methods of Moon, Naumburg, and Landgarten.

○ Are there indications within art therapy practice that patients are more grounded when attending to the purely physical qualities of images (Maclagan,1995, p.217)? Are aesthetic considerations 'inseparable' from 'psychological effects'? How do we access and channel the energies emitted through the physical expressions of artistic images?

The post-modernist emphasis on the endless multiplication of legitimate interpretations of a written text, suggests that the purpose of all meditations on visual images is meaningful engagement rather than explanation. The visual image stands as an objective and abiding presence, which stimulates the process of individual interpretations. Explore varied ways of relating to the physical

presence of an image by yourself and with others. Assess which methods yield the most satisfaction.

How do you define satisfaction? As aesthetic fulfillment? Psychological understanding? What is the correlation between personal satisfaction and therapeutic efficacy?

o Apply the psychological writings of George Kelly (1995) and the studies of Hans-Georg Gadamer (1977) on philosophical hermeneutics to the practice on interpretation in art therapy. Do we experience and create the world according to our constructs? Does every theoretical position operate within a set of beliefs or a paradigm? Is there such a thing as a correct or even valid interpretation? If we do interpret from bias and different theoretical perspectives, how can this be applied to the practice of art therapy in a positive way? How can the different beliefs collaborate with one another? What values do they share? Is it possible for distinctly different paradigms to find common ground within the art therapy experience?

o Imagination is an intelligence which is highly underrated in our approaches to research. It is the basic tool that all people use to approach and understand new areas of experience and to revision what they already know. Art-based research should charge itself with the task of demonstrating more direct and creative ways of engaging the imagination in scholarly inquiry. As Gaston Bachelard wrote, 'To verify images kills them, and it is always more enriching *to imagine* than *to experience*' (1994, p.88).

Imagine yourself as a painting that people interpret in different ways. As you empathize with the painting, document what you like and do not like about different interpretations. You might have volunteers take on the role of interpreters and encourage them to experiment freely. Make transcripts of the interpretations and then record your responses.

You might wish to use what I call 'Annie Hall' comments, silent narratives expressed while the interpreter is speaking. Imagine a painting feeling good or bad about how it is approached by a person.

In my 1991 paper 'Ethics and the autonomy of images' I suggest that the codes of ethical behavior in therapy and research have to be extended to the way in which we treat images. An ethical study might address the 'rights of images' within the practice of art therapy.

o Bruce Moon has continued to address the moral implications of how we interact with images in therapy and research (1992, 1994, 1997). Do we treat images with respect when interpreting them in therapy? As a person, how would you like to have another person authoritatively describe what 'you mean'? How do you

feel when labeled? When explained by another? Empathy for an image and the process of 'personifying' open up new ways of perceiving the implications of what we do in art therapy. The exploration of parallels between the way we approach images and people, has significant potential for research.

In *The Arts and Psychotherapy* (McNiff, 1981) I emphasis how art therapy introduces a 'third object' into the psychotherapeutic relationships. The artistic image is a participant, something to talk to and something that expresses itself to us, in what was previously a two-way dialogue between patient and therapist. This expanded discourse is the essential quality of the art therapy process that can only be researched with methods that understand what Harriet Wadeson described as 'the special factors' of the experience. Wadeson feels that the art object is 'an extension' of the person who made it and therefore 'it must be respected as such' (1980a, p.38). I have similarly experienced the artwork as an 'offspring' of the artist, something that is intimately related but yet separate. This respect for the image, and its therapeutic gifts will I hope guide the art therapy research of the future. We have to continuously explore ways of engaging images within the therapeutic process.

Wadeson says, 'Too often, art therapists act as if they *know* what a picture is saying' (Ibid., p.39). She describes how the joy and challenge of art therapy involves the discovery of what we do not know and the process of traveling to new places. We will do much better if we enter the relationship with the image with a greater sense of humility and respect for what it can give to us. The same applies to our dealings with another person.

○ In *Art as Medicine* (McNiff, 1992) I explore creative ways of responding to images through dialogue, poetic speech, performance, dreams, and different expressive modalities. I have discovered that interacting with an artwork with yet another artistic expression yields the same sense of expansion that is experienced in C. G. Jung's active imagination which encourages people to continue 'dreaming the dream forward'. The way in which we interact with images will determine what they yield.

Experiment with different ways of responding to images – verbal explanation, creative language, movement, vocal improvisation, ritual, and performance. Does each way of responding help you to express different reactions to the picture? Describe these differences. Does each expressive medium convey and create a different reality? Is there a constant and stable reality within an artwork, or within a person's relationship to an artwork, that can be accessed by any one or all of these media of response?

Paolo Knill's pioneering experiments with intermodal practice offer a wellspring of possibilities for research (1995). Explore 'transitions' from one

art modality to another while working with a particular feeling or problem. How does the shift of media affect the therapeutic experience? Is it possible to assume that a particular type of media transition will have relatively constant effects?

Use your dreams as a way of reflecting upon what is taking place in therapy with your clients and as a mode of interpreting the significance of artistic expressions. Dreams offer a view on experience that dramatically expands what we know through rational analysis. The dream needs to be embraced as an intelligent and useful way of understanding what we do.

o Research projects might explore the extent to which the practice of art therapy is conducted according to the needs, interests, and abilities of therapists. How is therapy shaped by what therapists can and cannot do as contrasted to what participants in therapy are capable of doing? To what degree is a therapist's ability to act in a certain way a reflection of choice and personal values? This is a rich vein for study. For example, children freely move from one art modality to another, from painting to drama, to movement, and so forth. Often the expression of children involves a combination of all these media at the same time. If the therapist chooses to limit the therapeutic session to a circumscribed practice of 'art therapy', is this move completely initiated according to the needs of the client? What are the needs which determine the boundaries of professional disciplines?

In addition to considering the needs of therapists and clients, we might approach the creative process as an autonomous entity and ask whether or not 'it' has needs which may help to deepen our understanding of the art therapy experience. What are the needs of the different contextual situations in which art therapy is practised, and how do these environmental factors influence what we do?

o There has been surprisingly little research done on the role of meditation in art therapy. I foresee important future studies exploring ways of contemplating images made in therapy. The practice of sitting meditation can be integrated with reflection on artistic images. Meditation and relaxation exercises can be introduced during the process of making art and the entire art therapy experience can be approached as a form of creative meditation. Major new studies connecting meditation practice to physical health and medical treatment have made this area a credible and practical focus for art therapy research.

o Bob Gilroy, my former art therapy graduate student who is a Jesuit priest, connects the spiritual exercises of St. Ignatius Loyola to the process of painting. How might art therapy methods be linked to the different prayer practices of

religious traditions (Brooke, 1996)? Considerable comparative research can be conducted on how art therapy relates to the rituals of religious traditions. Links can also be made between the practice of art therapy and religious ministry.

○ The effects of physical environments on the quality of the art experience have been unexplored in art therapy research. A research project might examine the practice of art therapy in different types of spaces. I believe that the spatial variable may be one of the most important influences on the quality of therapeutic experience. Is there a significant difference in the expressive power of art made in an open and inviting studio space as contrasted to an office setting? To what extent does the environment influence expression?

A research project could apply the literature of interior design to art therapy practice. The principles of *feng shui* and Gaston Bachelard's *Poetics of Space* (1994) might also be adapted to art therapy.

In his study of architecture Rudolf Arnheim has described a 'visible affinity between the look of things and their character' (1977, p.254). How does the appearance of an environment affect the people working in it? If spaces do have a significant impact on people, then how do we address this factor when designing therapeutic environments? To what extent do art therapists consciously design spaces to influence therapeutic outcomes? Is the same environmental design used by an individual therapist for all people? What are the advantages and disadvantages of this approach? Do individual clients benefit from different types of spatial arrangements? Is order always helpful? Do some people respond better to clutter?

A research project might interview therapists on these issues; study different therapeutic environments with the goal seeing relationships between design features and outcomes; document how an experimental group reacts to varied environmental conditions; and determine the extent to which art therapists view the environment as a significant factor in the therapeutic experience.

○ The disregard for anything that cannot be directly and immediately perceived displays a misunderstanding of the nature of reality. Although the arts offer researchers a wealth of perceptible phenomena, the subtleties of the creative process cannot be encapsulated within isolated frames of observable behavior which are seen as parts of an overall pattern of linear causes and effects. In my experience, the impact of artworks on viewers is more environmental. When I perceive an artwork, I enter its environment which is composed of a complex interplay of forces.

Behavioral psychologists like B. F. Skinner had a keen interest in what the overall environment does to influence human actions. As an artist I have many differences with behaviorism, which tends to deny the significance of inner

states, feelings, and expressive freedom while focusing on the control and manipulation of behavior. But there are other aspects of behaviorism's emphasis on environmental influences which deserve closer examination by creative arts therapists.

How do therapeutic environments and the people working in them influence one another? Do the imaginative expressions of individuals contribute to the creation of a supportive and stimulating environment?

Participants in my creative art therapy workshops consistently describe how it is the overall creative energy of the studio which stimulates their expression. A research project might explore how individual expressions of artists in a therapeutic studio contribute to the comprehensive influence of the environment. Can the principles of behavioral psychology be related to the creative auras and spirits of the art studio atmosphere? Does the strength of artistic medicine correspond to the creative energy generated by the environment. How does the therapist kindle the spirits of the studio and maintain their vitality? Does the depth and value of the creative arts therapy experience correspond to the extent to which these environmental forces are activated? Is there truth in Skinner's belief that environments are responsible for what people do?

I can envision a research project which compares the effects of the creative arts therapy studio to the Hellenic temple of Asklepios where people seeking help slept overnight and received healing through dreams. The person in need of help believed in the powers of the healing temple. Is this faith and commitment still necessary in order to be influenced by a therapeutic studio environment? Identify environmental medicines transmitted by the art therapy studio. Does the studio environment influence people in different or consistent ways?

○ I encourage art therapy research that re-examines and sustains the pioneering ideas presented in our literature. I suggest finding a single art therapy article, or a series of articles written by the same author, that can be amplified through a research project.

I envision many important studies growing from the seminal papers written by Frances Anderson and Sandra Packard (Anderson and Packard, 1976; Packard and Anderson, 1976) on the relationship of art therapy to art education. We have barely attended to the wealth of experimentation that can emerge from comparative analysis of the two disciplines? How are they similar? How are they different?

Although it might be relatively easy to find differences between the institutional entities of art therapy and art education, a comparative study of

individual art therapists and art educators might reveal closer bonds, especially when the researcher focuses on the process of creation and work with materials, or on comparisons between art therapists and art educators working in a special education setting.

Putting aside obvious differences in the numbers of people with whom typical art educators and art therapists engage, which consequently influences what they do, a research project might focus on a comparative analysis of work conducted with an individual child. Sustained observations of an art therapist working with a child can be compared to what an art educator does with the same child. Are differences stylistic or due to professional orientation? How can we align similarities with an insistence on separations of professional identity? Videotape might be used as a basis for generating data for observation by the researcher as well as utilizing other evaluators.

The researcher might also explore similarities and differences between the practice of art therapy and art education through personal experimentation in both environments. Are difference between the two areas essentially due to effects of the professional context? Role expectations? To what extent does the essential work with the person and art materials change in response to these factors or remain unaffected?

Do art therapists introduce clients to color interactions, texture, shape, and line in ways that are similar to the art educator? If expression is the objective in art therapy, how do we help people use the tools that they need to express themselves? A study might identify educational elements within art therapy and therapeutic aspects of art education.

Many other papers in the art therapy literature can inspire research projects. Cathy Malchiodi's article on 'Art therapists in cyberspace' describes how online communication enables art therapists to 'boldly go where few have gone before' (1996, p.231). She likens travel in unexplored cyberspace to the experimentation with the art therapy process. I anticipate a new world of art therapy research growing from the opportunities offers by digital media.

Rosalie Politsky's paper on the cultural significance of 'offensive and controversial art' can generate many important research projects for art therapists (1995b). Every art therapist needs to gain a better understanding of personal levels of tolerance for imagery and how our reactions affect the therapeutic relationship. The tolerance levels of art therapists can be compared to one another. Beginning art therapists can be compared to seasoned practitioners. Art therapists can be compared to artists and randomly selected people in society.

Martin Perdoux's paper dealing with 'non-western influences' on art therapy practice addresses a significant theme for research (1996). Perdoux

describes how the paradigm of 'humanism' limits his art therapy practice. How might we envision the art therapy experience from the world-views of quantum physics, shamanic spirits, Zen Buddhism, and so forth?

Holly Feen-Calligan's article focusing on the historical relationship of art therapy to other professional disciplines opens major research opportunities (1996). I can envision a new focus on comparative professional studies. To what extent is the definition of a profession shaped by its relationships to other professions? By characteristics unique to the discipline?

I agree with Feen-Calligan's insistence on studying how art therapy is a 'result of an historical process' which is responding to a need to 'serve some function for our culture now' (1996, p.172). She describes how art therapists must understand the broad and deep historical ramifications of this 'function' and discover how 'to realize it'.

Art therapy research can be conducted in collaboration with history and the highest standards of that discipline. Why is it that we identify almost exclusively with behavioral science methods and overlook opportunities to articulate the need for our discipline through historical evidence?

○ I have encouraged art therapy graduate students to use Rudolf Arnheim's study of Picasso's *Guernica* as a model for art-based inquiry (1962). Arnheim's description of the different phases of this particular painting and the way in which it evolved from preliminary sketches and drafts demonstrates how we might focus research on a formal analysis of how an artwork is constructed.

I have urged students to set up experiments in which they document the process of making an artwork with a series of photographs taken within one or two seconds of one another. Digital photography and other forms of computer technology support this type of inquiry and make it possible to begin a new era of research through visual imagery. The simple existence of the digital camera and its ability to generate images immediately on a computer screen, suggest endless possibilities for future research.

○ In the late 1970s and early 1980s I was interested in the parallels between creative arts therapy and shamanism. I researched the ethnological literature written on shamanic practices and identified similarities between the healing techniques of indigenous peoples and the contemporary practice of creative arts therapy. These parallels include dramatic enactment, expression in varied media, the exercise of creative imagination, ritual, rhythm, drumming, chant, free movement, the making and engagement of artifacts, the use of masks and costuming to transform physical appearances, and the need for a supportive community of people to activate healing energy (McNiff, 1979, 1981).

Ethnological field research involving the observation of indigenous healers in their natural surroundings was very important to my studies. However, as a practitioner I had to find ways of directly experiencing the corresponding elements between art therapy and shamanism. I was involved in sessions led by native healers and I benefited from them, but these activities were not closely linked to my practice of art therapy. With a small group of colleagues I decided to establish an experimental session that would meet for three or more hours weekly. We explored the experiential aspects of shamanism that we wanted to adapt to our creative arts therapy work – trance, drumming, chanting and so forth. Our goal was a first-hand encounter with what we perceived as shared characteristics between shamanism and art therapy. The main purpose was to enter a relatively unstructured environment with the goal of seeing what would emerge if we expressed ourselves in ways that resembled the practice of shamanism.

I asked myself: Is there a significant difference between the indigenous practices of shamanism and what I do today in art therapy? Is the shaman an archetypal aspect of every person's psyche? Can I discover the essential aspects of shamanic experience within my own experience? Are there universal aspects of shamanic experience which manifest themselves in every person? To what extent are shamanic practices shaped by cultural beliefs?

My experimentation with shamanism enabled me to explore empirically an area of experience which has for the most part been researched through descriptive studies of other cultures. Future studies might similarly conduct direct experiments with practices described by ethnologists – sand painting, the creation of amulets and talismans, the recitation of healing charms, the use of masks, transformation rituals, and so forth.

○ There is a need for videotapes which document how pioneering therapists work. A videotape has been created which shows how the dance therapist Carolyn Grant Fay uses drawings and sand tray figures in her practice of Jungian psychotherapy and active imagination (Fay, 1996). Fay's practice involves a natural movement between different art modalities which the medium of videotape vividly presents.

This professionally produced tape suggests many possibilities for research. The pioneering work of Fay at the C. G. Jung Educational Center of Houston is preserved as a historical record. This outcome is in itself an important goal for research.

The Carolyn Grant Fay tape also demonstrates how methodological innovations can be documented and studied. No amount of verbal rationale for integrating different art forms in the practice of psychotherapy can begin to

influence the viewer as convincingly as a well-produced videotape demonstration of the process in action. The aesthetic effects of the tape introduce a new way of determining the validity of a particular therapeutic method. Since dance therapists are required to use video or film to show and record their work, they help art therapy to see that we must similarly make use of these media if we want to show the kinetic dimension of our practice. Interestingly enough, it is this tape produced by a 'dance therapist' which offers one of the best existing recordings of clients drawing and working with three-dimensional figures.

Art therapy has been exclusively focused on the publication and analysis of static images. What will be the implications for research if we begin to demand kinetic presentations of practice?

In the tape documenting her work Fay shows how a woman becomes more deeply involved in movement experiences after making a drawing of a spiral. After the drawing was completed, Fay asks: 'Why don't we move some of this?' She describes how the woman's movement 'got much less stylized, more spontaneous' when she moved in response to her drawing. In reflecting on the experience Fay says, 'She actually seemed to enter the drawing and become that inward spiraling'.

This video presents what I call 'total expression' in art therapy. Fay shows how different art modalities support and amplify one another and the tape documents how to make transitions from one medium to another in the practice of therapy. There is a sense of natural flow from one activity to another within the overall context of the session.

The safe place that Fay creates for her clients is vividly expressed in the tape. She shows how to let a person move freely within a therapeutic environment and how to act as a witness to another's expression in a way that augments the sense of safety. I was stuck by the graceful and economical nature of Fay's movement in the videotape. Her way of being grounded in essential movement transmitted a sense of the sacred which permeated the environment and no doubt significantly involved the client. Future research projects might focus on how the qualities of a therapist's movement, voice, and overall presence affect the expression of clients. Videotape will become a primary medium for generating data and documenting effects.

o Videotape can be used as a primary mode of documenting the history of art therapy practice. Researchers might also chronicle the everyday practice of art therapy from an ethnological perspective using videotape as a way of studying the culture, values, and rituals of the experience.

Helen Landgarten has produced a videotape, 'Environmental Effects on the Artist', which reveals the way in which the physical environment influences her artistic expression. The tape shows the relationship between landscapes and the paintings they inspired. Paul Newham documents his work with the therapeutic use of voice in the video 'Shouting for Jericho'. Although intended as a training tool, the Newham videotape can be approached as in-depth inquiry into the therapeutic use of the voice. Every aspect of these video productions can be perceived as research.

Through videotape we have the opportunity to see and hear people reflect first-hand on their experiences and motivations. The video medium ensures that spoken language is only one aspect within the total context of research activities and descriptive communications. Most important, the well produced video is useful and likely to have a major impact on people. The justification mode of research might balance its focus on statistics with more attention given to the persuasive tool of video.

○ The producers of the Carolyn Fay Grant videotape have recently completed a film, 'A Time to Dance' (Canner, 1998), which documents the life and work of the pioneering dance-movement therapist, Norma Canner. The inspiration for this production came from the need to 'capture' Canner's way of working with people. Canner, like many artists, does not write about what she does. Her practice is lived in the moment with people and this can only be shown through film and video. The producers of the film demonstrate how this medium can be a mode of art-based research. They extensively interview Canner and record her work with people. They also interview people who have known her and worked with her through various periods of her life. The producers research archival records and reveal how Canner's practice took shape throughout her career. Historic film and video clips of Canner's work are edited into the final presentation, demonstrating how the documentary film-maker's art is a major research activity. The film illustrates how art-based research can result in the creation of high-quality art.

A project of this kind depends of significant funding from foundations and other sources. Film-maker Ian Brownell and his production team raised money to make 'A Time to Dance'; their goal being the presentation of Canner's practice of creative arts therapy to a wide public audience.

We need to confront ourselves with our professional inability to use artistic media to document and present the outcomes and processes of our work. If behavioral science concepts and words are incapable of revealing the unique qualities and spirits of art therapy, why do we persist in using them as exclusive modes of research?

○ The artistic use of videotape can further the study of art therapy as the microscope has advanced biology.

David Aldridge describes how talking about arts therapy experience 'is always several steps removed from the actual activity' (1993c, p.200). But even the direct experience of therapy as it 'lives and exists in the moment is only partially understood. It cannot be wholly reported' (Ibid., p.200). Videotape technology brings us significantly closer to the 'actual activity' but it will never totally record the experience.

Research projects can explore the many ways in which video narrows the gap between experience and documentation. We can also explore and document what is still unreported by the new technology. What exists in the domain of art therapy activity that 'cannot be wholly reported'? What can be reported? How do the two areas influence one another? What does the artistic medium of video documentation and interpretation 'add' to the experience of art therapy?

○ For five years I conducted art therapy sessions within a program where virtually every thing we did was videotaped. The experience taught us how aesthetic factors significantly influence the observation of everyday experience. The person operating the camera determines what will be preserved within a given instant. Every second of a therapeutic experience is subjected to the editing process of interpretation. There is no single, objective viewpoint on any life situation.

A research project can be designed in which three or more video-artists record one minute of action within a group experience or something as simple as a single person painting in a room. I predict that if the artists have highly developed creative styles, the tapes will be significantly different from one another. In addition to documenting variations amongst what different video-artists record, the analysis of tapes can identify patterns that exist in all of the different interpretations. Researchers might explore the extent to which aesthetic and free interpretations of the same experience express variation or similarity. What are the implications for art therapy practice?

After watching my therapeutic work on videotape for many years I saw how research projects can be closely associated with self-supervision. What are the qualities of your therapeutic style that you like? Dislike? How do you see yourself as effective? Ineffective? Do you see change in your work over time? What consistent qualities do you observe?

○ The research of William Condon in reviewing slow motion films of interpersonal interactions offers a model for how painstaking analysis of microscopic frames of

human expression can offer significant psychological insights. Condon's study of movement interactions revealed that people conversing with one another also communicate kinesthetically, maintaining a kind of rhythmic connection. As we talk with another person, bodily expressions contribute to the conversation as well as the contents of our speech. Condon observed in his film analyses that emotionally troubled people often do not sustain this movement contact with other people and they also tend to show a lack of rhythmic integration with the different parts of their personal bodily expression (Condon and Ogston, 1966). These discoveries have significant implications for movement therapies which strive to further integrated kinesthetic expression.

Condon's research also applies to the kinesthetic aspects of art therapy. Researchers might consider studying films of people making art. Are there patterns and themes that emerge from all of the tapes? Is it possible to attribute particular therapeutic properties to different movements? Do emotionally troubled people exhibit movements and gestures which can be connected to their mental states? Is it possible to identify a protocol of 'healthy' movement characteristics in artistic activity?

○ I have described how the transformative forces of creative energy correspond to the dynamics of healing. In art therapy, negative energy is transformed into life enhancing expressions. Edith Kramer described how:

> Art therapy was most effective when it helped them (children) to create art out of the very material that disrupted their lives. Creative work then engaged them in an intense struggle, focusing on subject matter that had taken on overwhelming importance. The emotional climate was akin to the dedicated artist's single-minded concentration rather than to the normal child's more casual enjoyment of art. (1971, p.232)

Research projects might be conducted which compare the therapeutic effects of artworks created during periods of agitation and emotional crisis to those made in a more relaxed and carefree state of mind. Does the degree of sincere struggle show any correlation to the extent of therapeutic transformation? Is there considerable variability to the way people express themselves during disturbing periods? Can we say that people tend to be more emotionally open or closed when agitated? Are connections between artists' expressions and their emotional states purely individual affairs?

○ Lynn Kapitan suggests that art therapy can make an important contribution to lessening violence within our culture (1997). How does art transform violent urges? Are there violent and destructive aspects of productive artmaking? Does art help us to become more aware of our violent aspects and find ways to use them

constructively? Does the artistic expression of violence always bring therapeutic transformation? Compare the effects of aggressive gestures in artmaking to the highly controlled depiction of violent subject matter. I can envision studies which investigate aggressive gestures in artmaking, and the extent to which these movements release and channel violence. Do these expressions further our understanding of the presence of violent energy sources within our bodies?

○ In my experience, the therapeutic space must convey a sense of safety in order to support the open engagement of conflict and tension. A research project might systematically explore what physical, psychological, and artistic conditions contribute to a sense of safety in an art therapy space. It would be equally important to investigate conditions that undermine safety. Interviews with therapists and participants in art therapy, as well as the researcher's personal exploration of making art in different kinds of environments, can provide data. Observations of therapy sessions and visits to different art therapy settings will also generate important information about how environments are constructed to encourage safety.

○ I have repeatedly discovered in my art therapy experience that frightening or violent images never 'come' to hurt the person who makes them. This acceptance of all forms of expression has been a key contributor to a sense of safety in my practice. A research project can be constructed to determine whether or not other art therapists agree with this position. Is my experience of the non-injurious nature of artistic imagery an extension of the safe environment I strive to create?

Art certainly has destructive powers. Historical and experimental studies might explore how and when art can hurt people. Strong medicines always have harmful qualities when misused. Researchers might explore different misuses of art therapy.

○ Sister Wendy Beckett, the nun who has become a popular art appreciation commentator, described how she first became seriously involved with art because of its healing power. She 'dove' into artistic images and they gave her energy. A research project might include interviews with different people involved with art in different capacities with the goal of determining what these people experience when contemplating artistic images. Energy? Pleasure? Aesthetic stimulation? Reverie? Inspiration? The interviews might also explore whether or not these engagements with art influence the more general life experience of the subjects. If there are influences, what are they?

○ My research has continuously explored how to stimulate, cultivate, and access the medicinal spirits of art. I define art medicine as an infusion of energy. Throughout

my career in art therapy I have been guided by ongoing assessments as to whether or not the creative spirit is alive within the therapeutic context. I try to kindle creative energy in my therapeutic work trusting that it will find its way to areas of need.

Harriet Wadeson describes the 'enlivening quality' of art therapy and she suggests that changes in people may be due to the activation of creative energy:

> I don't know how to explain this observation, but I have experienced the change in energy level in myself over and over again as well, as I have become 'activated' in art activity. It may be simply a matter of physical movement, but I doubt it, since often the physical activity is not much greater than talking. I am more inclined to believe that it is a release of creative energy and a more direct participation in experience than in talking. (1980a, pp.11–12)

Conduct studies where you carefully observe changes in a person's energy as described by Wadeson. This type of research might be more effectively done on a direct basis with your own artistic expression. Experiment with different types of artistic activity and record how they affect your energetic levels. Do you feel more open, relaxed, and receptive after being involved in artistic activity? Describe your energy levels before making art; at various points during the process of production; at the completion of artmaking; while interacting with the art object after it is completed; after talking about it or creatively interpreting it with other people? Biofeedback technology is able to provide data which can be compared to verbal assessments.

Discover qualities of artistic expression that energize you; sedate you; and stimulate other shifts in energetic levels.

Historically, the art therapy profession has viewed the use of art in therapy as furthering two primary outcomes: the communication of messages and the expressive release or sublimation of feelings. What happens when we approach the entire process of art therapy from a new perspective which focuses on opportunities to express and receive energy? Do other people's expressions energize you? Is there a positive contagion of energy within the art therapy experience?

In art-based research we are not just researching ourselves. We are studying the relatively autonomous processes of artistic energy as generated by the physical conditions of creative activity. We are concerned with interactions between ourselves and these materials and processes, and ultimately art therapy is interested in how the physical actions of artmaking affect people.

Document the energizing qualities of varied art materials as you experiment with them. Where do you experience arousal? Tranquillity? Keep records of

the emotional reactions you have to different art materials. Compare your responses to those of other people. Are these personal reactions to media relatively consistent or varied? What are the implications for therapeutic practice?

○ The energy of creation in groups and individuals can be likened to a circulatory and ecological system. I have found that this system needs to be activated in more than one area of expression in order to maximize the flow of creative energy. The engagement of all of the senses provides for a freer and more complete circulation of energy within the creative complex of an individual or group. This total expression in turn enhances creative work that is done within an individual discipline. Exclusive focus on one art modality may block the ebb and flow of the larger complex of creative expression.

Experiment with mixing art modalities and shifting from one to the other. Do you feel energized by doing movement warm-ups or kinesthetic meditations before painting? After? During? Do these bodily expressions help to focus or disperse your energy? How does drumming influence your painting. Flute playing?

○ As art therapy realizes the importance of its energetic qualities, we will begin to use research methods from medicine, physics, and the physical sciences to understand the dynamic effects of images on perception, the nervous system, emotions, and consciousness. There is considerable life in the artistic image and we have done little to understand how to access its medicinal force therapeutically. Biofeedback and other current technologies can be used to investigate how the perception of an artwork physically affects the perceiver.

Low tech experiments might also be applied to understanding the energetic qualities of artistic imagery. The methods of Reiki can be utilized to study the energetic qualities of artistic imagery. Through the sense of touch we can explore ways of physically experiencing the energy transmitted by three dimensional artworks. The hands can also be used to 'scan' the surfaces of two dimensional images and physically receive their energetic expression. These research activities will expand our ways of accessing life-enhancing energy in the practice of art therapy.

Histories

○ Descriptions of therapy are often described as case 'histories'. History chronicles experience. It tells the story of what has happened, typically in a narrative form, perhaps drawing attention to themes, significant changes, outcomes, and other

relatively objective characteristics of the data. Because therapy has been identified exclusively with science, we have not done enough in creative arts therapy to incorporate the research methods of history and the other humanities. The case 'history' connects therapy to long-standing traditions of research.

Junge and Linesch affirm the value of historical studies as one of the ways to pursue art therapy research (1993). There is a significant need for biographical and autobiographical accounts of the lives of art therapy founders and pioneers. Biographical studies might focus on a single person, two contrasting or closely related art therapists, and groups expressing different schools of thought or clinical orientations. Historical study can focus on ideas and methods as well as people. Tensions between points of view can provide a productive focus for research.

○ Art therapy needs to take its history more seriously and to attach more value to documenting and interpreting the experiences of practitioners. In addition to focusing on the lives of the founders of the profession, new information and novel perspectives on the field can be developed. 'Insider' and 'outsider' viewpoints on the history of art therapy can be recorded and compared. The insider might be defined as the practitioner recognized by the institutional forces of art therapy and the outsider as the person whose contributions have not yet been acknowledged. There is also a need for research which focuses on our professional literature as a reservoir of historical information.

○ A recent issue of *Art Therapy: Journal of the American Art Therapy Association* featured an extended interview with Cliff Joseph, an art therapy pioneer (Riley-Hiscox, 1997). The interview acknowledges Joseph's position as one of the first Afro-Americans practising art therapy and his participation in the first meetings of the American Art Therapy Association. This interview is an important historical document and I believe that as we augment this type of research, our profession will experience a corresponding expansion. I am particularly interested in Cliff Joseph's political motivations for becoming involved in art therapy, his formation of The Black Emergency Cultural Coalition, and his work with prisoners at the Tombs (Manhattan House of Detention) in New York City. Joseph describes how he left a career in commercial art because he felt that his 'talents' were not being properly used. He wanted to work in a more socially active way and these values continued to inspire his 'community' oriented practice of art therapy (Joseph and Harris, 1973; Joseph, 1974). I similarly became involved in art therapy with a desire to use art to build a deeper sense of community. I am sure there are many more creative arts therapists who share these ideals.

Historical studies might focus on a figure like Cliff Joseph as a focal point for broader themes that he represents. There is a tremendous need for studies which document how people have worked for political and social purposes within the creative arts therapy profession. I trust that the de-construction of institutionalized medicine will generate a new era of socially active creative arts therapy programs responding to the needs expressed by society. Where Cliff Joseph was able to serve his vision by working in large psychiatric hospitals, future activists will create new kinds of service such as inner city studio programs, community projects, and church related programs that are emerging today.

o The founding of individual educational programs can be studied. These inquiries are essential at this moment when it is still possible to interview founders and their colleagues. Interviews with academic administrators who supervised the first directors of art therapy educational programs, clinicians who supervised students in the field, and the first students, will generate important new insights into the formation of the early educational programs.

o In addition to histories focused on individual programs, a research project might compare two or more different program development efforts, two or more regions of the United States, two or more countries, and so on. It may be useful to focus on a particular historical period of time (1970–1975 or the 1970s) and strive to offer an overview of all educational programs operating at that time. Current training programs can be compared to earlier ones. Changes in a particular program over an extended period of time can be documented.

o An historical study might research the evolution of the American Art Therapy Association education guidelines, the process of program approval by the Association, and the overall place of education in the profession. The effectiveness of educational guidelines and program approval can be evaluated. I can envision a research project which gathers data from art therapy educators on the positive and negative experiences they have had with program approval; the overall value of the approval processes; recommendations for change; and so on. Studies of this kind need to be conducted within an historical context in order to appreciate the total spectrum of contributing factors.

One of the main obstacles to this type of historical inquiry may be the research interests of art therapists. Although I have been personally intrigued with the institutional dynamics of the art therapy profession and its relationship to larger historical and social forces, I have encountered few art therapy graduate students who want to do this type of research. Art therapists understandably tend to more interested in the psychological and therapeutic

dynamics of the art experience. Holly Feen-Calligan's 1996 study of the art therapy profession will, one hopes, encourage an increased interest in historical research.

In another historically-oriented study Feen-Calligan collaborates with Margaret Sands-Goldstein to explore the interplay between the personal artmaking activities and the clinical practice of art therapy pioneers (Feen-Calligan and Sands-Goldstein, 1996). The study utilizes the behavioral science questionnaire in order to gather historical information. Selected artworks made by each pioneer are also included. Feen-Calligan and Sands-Goldstein have written one of the most innovative papers in the recent art therapy literature. Their research methods include art, autobiographical reflection, history, and dialogue, all integrated into a paper dealing with the relationships between personal creation, career development, and clinical practice. This study models how creative researchers will always discover unique methods for examining issues that inspire them. An outcome of the project can be viewed as the production of new and thought provoking information which is presented in original ways.

○ Issues and outcomes such as job placement percentages, types of employment, backgrounds prior to entering graduate school, age of students, gender and cultural backgrounds, persistence in the field of art therapy, and career changes can be studied from a historical perspective. Reviews of comprehensive historical literature will generate many different focal points for research.

○ The ways of organizing historical research can be applied to case studies. I find it useful to experiment with the documentation of single case studies from multiple perspectives. It is common practice to include different sources of data (i.e. the observations of the therapist; patient reflections and entries into diaries, comments from family members, the opinions of other clinicians working with the patient, etc.) into a single narrative. However, it might be useful to experiment with separate narratives recording the observations of different people. This separation will reinforce the reality of different perspectives and help to prevent the inevitable amalgamation into the writer's point of view that characterizes a single narrative. There are many historical and literary studies offering models for this type of inquiry.

○ An historical study might document the broad spectrum of art therapy applications. Where has the work been practised geographically? What kinds of institutions have supported art therapy? What do art therapists do today and how similar are these activities to what others did during different historical periods?

Outcome assessments

o Simple questionnaires scored on a numerical scale can be given to participants in art therapy. We might ask how participants view the value of art therapy before and after the completion of the therapeutic experience; how satisfied they are with the art therapy process; whether or not they felt changes as a result of experience; and how they compare the value of their art therapy experiences to what they encountered in other therapies. A standard set of questions can be used by all art therapists and data can be organized for researchers through a central location such as the American Art Therapy Association.

I would also like to ask participants to evaluate the universal aspects of the art therapy experience – work with materials, the process of creation, the relationship with the therapist, the environment within which the therapeutic experience takes place. I believe it is relatively easily to determine basic outcomes that characterize every approach to art therapy and to then begin to 'measure' what might be described as 'outcome perceptions'.

The collection of comprehensive data from art therapy participants in response to these core questions is possible today because there are so many more people involved in art therapy than there were twenty or even ten years ago. Insightful respondents are also more plentiful as a result of art therapy's current inclusion of clients who represent the entire spectrum of therapeutic services. Where people receiving art therapy services are less capable of completing questionnaires, family members and other therapists involved in the person's care may supply data. However, art therapy outcomes will always involve personal assessments of feelings, perceptions, and interpretations of value. Art therapy procedures will probably never be able to meet the strict standards of scientific reliability and this does not have to be perceived as a detriment.

o Therapist satisfaction can be a focus for outcome research in art therapy. Does the degree of therapist satisfaction with the art therapy experience in any way indicate therapeutic efficacy? Is there a correlation between therapist and client satisfaction with the same therapeutic experience? Is the therapist more or less responsive to environmental factors than the client?

o Does a studio approach to art therapy require a completely different set of outcome measures than a traditional clinical environment?

Do the basic operational procedures of art therapy differ in a studio setting as contrasted to a psychiatric clinic? How is diagnosis and assessment approached in these different environments? Identify similarities in outcomes. Differences? To what extent does the context determine the definition and

achievement of outcomes? Can outcomes be assessed without consideration of environmental influences?

○ Experiment with outcome assessment in your personal artistic expression. Identify and envision goals before you begin to work and explore the extent to which the 'imaging' of outcomes influences their realization. Observe how different environmental conditions influence the fulfillment of goals.

○ The growing interest in portfolio-based assessments throughout the educational community present many opportunities for art therapy outcome studies. Portfolios are being widely used in public education because they concretely show what a student is capable of doing and how performance changes over time. Standardized tests have not provided this data. The increased attention being paid to the portfolio method of outcome assessment reinforces the need for more comprehensive data documenting what a person actually does within the area where progress is being evaluated.

The portfolio enables us to evaluate a 'collection' of work produced over an extended period of time as contrasted to art therapy's tendency to focus on single assessment sessions and/or instruments.

What are the implications for art therapy when outcome assessment focuses on the review of portfolios? Have our diagnostic activities been largely constructed according to the perspective of the psychological test and the belief that a singular expression can express the whole complex of a person's life?

In addition to artworks, portfolio documentation can include transcripts of sessions, notes, and other sources of information about what has taken place in art therapy. The client's observations and assessments can be included together with evaluations by family members and other clinical staff. Portfolio assessment is distinguished by its comprehensiveness, its inclusion of visual information, and its overall compatibility with the art therapy experience.

Digital equipment presents many new opportunities for research and portfolio documentation. Multi-media information can be stored in an orderly way and quickly accessed. Computer technology will revolutionize possibilities for creative analysis, presentation, and communication of art therapy data.

○ Identify art-based outcomes for art therapy – i.e. changes in the content of artistic expression, changes in the 'quality' of expression, increased spontaneity, greater persistence in the making of art, and fluctuations in the aesthetic satisfaction of both client and therapist. These changes can be studied within the context of single therapy sessions and over the course of extended therapeutic treatment.

Explore different ways of evaluating and reporting these outcomes – observation of the artmaking process by the client and therapist, the examination of artworks by both client and therapist, the use of other observers.

o I would like to see studies conducted which assess the extent to which the simple process of looking at an artwork together with a person in therapy energizes the image, the persons involved, and the immediate context. How does the time involved in looking determine the outcome? The degree of discipline and attentiveness?

Once again, the assessment of the enlivening qualities of 'looking' is an essentially aesthetic activity. Can we apply this aesthetic standard to the evaluation of research projects? Does the process of disciplined investigation animate the particular phenomena being studied? Is the outcome a direct extension of the quality of looking?

In his writings on active imagination C. G. Jung repeatedly describes how the simple act of contemplating an image has an animating effect: 'It begins to stir, the image becomes enriched by details, it moves and develops' (1997, p.145).

Investigate different ways of looking at images and experiences and assess their outcomes.

o Heuristic, self-assessments of how we feel during and/or after different types of artistic activity can be a major focus for art-based research. We might also document our different moods and desires when beginning to make art. My colleague Linda Klein describes how, 'Each time I paint I come to it from a different condition and with a different motivation, but every time the act of painting brings me to a more grounded place that allows me to step back from myself'. The stepping back can be likened to a sense of appreciation and a heightened awareness. Linda Klein reports a consistent outcome which persists in spite of the varied conditions from which artistic expressions emerge.

Outcomes may be researched by simply keeping a record over a period of time as to how you feel after making art. A formal research project will benefit from regular intervals of artmaking within a designated period of time. The researcher can work with the same materials and on a consistent scale in order to minimize physical variations. Another study might explore how different media, time factors, and working conditions influence outcomes.

Art therapy needs to ask itself these most basic questions about artmaking. We will benefit from experimental activities which document outcomes, beginning with our own direct involvement with the different aspects of the art experience. As we gain a more complete and intimate understanding of the

creative process, we will move closer to realizing its unlimited potential for healing.

Postscript

The great appeal of art therapy, together with the other creative arts therapies, is connected to the unlimited potential they hold for future innovation. I believe that we have only begun to make the most basic advances in understanding what the creative process is capable of doing within the context of healing. I hope that the previous two parts of this book focusing on art therapy will help to expand this discipline's conception of research and I trust that what I say about art therapy applies to all of the other creative arts therapies.

There has been an increasing realization that effective therapeutic outcomes are achieved through many approaches that operate outside the realm of conventional medical and psychological treatment. The creative arts therapies have made significant contributions to this expansion of curative possibilities. But for the most part, we have imagined and researched the powers of the arts in therapy from the perspective of traditional psychological and medical paradigms. In this book I have tried to suggest the vast potential for discovery that exists when we ground our research in the primary process of the art experience.

As we learn more about the unique healing properties of the creative process, these understandings will advance therapy as well as art. In my overview of possibilities for investigating the art therapy experience, I have tried to respect the way art-based research has emerged from more traditional psychological inquiry. I trust that this partnership will be sustained and advanced from the innovations offered by investigations of the healing properties of the creative process. It is my hope that the unique modes of inquiry offered by the arts will not only augment our vision of discovery within the creative arts therapies, but ultimately help to extend the parameters of research in every discipline committed to human understanding.

References

Adamson, E. (1990) *Art as Healing*. Boston, MA and London: Conventure.

Aldridge, D. (1993a) 'Music therapy research I: A review of the medical research literature within a general context of music therapy research.' *The Arts in Psychotherapy 20*, 1, 11–35.

Aldridge, D. (1993b) 'Music therapy research II: Research methods suitable for music therapy.' *The Arts in Psychotherapy 20*, 2, 117–131.

Aldridge, D. (1993c) 'Arts therapy: The integration of art and therapy.' *The Arts in Psychotherapy 20*, 3, 201–204.

Aldridge, D. (1994) 'Single-case research designs for the creative art therapist.' *The Arts in Psychotherapy 21*, 5, 333–342.

Aldridge, D. and Aldridge, G. (1996) 'A personal construct methodology for validating subjectivity in qualitative research.' *The Arts in Psychotherapy 23*, 3, 225–236.

Allen, P. (1992) 'Artist-in-residence: An alternative to "clinification" for art therapists.' *Art Therapy: Journal of the American Art Therapy Association 9*, 1, 22–29.

Allen, P. (1995a) *Art Is a Way of Knowing*. Boston, MA: Shambhala Publications.

Allen, P. (1995b) 'Coyote comes in from the cold: The evolution of the open studio concept.' *Art Therapy: Journal of the American Art Therapy Association 12*, 3, 161–166.

Allen, P. and Reeves, E. (1998) 'Calling forth voices: Thesis writing for art therapy graduate students, implications for training in art therapy.' Unpublished paper.

Anderson, F. and Packard, S. (1976) 'Opening Pandora's box: Issues in definition – art education/art therapy.' *Viewpoints 52*, 31–46.

Arnheim, R. (1954) *Art and Visual Perception: A Psychology of the Creative Eye*. Berkeley and Los Angeles, CA: University of California Press.

Arnheim, R. (1962) *The Genesis of a Painting: Picasso's Guernica*. Berkeley and Los Angeles, CA: University of California Press.

Arnheim, R. (1972) *Toward a Psychology of Art*. Berkeley and Los Angeles, CA: University of California Press.

Arnheim, R. (1977) *The Dynamics of Architectural Form*. Berkeley and Los Angeles, CA: University of California Press.

Arnheim, R. (1986) *New Essays on the Psychology of Art*. Berkeley and Los Angeles, CA: University of California Press.

Arnheim, R. (1992) *To the Rescue of Art: Twenty-six Essays*. Berkeley and Los Angeles, CA: University of California Press.

Bachelard, G. (1994) *The Poetics of Space.* Trans. by Maria Jolas. Boston, MA: Beacon Press.

Barzun, J. and Graff, H. (1957) *The Modern Researcher.* New York, NY: Harbinger.

Beittel, K.E. (1973) *Alternatives for Art Education Research.* Dubuque, IO: William C. Brown.

Berry, P. (1974) 'An approach to the dream.' *Spring 1974,* 58–79.

Betensky, M. (1973) *Self-Discovery through Self-Expression: Use of Art in Psychotherapy with Children and Adolescents.* Springfield, ILL: Charles C. Thomas.

Betensky, M. (1977) 'The phenomenological approach to art expression and art therapy.' *Art Psychotherapy 4,* 3/4, 173–179.

Betensky, M. (1987) 'Phenomenology of therapeutic art expression and art therapy.' In J. Rubin (ed) *Approaches to Art Therapy: Theory and Technique.* New York, NY: Brunner/Mazel.

Betensky, M. (1996) *What Do You See? Phenomenology of Therapeutic Art Expression.* London: Jessica Kingsley.

Beveridge, W.I.B. (1950) *The Art of Scientific Investigation.* New York, NY: Vintage Books.

Bohr, N. (1987) 'Quantum physics and philosophy – Causality and complementarity.' In *Essays 1958–1962 on Atomic Physics and Human Knowledge; Volume III, The Philosophical Writings of Niels Bohr.* Woodbridge, CT: Ox Bow Press.

Brooke, A. (1996) *Healing in the Landscape of Prayer.* Cambridge, MA: Coley Publications.

Burke, K. (1997) Interview. Pepper Pike, OH.

Burleigh, L. and Beutler, L. (1997) 'A critical analysis of two creative arts therapies.' *The Arts in Psychotherapy 23,* 5, 375–381.

Burt, H. (1996) 'Beyond practice: A postmodern feminist perspective on art therapy research.' *Art Therapy: Journal of the American Art Therapy Association 13,* 1, 12–19.

Canner, N. (1998) 'A Time to Dance' (videotape). Produced by BTI Productions, Somerville, MA.

Capra, F. (1975) *The Tao of Physics.* Boston, MA: Shambhala.

Carnap, R. (1950) 'Empiricism, semantics, and ontology.' *Revue Internationale de Philosophie 4.*

Cassirer, E. (1954) *An Essay on Man.* New York, NY: Doubleday.

Cohen, B., Mills, A. and Kijak, A.K. (1994) 'An introduction to the diagnostic drawing series: A standardized tool for diagnostic and clinical use.' *Art Therapy: Journal of the American Art Therapy Association 11,* 2, 105–110.

Cohen, L. (1994) 'Phenomenology of therapeutic reading with implications for research and practice of bibliotherapy.' *The Arts in Psychotherapy 21,* 1, 37–44.

Condon, W.S. and Ogston, W.D. (1966) 'Sound and film analysis of normal and pathological behavior patterns.' *Journal of Nervous and Mental Disease 143,* 4, 338–347.

Derrida, J. (1994) 'Institutions, GREPH' in roundtable discussion with Jacques Derrida. Villanova University, October 3, 1994, http://www.cas.usf.edu/journal/fobo/vill1.

Einstein, A. (1901) Letter to Marcel Grossman, April 15. In G. Holton (1993) *Science and Anti-Science.* Cambridge MA: Harvard University Press.

Fay, C.G. (1996) 'At the Threshold: A Journey to the Sacred through the Integration of Jungian Psychology and the Expressive Arts' (videotape). Houston, Texas: The C. G. Jung Educational Center of Houston (produced by BTI Productions, Somerville, MA).

Feen-Calligan, H. (1996) 'Art therapy as a profession: Implications for the education and training of art therapists.' *Art Therapy: Journal of the American Art Therapy Association 13,* 3, 166–173.

Feen-Calligan, H. and Sands-Goldstein, M. (1996) 'A picture of our beginnings: The artwork of art therapy pioneers.' *American Journal of Art Therapy 35,* 2, 43–59.

Feen-Calligan, H. (1998) Letter to Shaun McNiff, January 13.

Fenner, P. (1996) 'Heuristic research study: Self-therapy using the brief image-making experience.' *The Arts in Psychotherapy 23,* 1, 37–51.

Fry, R. (1962) 'The artist and psychoanalysis.' *Bulletin of Art Therapy 1,* 4, 3–18.

Fryrear, J. and Fleshman, B. (1981) *Videotherapy in Mental Health.* Springfield, ILL: Charles C. Thomas.

Fryrear, J. and Corbit, I. (1992) *Photo Art Therapy: A Jungian Perspective.* Springfield, ILL: Charles C. Thomas.

Gadamer, H. (1977) *Philosophical Hermeneutics.* (D. Linge, trans. and ed.) Berkeley and Los Angeles, CA: University of California Press.

Gadamer, H. (1994) *Truth and Method.* Second, revised edition; translation revised by J. Weinsheimer and D. G. Marshall. New York, NY: Continuum.

Gallas, K. (1994) *The Languages of Learning: How Children Talk, Write, Dance, Draw, and Sing their Understanding of the World.* New York, NY: Teachers College Press.

Gardner, H. (1983) *Frames of Mind: The Theory of Multiple Intelligences.* New York, NY: Basic Books.

Geertz, C. (1973) *The Interpretation of Cultures.* New York, NY: Basic Books.

Giorgi, A. (ed) (1985) *Phenomenology and Psychological Research.* Pittsburg, PA: Duquesne University Press.

Grenadier, S. (1995) 'The place wherein truth lies.' *The Arts in Psychotherapy 22,* 5, 393–402.

Heisenberg, W. (1958) *Physics and Philosophy.* New York, NY: Harper Torchbooks.

Hillman, J. (1977) 'An inquiry into image.' *Spring 1977,* 62–88.

Hillman, J. (1978) 'Further notes on images.' *Spring 1978,* 152–182.

Hillman, J. (1979) 'Image-sense.' *Spring 1979,* 130–143.

Holton, G. (1973) *Thematic Origins of Scientific Thought.* Cambridge: Harvard University Press.

Holton, G. (1993) *Science and Anti-Science.* Cambridge, MA: Harvard University Press.

Horowitz-Darby, E. (1994) *Spiritual Art Therapy: An Alternate Path.* Springfield, ILL: Charles C. Thomas.

Jackson, K. (1997) Interview. Pepper Pike, Ohio.

Jenkins, K. (1988) 'Women of the cave: Nine images and an artist-therapist face each other.' Cambridge, MA: Lesley College Library. Unpublished masters thesis.

Jones, M. (1953) *The Therapeutic Community: A New Treatment Method in Psychiatry.* New York, NY: Basic Books.

Jones, M. (1982) *The Process of Change.* Boston, MA: Routledge & Kegan Paul.

Joseph, C. and Harris, J. (1973) *Murals of the Mind: Image of a Psychiatric Community.* New York, NY: International Universities Press.

Joseph, C. (1974) 'Art therapy and the third world.' Paper presented at the fifth annual convention of the American Art Therapy Association, New York, NY.

Jung, C.G. (1997) *Jung on Active Imagination.* Edited and with an introduction by Joan Chodorow. Princeton, NJ: Princeton University Press.

Junge, M.B. and Linesch, D. (1993) 'Our own voices: New paradigms for art therapy research.' *The Arts in Psychotherapy 21,* 1, 61–67.

Junge, M.B. (1994) 'The perception of doors: A sociodynamic investigation of doors in twentieth century painting.' *The Arts in Psychotherapy 21,* 5, 343–357.

Kapitan, L. (1997) 'Making or breaking: Art therapy in the shifting tides of a violent culture.' *Art Therapy: Journal of the American Art Therapy Association 14,* 4, 255–260.

Kapitan, L. (1998) 'In pursuit of the irresistible: Art therapy research in the hunting tradition.' *Art Therapy: Journal of the American Art Therapy Association 15,* 1, 22–28.

Kellogg, R. (1970) *Analyzing Children's Art.* Palo Alto, CA: National Press Books.

Kelly, G. (1995) *The Psychology of Personal Constructs* (Vols. I and II). New York, NY: Norton.

Kidd, J. and Wix, L. (1996) 'Images of the heart: Archetypal imagery in therapeutic artwork.' *Art Therapy: Journal of the American Art Therapy Association 13,* 2, 108–113.

Knapp, N. (1994) 'Research with diagnostic drawings for normal and Alzheimer's subjects.' *Art Therapy: Journal of the American Art Therapy Association 11,* 2, 131–138.

Knill, P., Nienhaus Barba, H. and Fuchs, M. (1995) *Minstrels of Soul: Intermodal Expressive Therapy.* Toronto: Palmerston Press.

Kramer, E. (1971) *Art as Therapy with Children.* New York, NY: Schocken Books.

Kraus. D. and Fryrear, J. (1983) *Phototherapy in Mental Health.* Springfield, ILL: Charles C. Thomas.

Langarten, H. (1981) *Clinical Art Therapy: A Comprehensive Guide.* New York, NY: Brunner/Mazel.

Landgarten, H. (1987) *Family Art Psychotherapy.* New York, NY: Brunner/Mazel.

Landgarten, H. (1993) *Magazine Photo Collage: A Multicultural Assessment and Treatment Technique.* New York, NY: Brunner/Mazel.

Landy, R. (1996) *Essays in Drama Therapy: The Double Life.* London: Jessica Kingsley.

Larew, H. (1997) 'Group art therapy used to increase socialization skills of older adults with mental retardation.' Pepper Pike, Ohio: Ursuline College Art Therapy Program. Unpublished masters thesis.

Larsen, S. (1977) *The Shaman's Doorway: Opening the Mythic Imagination to Contemporary Consciousness.* New York, NY: Harper and Row.

Levick, M. (1975) 'Transference and counter-transference as manifested in graphic productions.' *Art Psychotherapy 2,* 3/4, 203–215.

Levine, E. (1995) *Tending the Fire: Studies in Art, Therapy and Creativity.* Toronto, Palmerston Press.

Levine, S. (1997) *Poiesis: The Language of Psychology and the Speech of the Soul.* London: Jessica Kingsley.

Linesch, D. (1992) 'Research approaches within masters level art therapy training programs.' *Art Therapy: Journal of the American Art Therapy Association 9,* 3, 129–134.

Linesch, D. (1994) 'Interpretation in art therapy research and practice: The hermeneutic circle.' *The Arts in Psychotherapy 21,* 3, 185–195.

Linesch, D. (1995) 'Art therapy research: Learning from experience.' *Art Therapy: Journal of the American Art Therapy Association 12,* 4, 261–265.

Maclagan, D. (1995) 'Fantasy and the aesthetic: Have they become the uninvited guests at art therapy's feast?' *The Arts in Psychotherapy 22,* 3, 217–221.

McGraw, M. (1995) 'The art studio: A studio-based art therapy program.' *Art Therapy: Journal of the American Art Therapy Association 12,* 3, 167–174.

McNiff, S. (1973) 'A new perspective in group art therapy.' *Art Psychotherapy 1,* 3/4, 243–245.

McNiff, S. (1974) 'Organizing visual perception through art.' *Academic Therapy Quarterly 9,* 6, 407–410.

McNiff, S. and Oelman, R. (1975) 'Images of fear.' *Art Psychotherapy 2,* 3/4, 267–277.

McNiff, S. (1975a) 'Anthony: A study in parallel artistic and personal development.' *American Journal of Art Therapy 14,* 4, 126–131.

McNiff, S. (1975b) 'Video art therapy.' *Art Psychotherapy 2,* 1, 55–63.

McNiff, S. (1976) 'The effects of artistic development on personality.' *Art Psychotherapy 3,* 2, 69–75.

McNiff, S. (1977) 'Motivation in art.' *Art Psychotherapy 4,* 3/4, 125–136.

McNiff, S. (1979) 'From shamanism to art therapy.' *Art Psychotherapy 6,* 3, 155–161.

McNiff, S. (1981) *The Arts and Psychotherapy.* Springfield, ILL: Charles C. Thomas.

McNiff, S. (1986a) *Educating the Creative Arts Therapist: A Profile of the Profession.* Springfield, ILL: Charles C. Thomas.

McNiff, S. (1986b) 'Freedom of research and artistic inquiry.' *The Arts in Psychotherapy 13*, 4, 279–284.

McNiff, S. (1987a) 'Pantheon of creative arts therapies: An integrative perspective.' *Journal of Integrative and Eclectic Psychotherapy 6*, 3, 259–285.

McNiff, S. (1987b) 'Research and scholarship in the creative arts therapies.' *The Arts in Psychotherapy 14*, 2, 285–292.

McNiff, S. (1988) *Fundamentals of Art Therapy*. Springfield, ILL: Charles C. Thomas.

McNiff, S. (1989) *Depth Psychology of Art*. Springfield, ILL: Charles C. Thomas.

McNiff, S. (1991) 'Ethics and the autonomy of images.' *The Arts in Psychotherapy 18*, 4, 277–283.

McNiff, S. (1992) *Art as Medicine: Creating a Therapy of the Imagination*. Boston, MA: Shambhala Publications.

McNiff, S. (1993) 'The authority of experience.' *The Arts in Psychotherapy 20*, 1, 3–9.

McNiff, S. (1995a) 'Auras and their medicines.' *The Arts in Psychotherapy 22*, 4, 297–305.

McNiff, S. (1995b) *Earth Angels: Engaging the Sacred in Everyday Things*. Boston, MA: Shambhala Publications.

McNiff, S. (1995c) 'Keeping the studio.' *Art Therapy: Journal of the American Art Therapy Association 12*, 3, 179–183.

McNiff, S. (1997) 'Art therapy: A spectrum of partnerships.' *The Arts in Psychotherapy 24*, 1, 37–44.

McNiff, S. (1998) *Trust the Process: An Artistic Guide to Letting Go*. Boston, MA: Shambhala Publications.

Malchiodi, C. (1994) 'Introduction to special section of art-based assessments.' *Art Therapy: Journal of the American Art Therapy Association 11*, 2, 104.

Malchiodi, C. (1995) 'Studio approaches to art therapy.' *Art Therapy: Journal of the American Art Therapy Association 12*, 3, 154–156.

Malchiodi, C. (1996) 'Art therapists in cyberspace.' *Art Therapy: Journal of the American Art Therapy Association 13*, 4, 230–231.

Mills, C.W. (1959) *The Sociological Imagination*. London: Oxford University Press.

Moon, B. (1990) *Existential Art Therapy: The Canvas Mirror*. Springfield, ILL: Charles C. Thomas.

Moon, B. (1992) *Essentials of Art Therapy Training and Practice*. Springfield, ILL: Charles C. Thomas.

Moon, B. (1994) *Introduction to Art Therapy: Faith in the Product*. Springfield, ILL: Charles C. Thomas.

Moon, B. (1997) *Art and Soul*. Springfield, ILL: Charles C. Thomas.

Moore, T. (1990) *Dark Eros: The Imagination of Sadism*. Dallas, T: Spring Publications.

Moustakas, C. (1990) *Heuristic Research: Design, Methodology, and Applications*. Newbury Park, CA: Sage Publications.

Naumburg, M. (1973) *An Introduction to Art Therapy: Studies of the 'Free' Art Expression of Behavior Problem Children and Adolescents as a Means of Diagnosis and Therapy.* New York, NY: Teachers College Press.

Neale, E. and Rosal, M.L. (1993) 'What can art therapists learn from the research on projective drawing techniques for children? A review of the literature.' *The Arts in Psychotherapy 20,* 1, 37–49.

Newham, P. (1993) *The Singing Cure: An Introduction to Voice Movement Therapy.* London: Rider Random House.

Newham, P. (1998) *Therapeutic Voicework.* London: Jessica Kingsley.

Packard, S. and Anderson, F. (1976) 'A shared identity crisis: Art education and art therapy.' *American Journal of Art Therapy 16,* 21–32.

Paquet, N. (1997). 'The mask ritual: An ancient path of transformation for modern times.' Institute of Transpersonal Psychology, Palo Alto, CA: Unpublished doctoral dissertation.

Perdoux, M. (1996) 'Art beyond humanism: Non-western influences on an art therapist's practice.' *Art Therapy: Journal of the American Art Therapy Association 13,* 4, 286–288.

Polanyi, M. (1966) *The Tacit Dimension.* Garden City, NY: Doubleday.

Politsky, R. (1995a) 'Penetrating our personal symbols: Discovering our guiding myths.' *The Arts in Psychotherapy 22,* 1, 9–20.

Politsky, R. (1995b) 'Acts of last resort: The analysis of offensive and controversial art in an age of cultural transition.' *The Arts in Psychotherapy 22,* 2, 111–118.

Politsky, R. (1995c) 'Toward a typology of research in the creative art therapies.' *The Arts in Psychotherapy 22,* 4, 307–314.

Prinzhorn, H. (1972) *Artistry of the Mentally Ill,* trans. by Eric von Brockdorff. New York, NY: Springer-Verlag (Originally published in German in 1922).

Quail, J. and Peavy, R.V. (1994) 'A phenomenological research study of a client's experience in art therapy.' *The Arts in Psychotherapy 21,* 1, 45–57.

Rice, J.S. (1987) 'Mother may I? The story of the painting "Last Day at State Beach": A portrait of a mother by her daughter, its beginning, its life as a creative process, and how this process may never end.' Cambridge, MA: Lesley College Library. Unpublished masters thesis.

Richards, M.C. (1995) Foreword. In: P. Allen, *Art is a Way of Knowing.* Boston, MA: Shambhala Publications.

Riley, S. (1997) 'Social constructionism: The narrative approach and clinical art therapy.' *Art Therapy: Journal of the American Art Therapy Association 14,* 4, 282–284.

Riley-Hiscox, A. (1997) 'Interview – Cliff Joseph: Art therapist, pioneer, artist.' *Art Therapy: Journal of the American Art Therapy Association 14,* 4, 273–278.

Robbins, A. (1973) 'The art therapist's imagery as a response to a therapeutic dialogue.' *Art Psychotherapy 1,* 3/4, 181–184.

Robbins, A. (1987) *The Artist as Therapist.* New York, NY: Human Sciences Press.

Rogers, C. (1965) 'Some thoughts regarding the current philosophy of the behavioral sciences.' *Journal of Humanistic Psychology 5*, 182–194.

Rosal, M.L. (1989) 'Master's papers in art therapy: Narrative or research case studies?' *The Arts in Psychotherapy 16*, 2, 71–75.

Rosal, M.L. (1993) 'Comparative group art therapy research to evaluate changes in locus of control in behavior disordered children.' *The Arts in Psychotherapy 20*, 3, 231–241.

Rubin, J. (1984) *The Art of Art Therapy*. New York, NY: Brunner/Mazel.

Rubin, J. (1987) *Approaches to Art Therapy: Theory and Technique*. New York, NY: Brunner/Mazel.

Salvo, D. (1997) *Home Altars of Mexico*. Albuquerque: University of New Mexico Press.

Santayana, G. (1955) *The Sense of Beauty*. New York, NY: Dover.

Schön, D.A. (1983) *The Reflective Practitioner: How Professionals Think in Action*. London: Basic Books.

Shapiro, J. (1989) 'Descent into image: An archetypal picture-story. Cambridge, MA: Lesley College Library. Unpublished masters thesis.

Shlain, L. (1991) *Art and Physics*. New York, NY: Morrow.

Skinner, B.F. (1962) *Walden Two*. New York, NY: Macmillan.

Skinner, B.F. (1972) *Beyond Freedom and Dignity*. New York, NY: Knopf.

Talbott-Green, M. (1989) 'Feminist scholarship: Spitting into the mouths of the gods.' *The Arts in Psychotherapy 16*, 4, 253–261.

Tibbetts, T. (1995) 'Art therapy at the crossroads: Art and science.' *Art Therapy: Journal of the American Art Therapy Association 12*, 4, 257–258.

Toma, J.D. (1997) 'Alternative inquiry paradigms, faculty cultures, and the definition of academic lives.' *Journal of Higher Education 68*, 6, 679–705.

Trotter, W. (1941) *Collected Papers of Wilfred Trotter*. London: Oxford University Press.

Ursuline College (1989) *Graduate Studies Theses Presentation: Master of Arts in Art Therapy*. Pepper Pike, Ohio.

Ursuline College (1990) *Graduate Studies Theses Presentation: Master of Arts in Art Therapy*. Pepper Pike, Ohio.

Ursuline College (1991) *Graduate Studies Theses Presentation: Master of Arts in Art Therapy*. Pepper Pike, Ohio.

Ursuline College (1992) *Graduate Studies Theses Presentation: Master of Arts in Art Therapy*. Pepper Pike, Ohio.

Ursuline College (1993) *Graduate Studies Theses Presentation: Master of Arts in Art Therapy*. Pepper Pike, Ohio.

Ursuline College (1994) *Graduate Studies Theses Presentation: Master of Arts in Art Therapy*. Pepper Pike, Ohio.

Ursuline College (1995) *Graduate Studies Theses Presentation: Master of Arts in Art Therapy.* Pepper Pike, Ohio.

Ursuline College (1996) *Graduate Studies Theses Presentation: Master of Arts in Art Therapy.* Pepper Pike, Ohio.

Ursuline College (1997) *Graduate Studies Theses Presentation: Master of Arts in Art Therapy.* Pepper Pike, Ohio.

Wadeson, H. (1978) 'Some uses of art therapy data in research.' *American Journal of Art Therapy 18,* 1, 11–18.

Wadeson, H. (1980a) *Art Psychotherapy.* New York, NY: Wiley.

Wadeson, H. (1980b) 'Art therapy research.' *Art Education 33,* 4, 31–35.

Wadeson, H. (1992) *A Guide to Conducting Art Therapy Research.* Mundelein, ILL: American Art Therapy Association.

Weiser, J. (1993) *Photo Therapy Techniques: Exploring the Secrets of Personal Snapshots and Family Albums.* San Fransisco, CA: Jossey-Bass.

Wertheimer, M. (1959) *Productive Thinking.* New York, NY: Harper.

Wolf, R. (1995) Invited response to 'Art therapy at the crossroads: Art and science.' *Art Therapy: Journal of the American Art Therapy Association 12,* 4, 259–260.

Index

Action research, 113
Active imagination, 148, 185, 191, 204, 212
Adamson, Edward, 103–104, 131, 209
Aesthetic criteria for reliability and validity, 57–61, 172–174, 192
Aesthetic measurement, 171–178
Aesthetic quality, 171–178
Aldridge, David, 160–161, 194, 209
Allen, Pat, 13, 28, 33, 36, 59–60, 115, 123–124, 130–131, 163, 209
Allen, Woody, 164
American Art Therapy Association, 182, 199–200, 202
American Art Therapy Association Guidelines for Research, 136
Amplification, 159–167
Anderson, Frances, 114, 188, 209, 215
Aquinas, Thomas, 59–60
Archetypal imagery, 125–128, 191
Archetypal methods and inquiries, 26, 53, 76, 115, 125–128
Architecture, 187
Arnheim, Rudolf, 58, 61–62, 104, 132–133, 165, 174, 178, 187, 190, 209
Arrested motion, 59–60
Art as Healing (Adamson), 103, 209
Art as Therapy with Children (Kramer), 102–103, 212
Art as Medicine (McNiff), 28, 185, 214
Art education, 114, 188–189, 210, 215
Art history, 125–126, 173
Art is a Way of Knowing (Allen), 28, 36, 59, 123–124, 163, 209

Artistic knowing, 182–183
Artist in residence model, 33, 104, 209
Artistry of the Mentally Ill (Prinzhorn), 177, 215
Art Psychotherapy (Wadeson), 102, 216
Asklepios, 189
'A Time to Dance' (Canner), 193, 210
Audubon, John, 51
Authority of experience, 78–82, 146, 214
Autism, 101
Autobiographical inquiry, 94, 124–125, 163, 199, 201

Bachelard, Gaston, 107, 184, 187, 210
Barba, Helen, 33, 212
Barzun, Jacques, 54, 210
Beauty, 57–60
Beckett, Sr. Wendy, 196
Beittel, Kenneth, 116, 210
Benson, Herbert, 181
Berry, Patricia, 127–128, 182, 210
Betensky, Mala, 92, 100–101, 210
Beutler, Larry, 118, 210
Beveridge, W. I. B. 42, 50, 170, 210
Bias, 95, 113, 136
Biofeedback, 181, 197–198
Biographical inquiry, 94, 124, 163, 199
Bohr, Niels, 46–47, 106, 210
Bracketing, 93, 118
Brooke, Avery, 187, 210
Brownell, Ian, 193
Burke, Sr. Kathleen, 135–142, 210
Burleigh, Laura, 118, 210
Burt, H. 210

Canner, Norma, 193, 210
Capra, Fritjof, 106, 210
Carnap, Rudolf, 40–41, 210
Case study, 73–74, 85, 95, 103, 117, 124–125, 136–142, 159–167, 183,

198–199, 201
Cassirer, Ernst, 98, 210
Charms, 191
Chodorow, Joan, 212
Clinical Art Therapy (Landgarten), 101–102, 212
'Clinification syndrome', 33, 115
Cohen, Barry, 118–119, 210
Cohen, L. 210
Collaborative research, 157
Color, 178, 181–182, 189
Comparative research, 113–114, 187–189
Complementarism, 46
Condon, William, 194–195, 210
Consensual validation, 59, 160–161
Constructs, 184, 212
Contagion, 197
Corbit, Irene, 179, 211
Correspondence principle, 181
Counter-transference, 42, 75–76, 108, 213
Counting, 117
Cyberspace, 189, 214

Dance therapy, 182, 191–193
Dark Eros (Moore), 129, 214
Deductive methods, 145–146
Depth Psychology of Art (McNiff), 28, 214
Derrida, Jacques, 40, 55, 211
Descriptive psychology, 165–167
Diagnostic art, 92, 99–100, 104, 117–119, 122, 174, 203, 210, 212
Dialoguing with images, 147–149, 185
Digital photography, 190, 203
Disintegration, 37, 132
Door imagery, 125–127, 212
'Double life', 29, 63
Dream imagery, 95, 122, 127, 132, 185–186, 188, 210
Durrell, Lawrence, 170
Dutch art therapists, 96, 179

Earth Angels (McNiff), 179, 214
Ecology, 104, 130, 198
Efficacy, 31, 41, 68, 85, 118–119, 175–176
Effort shape analysis, 182
Einheitlichkeit, 133
Einstein, Albert, 133, 211
Empathy, 165, 184
Empirical research, 12, 24, 49–62, 79–80, 102, 109–110, 113, 117, 119, 132,146, 210
Energy, 45, 71, 104, 107–108, 130–133, 146, 149, 178, 181–182, 188, 190–191, 196–198
Environment, 103–104,106–107, 110, 129–132, 143, 186–188, 191–193, 196–198, 202–203
Ethics and images, 184–185, 214
Ethnographic research, 63, 113,179, 191
Evaluation research, 113

Faith, 188
Family Art Psychotherapy (Landgarten), 102, 212
Fay, Carolyn Grant, 191–192, 211
Feen-Calligan, Holly, 162, 190, 200–201, 211
Feng shui, 187
Fenner, Patricia, 118, 123, 211
Fictional case study, 73–74, 173
Film, 193–195, 210
First-hand inquiry, 74–82, 94, 122–125
Fleshman, Bob, 179, 211
Framework, 40
Freedom of research and choice, 139–142, 213
Freud, Sigmund, 46, 52, 122, 163, 172
Fry, Roger, 98, 211
Fryrear, Jerry, 179, 211, 212
Fuchs, Margot, 33, 212

Fundamentals of Art Therapy (McNiff), 73, 214

Gadamer, Hans-Georg, 14–15, 63, 95, 107, 148, 153–154, 184, 211
Gallas, Karen, 43, 63–66, 211
Gardner, Howard, 44, 211
Geertz, Clifford, 170, 173, 211
Gesamtkunstwerk, 133
Gilroy, Bob, 81, 187
Giorgi, Amedea, 128, 146, 165–166, 211
Graff, Henry, 54, 210
Grenadier, Stephanie, 78–82, 211
Guernica, (Picasso), 190, 209

Harris, J. 199, 212
Heart imagery, 127, 212
Heidegger, Martin, 95
Heisenberg, Werner, 47, 106, 211
Hermeneutic research, 14–15, 53, 113, 184, 211
Herschbach, Dudley, 133
Heuristic research, 14–15, 49, 52–55, 61–62, 113, 123, 136–142, 204, 211, 214
Hillmann, James, 127–128, 182, 211
Historical research, 85, 94, 113, 190, 192–193, 196, 198–201
Holt, John, 64
Holton, Gerald, 133, 211
Home Altars of Mexico (Salvo), 179, 216
Homeopathic medicine, 181
Horowitz, Ellen, 153–154, 177, 212
Hunting 115–116, 212
Husserl, Edmund, 14

Imagination, 13, 16–18, 26, 28, 31, 39–47, 50, 58, 68–69, 71–72, 74, 79–80, 105, 110, 115–116, 124, 126, 132, 148–149, 153, 163, 171, 184–185, 188, 190–191, 204
Imaginative science, 39–47, 98, 170
Improvisation, 71–72
Integrative creative arts therapy, 16–17, 44, 68–72, 185–186, 191–192
Integrative method of research, 55, 112–113 , 125–127
Intermodal expressive therapy, 185
Internet, 94–95
Introduction to Art Therapy (Naumburg), 103, 214
Introspection, 49–62, 151–152

Jackson, Katherine, 136, 138, 140, 212
Jenkins, Kit, 23–24, 212
Jones, Maxwell, 130, 212
Joseph, Cliff, 199–200, 212, 215
Jung, Carl Gustav, 13, 17, 25, 28, 46, 52, 122, 127, 148, 163, 179, 191, 204,
Junge, Maxine, 49, 112–114, 125–127, 135, 199, 212
Justification, 31–38

Kant, Emmanuel, 52
Kapitan, Lynn, 115–116, 195–196, 212
Kellogg, Rhoda, 92, 97–98, 101, 212
Kelly, George, 184, 212
Kidd, Judith, 127, 212
Kijak, A. K. 118–119, 210
Kinesthetic, 182, 191–193, 195
Klein, Linda, 181, 204
Knapp, Nancy, 118–119, 212
Knill, Paolo, 33, 70, 185, 212
Koch, Kenneth, 64
Kramer, Edith, 102–103, 171–172, 195, 212
Kraus, David, 179, 212

Landgarten, Helen, 101–102, 179, 181, 183, 193, 212
Landy, Robert, 29, 63, 213
Languages of Learning (Gallas), 64, 211
Larew, H. 141, 213
Larsen, Stephen, 126, 213
Leonardo Da Vinci, 51
Levick, Myra, 108–109, 213
Levine, Ellen, 35, 213
Levine, Stephen, 37, 213
Liberal arts orientation to research, 135, 139
Linesch, Debra, 13, 49, 112–115, 119, 121, 131, 135, 142, 199, 212, 213
Lipps, Theodor, 59, 165
Literary inquiry, 63–64, 95–96, 163–165
Literature review, 155–156, 173, 188–190, 199
Lopez Pedraza, Rafael, 127
Lowenfeld, Viktor, 97

Maclagan, David, 107, 183, 213
Magazine Photo Collage (Landgarten), 179, 212
Magic, 43–44
Malchiodi, Cathy, 119, 129–130, 143, 163, 189, 214
Mandala, 181
Mapplethorpe, Robert, 128
McGraw, Mary, 104, 213
McLuhan, Marshall, 70
McNiff, Shaun, 16, 45, 54, 66–67, 69, 71, 73–74, 76, 78, 101, 104, 108, 111–122, 147, 179, 185, 190, 213–214
Media inquiry, 96, 107–108, 123–124, 143, 179, 183, 198
Meditation, 107, 180, 183, 185
Method, 145–149, 151, 156, 159–160, 164, 169, 178–198
Mills, A. 118–119, 210
Mills, C. Wright, 86, 214
Mind/body medicine, 181

Moon, Bruce, 28, 64, 162, 182–184, 214
Moore, Thomas, 129, 214
Mount Mary College, 115
Moustakas, Clark, 53, 61–62, 214
Multi-media, 95
Munch, Edvard, 181

Narrative inquiry, 64, 91, 95–96, 117, 125, 136–142, 162, 165, 175, 178, 182, 201
Naumburg, Margaret, 91–92, 102–103, 163, 183, 214
Nazareth College, 154
Neale, Elizabeth Leigh, 118, 214
Neel, Alice, 126
Newham, Paul, 72, 193, 214–215

Oelman, Robert, 111–112
Ogston, W. D. 195, 210
O'Keefe, Georgia, 126
Outcomes, 12, 18, 53, 67, 91, 100, 109–110, 117, 119, 129, 131, 148, 152, 154, 157, 165, 169, 171, 174, 182, 198, 202–205, 207

Packard, Sandra, 114, 188, 209, 215
Paquet, Nicole, 37, 215
Paracelsus, 24
Peavey, R. V. 118, 125, 215
Perdoux, 189–190, 215
Performance, 64–65, 71–72, 78
Personify, 165, 184
Phenomenological research, 14–15, 49, 53, 91–110, 113, 118, 127–128, 132–133, 145–146, 165–166, 210, 211, 215
Philosophical Hermeneutics (Gadamer), 53, 211
Photo Art Therapy: A Jungian Perspective (Fryrear and Corbit), 179, 211

Phototherapy, 179, 211, 212, 217
Physics, 45–47, 79–80, 106, 127, 133, 149, 160–161, 198, 210, 211, 216
Picasso, Pablo, 190
Play, 107, 153
Poetics of Space (Bachelard), 187, 210
Polanyi, Michael, 132, 145, 164, 215
Politsky, Rosalie, 28, 113, 123, 128–129, 189, 215
Portfolio documentation and assessment, 159, 203
Positivism, 52, 88, 112–113, 115
Practitioner research, 63–82, 86–88, 102, 104–105, 111, 115, 119, 159
Prayer, 187, 210
Prinzhorn, Hans, 92, 97–103, 177, 215
Psychoanalysis, 51–52, 108, 211

Quail, J. 118, 125, 215
Qualitative research, 12–14, 21, 49, 52, 113, 136–142, 165, 209
Quantitative research, 12–13, 21, 29, 49, 51–52, 85–87, 113, 115, 117, 135–142, 146, 148–149, 175

Reductio ad absurdum, 34
Reeves, E. 140, 209
Reiki, 198
Rhetorical persuasion, 133–134, 162, 166–167
Rice, Jo, 24–26, 215
Richards, M. C. 36, 215
Richardson, Elwyn, 64
Riley, Shirley, 117, 215
Riley-Hiscox, A. 199, 215
Ritual, 70, 187, 191–192, 215
Robbins, Arthur, 92, 105–107, 162, 215
Rogers, Carl, 170, 215
Rosal, Marcia, 117–118, 214, 215

Rubin, Judy, 89, 116–119, 215–216
Safety, 192, 196
Salvo, Dana, 179, 216
Sands-Goldstein, Margaret, 201, 211
Santayana, George, 57–59, 216
Satisfaction assessments, 68, 165, 176, 202–203
Schön, Donald, 88, 216
Scientism, 14, 31, 47, 50, 145
Self-Discovery through Self-Expression (Betensky), 100, 210
Shamanism, 70, 76–77, 190–191, 213
Shapiro, Janice, 26–28, 216
Shlain, Leonard, 80, 216
'Shouting for Jericho' (Newham), 193
Single-case experimental research design, 117, 160, 209
Skinner, B. F. 187, 216
Space, 103–104,106–107, 110, 129–132, 143, 186–188, 191–193, 196–198
Spirits of art, 196–197
'Spiritual effect' in science, 133–134
Spiritual inquiry, 81, 177, 186, 212
Spontaneous writing, 153–154
Stein, Gertrude, 127
Stories, 95, 125, 162–164
Studio inquiry and environments, 104, 129–132, 146–147, 175–176, 179, 186– 188, 191–193, 196–198, 202–203, 209, 213, 214
Sullivan, Harry Stack, 59

The Black Emergency Cultural Coalition, 199
The Open Studio Project in Chicago, 130–131, 209
Theoretical research, 113
Therapeutic community, 130, 190–191, 199–200, 212
Therapeutic community of images, 104
Therapeutic relationship, 101, 105–110, 122, 184–185
Therapeutic space, 103– 104, 106–107, 110, 129–132, 143, 186–188, 191–193, 196–198
The Sense of Beauty (Santayana), 58, 216
The Shaman's Doorway (Larsen), 126, 213
Third object, 184–185
Thoreau, Henry David, 109
Tibbetts, T. 216
Tikkun ha'olam, 35
Toma, J. D. 216
Total exrpession, 192
Transference, 42, 75–76, 108, 122, 131, 152, 213
Trotter, W. 216
'Trust the process', 37, 75–82, 214
Truth and Method (Gadamer), 107, 153, 211

Ursuline College, 135–142, 213, 216

Videotape, 179, 189, 191–195, 211
Videotherapy, 179, 213
Violence, 195–196
Visual inquiry, 95–101

Wix, Linney, 127, 212
Wolf, R. 217
Worldwide Web, 94–95
Worringer, Wilhelm, 165

Zen Buddhism, 180, 190

Talbott-Green, M. 216
Tending the Fire (Levine), 35, 213
The Arts and Psychotherapy (McNiff), 184–185, 213
The Art of Scientific Investigation (Beveridge), 42, 170, 210

Wadeson, Harriet, 89, 102, 108, 118, 136, 185, 197, 216–217
Warner, Sylvia Ashton, 64
Watson, John, 53
Weiser, Judy, 179, 217
Weltbilt, 94, 96
Wertheimer, Max, 79–80, 217

9 781853 026218